GALLERIA VEZZOLI

EDITED BY ANNA MATTIROLO

MAXXI
NATIONAL MUSEUM OF XXI CENTURY ARTS

ELECTA

BY

CONTENTS

Francesco Vezzoli

WORKS

EDITED BY FLAVIA DE SANCTIS MANGELLI

Divided into twenty-four themes, they chronologically document all the works realized by Francesco Vezzoli from his debut up to 2012. The entries contain a short description of the projects, followed by a list of the works exhibited for each event and a selection of images. Ownership was only indicated if a museum, public institution or foundation is concerned.

I

HOMAGE
TO
JOSEF ALBERS

I

HOMAGE
TO JOSEF ALBERS

Conceived as a tribute to Josef Albers, Peter
Halley and Bridget Riley, the works exploit
the abstract patterns of twentieth-century
paintings, and then turn them into decorative
motifs repeated obsessively in the embroidery.
The original works, modified by the artist,
thus become an ensemble of colored signs,
ornamental themes that are hard to recognize.

9

A Place in the Sun, 2009
wool embroidery on canvas,
60 × 40 cm (framed)

*Homage to the Hollywood Squares
(Featuring Bridget Riley)*, 2008
Gobelin tapestry in handwoven wool,
metal needle, 300 × 300 cm

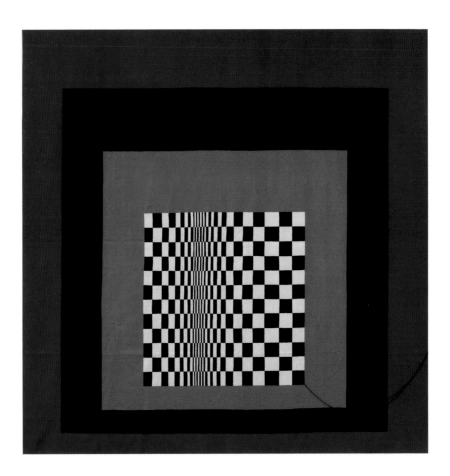

11

Homage to Josef Albers' Homage to the Square (Al Corley's Square Rooms), 2003
wool embroidery on canvas,
60 × 57.5 cm (framed)

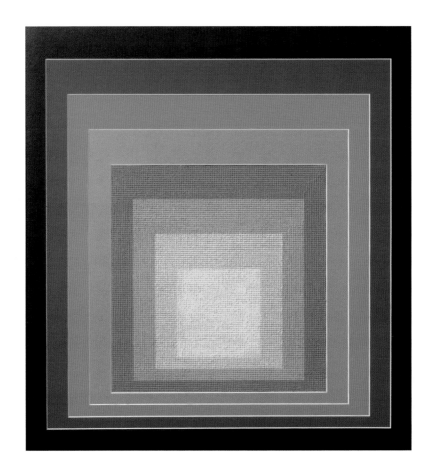

Exhibitions
Homage to Josef Albers

1999

Galleria Giò Marconi, Milan

Fountain, 1996, cotton embroidery on canvas, 17 × 22.5 cm

2000

Galleria Franco Noero, Turin

I Embroideread, 2000, laser print on metallic embroidery, 30 elements, 33×43.5 cm ea. (framed)

2003

Galleria Franco Noero, Turin

Homage to Peter Halley (The Black Room), 1995, cotton embroidery on canvas, 30 × 24 cm (framed)

2005

Fundacão de Serralves, Museu de Arte Contemporanea, Porto

Phone cock, 1994, embroidered pillow, wood and velvet sofa, 35 × 20 ×18 cm

Galleria Franco Noero, Turin

Homage to the Square – The Remake, 2005, wool embroidery on canvas, 73 × 73 cm

2006

Galerie Neu, Berlin

Homage to Josef Albers' "Homage to the Square" (Fade to Grey), 1995, cotton embroidery on canvas, 30 × 24 cm (framed)

Homage to Josef Albers's "Homage to the Square" (Sympathy for the Devil), 1995, cotton embroidery on canvas, 30 × 24 cm (framed)

2007

The Power Plant, Toronto

Homage to Josef Albers (Heart of Grass), 1994, cotton embroidery on canvas, 33 × 28 cm (framed)

Homage to Josef Albers (Small Acts), 1994, cotton embroidery on canvas, 20 × 15 cm (framed)

Homage to Josef Albers (Textures), 1994, cotton embroidery on canvas, 17.5 × 17.5 cm (framed)

Homage to Josef Albers' "Homage to the Square" (Back to the Egg), 1995, cotton embroidery on canvas, 30 × 24 cm (framed)

Homage to Josef Albers' "Homage to the Square" (Brown Sugar), 1995, cotton embroidery on canvas, 30 × 24 cm (framed)

Homage to Josef Albers' "Homage to the Square" (Fade to Grey), 1995, cotton embroidery on canvas, 30 × 24 cm (framed)

Homage to Josef Albers' "Homage to the Square" (Four Seasons of Love), 1995, cotton embroidery on canvas, 30 × 24 cm (framed)

Homage to Josef Albers' "Homage to the Square" (Glitter), 1995, cotton embroidery on canvas, 30 × 24 cm (framed)

Homage to Josef Albers' "Homage to the Square" (Green), 1995, cotton embroidery on canvas, 32 × 26 cm (framed)

Homage to Josef Albers' "Homage to the Square" (Out of the Blue), 1995, cotton embroidery on canvas, 30 × 24 cm (framed)

Homage to Josef Albers' "Homage to the Square" (Pink Moon), 1995, cotton embroidery on canvas, 30 × 24 cm (framed)

Homage to Josef Albers' "Homage to the Square" (Sympathy for the Devil), 1995, cotton embroidery on canvas, 30 × 24 cm (framed)

Hans Josef Albers, 1996, cotton embroidery on canvas, 15.5 × 15.5 cm

Homage to Josef Albers (Floorfiller), 1996, cotton embroidery on canvas, 30 × 23 cm (framed)

Anni Albers and Maximilian Schell, 2000, cotton embroidery on canvas, 9 elements, 34 × 34 cm ea. (framed)

Anni Albers Was an Embroiderer, 2000, cotton embroidery on canvas, 9 elements, 34 × 34 cm ea. (framed), collection Museum Ritter, Waldenbuch

Anni Albers and Bridget Riley Were Lovers, 2001, cotton embroidery on canvas, 32.5 × 32.5 cm (framed), collection Società Pesaro per l'arte contemporanea, Pesaro

Anni Albers and Marlene Dietrich, 2001, cotton embroidery on canvas, 9 elements, 34 × 34 cm ea. (framed)

Homage to Josef Albers' "Homage to the Square" (Al Corley's Square Rooms), 2003, wool embroidery on canvas, 60 × 57.5 cm (framed)

Homage to Josef Albers' "Homage to the Square" (New New Gate), 2003, cotton embroidery on canvas, 44.5 × 44.5 cm (framed)

"Homage to the Square" – The Remake, 2005, wool embroidery on canvas, 73 × 73 cm

2008

MAMbo, Museo d'Arte Moderna di Bologna, Bologna

Homage to the Hollywood squares (Featuring Bridget Riley), 2008, Gobelin tapestry in handwoven wool, metal needle, 300 × 300 cm, collection MAMbo, Museo d'Arte Moderna di Bologna

2009

Kunsthalle, Vienna

Homage to Josef Albers (Heart of Grass), 1994, cotton embroidery on canvas, 33 × 28 cm (framed)

Homage to Josef Albers (Small Acts), 1994, cotton embroidery on canvas, 20 × 15 cm (framed)

Homage to Josef Albers (Textures), 1994, cotton embroidery on canvas, 17.5 × 17.5 cm (framed)

Homage to Josef Albers' "Homage to the Square" (Back to the Egg), 1995, cotton embroidery on canvas, 30 × 24 cm (framed)

Homage to Josef Albers' "Homage to the Square" (Brown Sugar), 1995, cotton embroidery on canvas, 30 × 24 cm (framed)

Homage to Josef Albers' "Homage to the Square" (Fade to Grey), 1995, cotton embroidery on canvas, 30 × 24 cm (framed)

Homage to Josef Albers' "Homage to the Square" (Four Seasons of Love), 1995, cotton embroidery on canvas, 30 × 24 cm (framed)

Homage to Josef Albers' "Homage to the Square" (Green), 1995, cotton embroidery on canvas, 32 × 26 cm (framed)

Homage to Josef Albers' "Homage to the Square" (Out of the Blue), 1995, cotton embroidery on canvas, 30 × 24 cm (framed)

Homage to Josef Albers' "Homage to the Square" (Pink Moon), 1995, cotton embroidery on canvas, 30 × 24 cm (framed)

Homage to Josef Albers's "Homage to the Square" (Sympathy for the Devil), 1995, cotton embroidery on canvas, 30 × 24 cm (framed)

Homage to Josef Albers (Floorfiller), 1996, cotton embroidery on canvas, 30 × 23 cm (framed)

Homage to Josef Albers' "Homage to the Square" (Al Corley's Square Rooms), 2003, wool embroidery on canvas, 60 × 57.5 cm (framed)

Homage to Josef Albers' "Homage to the Square" (New New Gate), 2003, cotton embroidery on canvas, 44.5 × 44.5 cm (framed)

2011

Galleria Giò Marconi, Milan

Phone cock, 1994, embroidered pillow, wood and velvet sofa, 35 × 20 × 18 cm

II

AN EMBROIDERED TRILOGY

II

AN EMBROIDERED
TRILOGY

The project is an ambitious apology for embroi-
dery but also a tour through the creative
imaginary of the artist, who sums up his chief
passions and obsessions in this work. From
the cinema of Luchino Visconti to Silvana
Mangano, to 1980s quiz shows, to the Pop
music of Iva Zanicchi: different citations are
interlaced in the Trilogy, breathing life into
a magmatic universe which blends together
cultural references, personal memories and
impossible linguistic cross-pollinations.

The Life of Silvana Mangano, 1999,
laser print on canvas with metallic
embroidery, 36 Elements, 33 × 43,5 cm
ea. (framed), detail

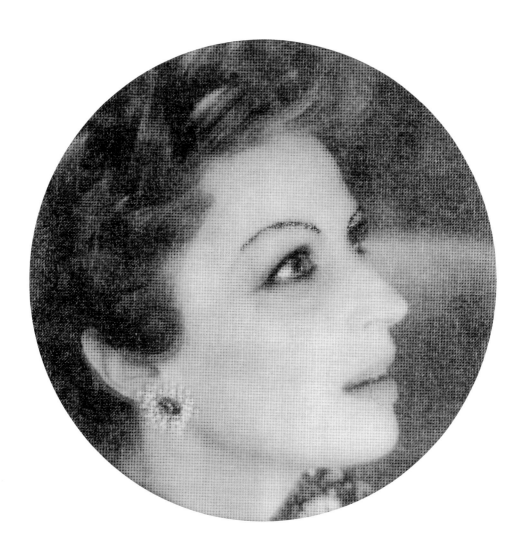

The End (teleteatro), 1999
video projection, DVD, color,
stereo sound, 4'

17 *Ricamo Praz*, 1997
 cotton embroidery on canvas,
 29.7 × 28.2 (framed)

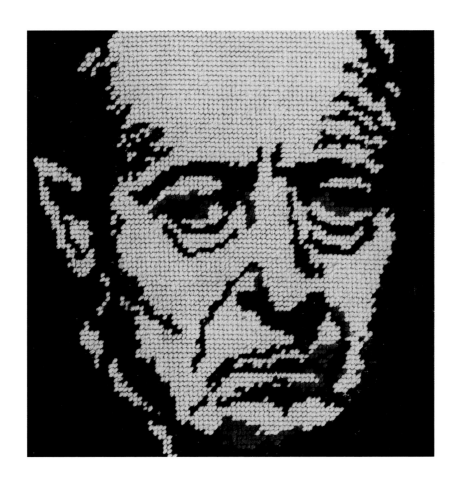

Exhibitions
An Embroidered Trilogy

1997

Centre d'Art Contemporain, Geneva

Ok – The Praz is Right!, 1997, video projection, DVD, color, stereo sound, 5', Edition of 6 and 2 artist's proofs

1998

Brown University, Providence

Ok – The Praz is Right!, 1997, video projection, DVD, color, stereo sound, 5', Edition of 6 and 2 artist's proofs

Palazzo delle Esposizioni, Rome

Ok – The Praz is Right!, 1997, video projection, DVD, color, stereo sound, 5', Edition of 6 and 2 artist's proofs

1999

Galleria Giò Marconi, Milan

Ok – The Praz is Right!, 1997, video projection, DVD, color, stereo sound, 5', Edition of 6 and 2 artist's proofs

The British School at Rome, Rome

Ok – The Praz is Right!, 1997, video projection, DVD, color, stereo sound, 5', Edition of 6 and 2 artist's proofs

Il sogno di Venere, 1998, video projection, DVD, color, stereo sound, 4', Edition of 6 and 2 artist's proofs

The End (teleteatro), 1999, video projection, DVD, color, stereo sound, 4', Edition of 6 and 2 artist's proofs

GAM, Galleria d'Arte Moderna, Bologna

Ok – The Praz is Right!, 1997, video projection, DVD, color, stereo sound, 5', Edition of 6 and 2 artist's proofs

Il sogno di Venere, 1998, video projection, DVD, color, stereo sound, 4', Edition of 6 and 2 artist's proofs

The End (teleteatro), 1999, video projection, DVD, color, stereo sound, 4', Edition of 6 and 2 artist's proofs

International Istanbul Biennial, Istanbul

Ok – The Praz is Right!, 1997, video projection, DVD, color, stereo sound, 5', Edition of 6 and 2 artist's proofs

Il sogno di Venere, 1998, video projection, DVD, color, stereo sound, 4', Edition of 6 and 2 artist's proofs

The End (teleteatro), 1999, video projection, DVD, color, stereo sound, 4', Edition of 6 and 2 artist's proofs

Antony d'Offay Gallery, London

Ok – The Praz is Right!, 1997, video projection, DVD, color, stereo sound, 5', Edition of 6 and 2 artist's proofs

Il sogno di Venere, 1998, video projection, DVD, color, stereo sound, 4', Edition of 6 and 2 artist's proofs

Cattleya I, 1999, cotton embroidery on canvas, 15.5×15.5 cm

Cattleya II, 1999, cotton embroidery on canvas, 15.5×15.5 cm

Cattleya III, 1999, cotton embroidery on canvas, 15.5×15.5 cm

Cattleya IV, 1999 cotton embroidery on canvas, 15.5×15.5 cm

Cattleya V, 1999, cotton embroidery on canvas, 15.5×15.5 cm

Cattleya VI, 1999, cotton embroidery on canvas, 15.5×15.5 cm

Cattleya VII, 1999, cotton embroidery on canvas, 15.5×15.5 cm

The End (teleteatro), 1999, video projection, DVD, color, stereo sound, 4', Edition of 6 and 2 artist's proofs

New Museum of Contemporary Art, New York

Ok – The Praz is Right!, 1997, video projection, DVD, color, stereo sound, 5', Edition of 6 and 2 artist's proofs

Il sogno di Venere, 1998, video projection, DVD, color, stereo sound, 4', Edition of 6 and 2 artist's proofs

The End (teleteatro), 1999, video projection, DVD, color, stereo sound, 4', Edition of 6 and 2 artist's proofs

Centre d'Art Contemporain, Geneva

Ok – The Praz is Right!, 1997, video projection, DVD, color, stereo sound, 5', Edition of 6 and 2 artist's proofs

Il sogno di Venere, 1998, video projection, DVD, color, stereo sound, 4', Edition of 6 and 2 artist's proofs

The End (teleteatro), 1999, video projection, DVD, color, stereo sound, 4', Edition of 6 and 2 artist's proofs

1999-2000

Chisenhale Gallery, London

Ok – The Praz is Right!, 1997, video projection, DVD, color, stereo sound, 5', Edition of 6 and 2 artist's proofs

Il sogno di Venere, 1998, video projection, DVD, color, stereo sound, 4', Edition of 6 and 2 artist's proofs

The End (teleteatro), 1999, video projection, DVD, color, stereo sound, 4', Edition of 6 and 2 artist's proofs

2000

Flash Art Museum, Trevi

Ok – The Praz is Right!, 1997, video projection, DVD, color, stereo sound, 5', Edition of 6 and 2 artist's proofs

Il sogno di Venere, 1998, video projection, DVD, color, stereo sound, 4', Edition of 6 and 2 artist's proofs

The End (teleteatro), 1999, video projection, DVD, color, stereo sound, 4', Edition of 6 and 2 artist's proofs

2001

Edsvik konst och kultur, Sollentuna

Ok – The Praz is Right!, 1997, video projection, DVD, color, stereo sound, 5', Edition of 6 and 2 artist's proofs

Il sogno di Venere, 1998, video projection, DVD, color, stereo sound, 4', Edition of 6 and 2 artist's proofs

The End (teleteatro), 1999, video projection, DVD, color, stereo sound, 4', Edition of 6 and 2 artist's proofs

The London Festival of Moving Image, The Lux Centre, London

Ok – The Praz is Right!, 1997, video projection, DVD, color, stereo sound, 5', Edition of 6 and 2 artist's proofs

Il sogno di Venere, 1998, video projection, DVD, color, stereo sound, 4', Edition of 6 and 2 artist's proofs

Ok – The Praz is Right!, 1997, video projection, DVD, color, stereo sound, 5', Edition of 6 and 2 artist's proofs

Konsthall, Lund

Ok – The Praz is Right!, 1997, video projection, DVD, color, stereo sound, 5', Edition of 6 and 2 artist's proofs

Il sogno di Venere, 1998, video projection, DVD, color, stereo sound, 4', Edition of 6 and 2 artist's proofs

The End (teleteatro), 1999, video projection, DVD, color, stereo sound, 4', Edition of 6 and 2 artist's proofs

Manifattura Tabacchi, Florence

Maria Callas played "La Traviata" 63 times, 1999, laser print on canvas with metallic embroidery, 63 elements, 33×43.5 cm ea. (framed)

Contemporary Art Centre, Vilnius

Ok – The Praz is Right!, 1997, video projection, DVD, color, stereo sound, 5', Edition of 6 and 2 artist's proofs

Il sogno di Venere, 1998, video projection, DVD, color, stereo sound, 4', edition of 6 and 2 artist's proofs

The End (teleteatro), 1999, video projection, DVD, color, stereo sound, 4', edition of 6 and 2 artist's proofs

2002

New Museum of Contemporary Art, New York

Ok – The Praz is Right!, 1997, video projection, DVD, color, stereo sound, 5', Edition of 6 and 2 artist's proofs

Il sogno di Venere, 1998, video projection, DVD, color, stereo sound, 4', edition of 6 and 2 artist's proofs

The End (teleteatro), 1999, video projection, DVD, color, stereo sound, 4', edition of 6 and 2 artist's proofs

La Criée Centre d'Art Contemporain, Rennes

Ok – The Praz is Right!, 1997, video projection, DVD, color, stereo sound, 5', edition of 6 and 2 artist's proofs

Il sogno di Venere, 1998, video projection, DVD, color, stereo sound, 4', Edition of 6 and 2 artist's proofs

The End (teleteatro), 1999, video projection, DVD, color, stereo sound, 4', Edition of 6 and 2 artist's proofs

Silvana Mangano Was an Embroiderer, 2000, laser print on canvas with metallic embroidery, 9 elements, Ø 24 cm e 33 × 43.5 cm ea. (framed)

Chanel, New York

The End (teleteatro), 1999, video projection, DVD, color, stereo sound, 4', Edition of 6 and 2 artist's proofs

Artium, Centro Museo Vasco de Arte Contemporanea, Vitoria-Gasteiz

Ok – The Praz is Right!, 1997, video projection, DVD, color, stereo sound, 5', Edition of 6 and 2 artist's proofs

Il sogno di Venere, 1998, video projection, DVD, color, stereo sound, 4', Edition of 6 and 2 artist's proofs

The End (teleteatro), 1999, video projection, DVD, color, stereo sound, 4', Edition of 6 and 2 artist's proofs

Galleria Roma, Roma, Roma, Rome,

Ricamo Praz, 1997, cotton embroidery on canvas, 29.7 × 28.2 (framed)

Galerie fur Zeitgenössische Kunst, Leipzig

Ok – The Praz is Right!, 1997, video projection, DVD, color, stereo sound, 5', Edition of 6 and 2 artist's proofs

Il sogno di Venere, 1999, video projection, DVD, color, stereo sound, 4', edition of 6 and 2 artist's proofs

The End (teleteatro), 1999, video projection, DVD, color, stereo sound, 4', edition of 6 and 2 artist's proofs

Liza Minnelli, 1999, cotton embroidered on canvas, 36 × 30 cm (framed)

Maria Callas Played "La Traviata" 63 times, 1999, laser print on canvas with metallic embroidery, 63 elements, 33 × 43.5 cm ea. (framed)

Mother Theresa, 1999, cotton embroidered on canvas, 36 × 30 cm (framed)

Truman Capote, 1999, cotton embroidered on canvas, 36 × 30 cm (framed)

MACRO – Museo d'Arte Contemporanea, Rome

Ok – The Praz is Right!, 1997, video projection, DVD, color, stereo sound, 5', Edition of 6 and 2 artist's proofs

Il sogno di Venere, 1998, video projection, DVD, color, stereo sound, 4', Edition of 6 and 2 artist's proofs

The End (teleteatro), 1999, video projection, DVD, color, stereo sound, 4', Edition of 6 and 2 artist's proofs

Granada, Centro José Guerrero

Ok – The Praz is Right!, 1997, video projection, DVD, color, stereo sound, 5', Edition of 6 and 2 artist's proofs

Il sogno di Venere, 1998, video projection, DVD, color, stereo sound, 4', Edition of 6 and 2 artist's proofs

The End (teleteatro), 1999, video projection, DVD, color, stereo sound, 4', Edition of 6 and 2 artist's proofs

2003

Sala Murat, Bari

Ok – The Praz is Right!, 1997, video projection, DVD, color, stereo sound, 5', Edition of 6 and 2 artist's proofs

Il sogno di Venere, 1998, video projection, DVD, color, stereo sound, 4', Edition of 6 and 2 artist's proofs

The End (teleteatro), 1999, video projection, DVD, color, stereo sound, 4', Edition of 6 and 2 artist's proofs

2005

Fundação de Serralves, Museo de Arte Contemporanea, Porto

Crying Divas from the Screenplays of an Embroiderer I, 1999, laser print on canvas with metallic embroidery, 30 elementi, 33 × 43.5 cm ea.

Crying Divas from the Screenplays of an Embroiderer II, 1999, laser print on canvas with metallic embroidery, 30 elements, 33 × 43.5 cm ea.

2006

Le Consortium, Dijon

Ok – The Praz is Right!, 1997, video projection, DVD, color, stereo sound, 5', Edition of 6 and 2 artist's proofs

Il sogno di Venere, 1998, video projection, DVD, color, stereo sound, 4', Edition of 6 and 2 artist's proofs

The End (teleteatro), 1999, video projection, DVD, color, stereo sound, 4', Edition of 6 and 2 artist's proofs

Magasin – Centre National d'Art Contemporain, Grenoble

Ok – The Praz is Right!, 1997, video projection, DVD, color, stereo sound, 5', Edition of 6 and 2 artist's proofs

Il sogno di Venere, 1998, video projection, DVD, color, stereo sound, 4', Edition of 6 and 2 artist's proofs

The End (teleteatro), 1999, video projection, DVD, color, stereo sound, 4', Edition of 6 and 2 artist's proofs

2009

Moderna Museet, Stockholm

Ok – The Praz is Right!, 1997, video projection, DVD, color, stereo sound, 5', Edition of 6 and 2 artist's proofs

Il sogno di Venere, 1998, video projection, DVD, color, stereo sound, 4', Edition of 6 and 2 artist's proofs

The End (teleteatro), 1999, video projection, DVD, color, stereo sound, 4', Edition of 6 and 2 artist's proof

Suor Anna, 1999, laser print on canvas with metallic embroidery, 54 × 37 cm

Visconti!, 2008, laser print on canvas with metallic embroidery, 26 × 20 cm

The Arnold & Marie Schwartz Gallery, New York

Silvana Mangano as Mary Magdalene, 1999-2009, print on canvases and metallic needles, 59 × 49 cm (framed)

Palazzo Grassi, Venice

Ok – The Praz is Right!, 1997, video projection, DVD, color, stereo sound, 5', Edition of 6 and 2 artist's proofs

Il sogno di Venere, 1998, video projection, DVD, color, stereo sound, 4', Edition of 6 and 2 artist's proofs

The End (teleteatro), 1999, video projection, DVD, color, stereo sound, 4', Edition of 6 and 2 artist's proof

2009–2010

Museum of Contemporary Art,
Chicago

Ok – The Praz is Right!, 1997, video
projection, DVD, color, stereo sound,
5', Edition of 6 and 2 artist's proofs

Il sogno di Venere, 1998, video
projection, DVD, color, stereo sound,
4', Edition of 6 and 2 artist's proofs

The End (teleteatro), 1999, video
projection, DVD, color, stereo sound,
4', Edition of 6 and 2 artist's proof

2010

Museion, Bolzano

Ok – The Praz is Right!, 1997, video
projection, DVD, color, stereo sound,
5', Edition of 6 and 2 artist's proofs
Fondazione MUSEION collection,
Museo d'arte moderna e contemporanea
Bolzano, Enea Righi collection

Il sogno di Venere, 1998, video
projection, DVD, color, stereo sound,
4', Edition of 6 and 2 artist's proofs
Fondazione MUSEION collection,
Museo d'arte moderna e contemporanea
Bolzano, Enea Righi collection

The End (teleteatro), 1999, video
projection, DVD, color, stereo sound,
4', Edition of 6 and 2 artist's proof
Fondazione MUSEION collection,
Museo d'arte moderna e contemporanea
Bolzano, Enea Righi collection

Le notti bianche, 1999, laser print
on canvas with metallic embroidery,
3 elements, 40 × 29 cm ea.
47 × 35 cm (framed)

2011

GAM – Galleria d'Arte Moderna, Turin

Maria Callas Played La Traviata 63 times,
1999, laser print on canvas with
metallic embroidery, 63 elements,
33 × 43.5 cm ea. (framed)

2012

Metropolitan Museum of Art,
New York

Liza Minnelli, 1999, cotton embroidered
on canvas, 36 × 30 cm (framed)

III

A
LOVE
TRILOGY

III

A LOVE TRILOGY

The *Trilogy* is a tribute to the legend of Édith Piaf but it is also an apology for embroidery, a pastime that the French singer was especially fond of. In the video *A Love Trilogy – Self-Portrait with Marisa Berenson as Édith Piaf,* Marisa Berenson plays the role of Édith Piaf in an atmosphere rich with citations from Visconti's films. As emphasized by the title, the video is also a self-portrait of the artist (Vezzoli) himself, who reconstructs his own image by hiding behind the identity of Édith Piaf and Marisa Berenson.

23

Édith Piaf, 1999
cotton embroidery on canvas,
28 × 20 cm (framed)

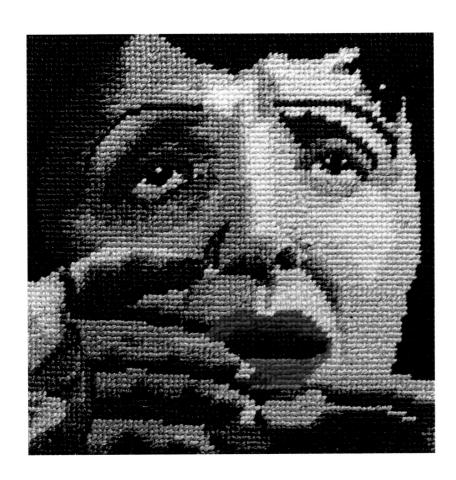

A love trilogy: Self-Portrait with Marisa Berenson as Edith Piaf, 1999
video projection, DVD, color, stereo
sound, 5' 10''

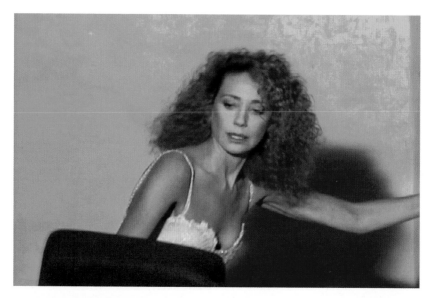

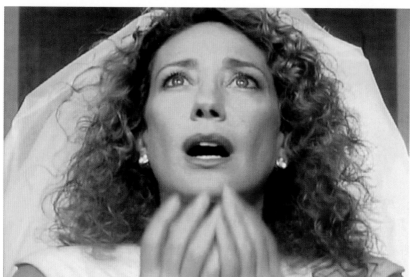

A love trilogy: Self-Portrait with Marisa Berenson as Edith Piaf, 1999
video projection, DVD, color, stereo sound, 5' 10''

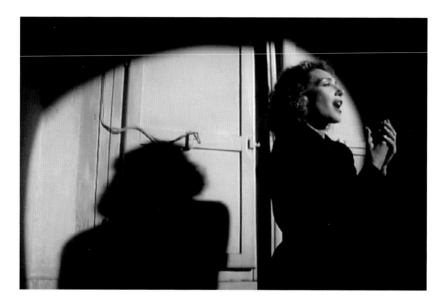

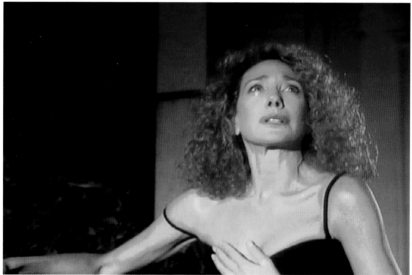

Exhibitions
A Love Trilogy

Édith Piaf, 1999, cotton embroidery
on canvas, 28 × 20 cm (framed)

2006

Le Consortium, Dijon

*A Love Trilogy – Self-Portrait with Marisa
Berenson as Édith Piaf*, 1999, video
projection, DVD, color, stereo sound,
5' 10'', Edition of 6 and 1 artist's proof

2000

GAM, Galleria d'Arte Moderna,
Bologna

*A Love Trilogy – Self-Portrait with Marisa
Berenson as Édith Piaf*, 1999, video
projection, DVD, color, stereo sound,
5' 10'', Edition of 6 and 1 artist's proof

*Édith Piaf as Marisa Berenson, Marisa
Berenson as Édith Piaf*, 2000,
laser print on canvas with metallic
embroidery, 2 elements Ø 24 cm ea.,
33 × 43.5 cm (framed)

La vie en rose, 2000, laser print
on canvas with metallic embroidery,
19 elements, 33 × 43.5 cm ea.

Mourir sur scène, 2000, laser print
on canvas with metallic embroidery,
27 elements, 33 × 43.5 cm ea.

The Love Trilogy, 2000, laser print
on canvas with metallic embroidery,
27 elements, 33 × 43.5 cm ea.

2001

Fundação de Serralves, Museu de
Arte Contemporânea, Porto

*A Love Trilogy – Self-Portrait with Marisa
Berenson as Édith Piaf*, 1999, video
projection, DVD, color, stereo sound,
5' 10'', Edition of 6 and 1 artist's proof

Bagni Reali, Karlovy Vary

*A Love Trilogy – Self-Portrait with Marisa
Berenson as Édith Piaf (Caterina Boratto
in Le bel indifférent)*, 1999, special
edition of the video *A Love Trilogy – Self-
Portrait with Marisa Berenson as Édith
Piaf*, special guest star Caterina Boratto,
6', video projection, DVD, color, stereo
sound, Edition of 1 and 1 artist's proof

2002

New Museum of Contemporary Art,
New York

*A Love Trilogy – Self-Portrait with Marisa
Berenson as Édith Piaf*, 1999, video
projection, DVD, color, stereo sound,
5' 10'', Edition of 6 and 1 artist's proof

2005

Fundação de Serralves, Museu de
Arte Contemporânea, Porto

*A Love Trilogy – Self-Portrait with Marisa
Berenson as Édith Piaf*, 1999, video
projection, DVD, color, stereo sound,
5' 10'', Edition of 6 and 1 artist's proof

2009

Moderna Museet, Stockholm

Double Proust, 1999, cotton embroidery
on canvas, 15.5 × 15.5 cm

Les Parapluies de Cherbourg, 1999,
cotton embroidery on canvas,
15.5 × 15.5 cm

IV

THE KISS

IV

THE KISS

The project includes a video and several embroideries that focus on a reading of an episode from the well-known soap opera *Dynasty*. The video *The Kiss* portrays a dialogue between Helmut Berger and Francesco Vezzoli as Alexis Carrington and her son Steve. It is a heated exchange of lines that ends with a kiss between the two actors. In a setting replete with citations from some of Visconti's films, the work presents an ironic reversal of roles, a play of juxtapositions and cross-references between classical cinema and the Pop atmospheres of American soaps.

You don't have to watch Dynasty to have an attitude (After Gustav Klimt), 2009
cotton embroidery on canvas and
metallic embroidery, 39 × 63 cm (framed)

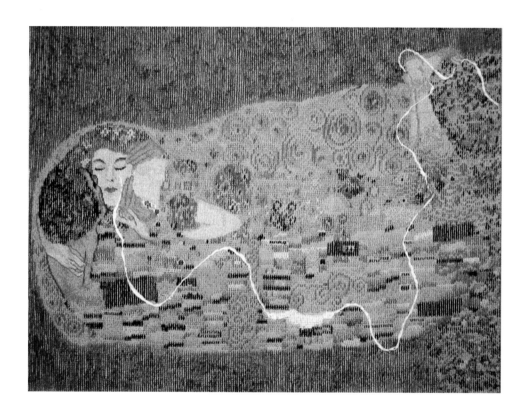

*Il ragazzo che ha freddo (Helmut Berger
& Luchino Visconti)*, 2000-2001
laser print on canvas with metallic
embroidery,15 elements, Ø 24 cm
33 × 45.5 cm ea. (framed)

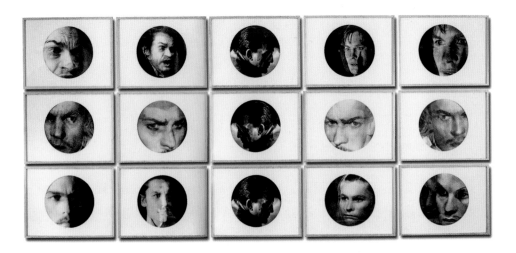

31 *The Kiss*, 2000
video projection, DVD, color,
stereo sound, 6'

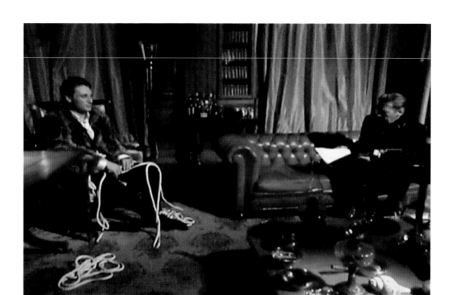

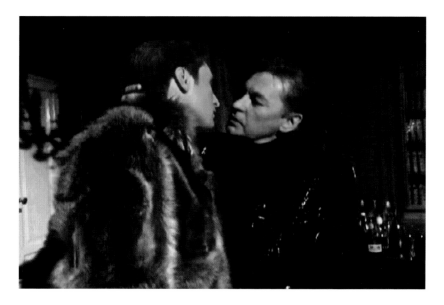

Exhibitions
The Kiss

2000

Centro nazionale per le arti
contemporanee, Rome

The Kiss (Let's Play Dynasty!), 2000, video
projection, DVD, color, stereo sound, 6',
edition of 6 and 1 artist's proof

2001

National Gallery and Chinese
Pavillion, Tirana

The Kiss (Let's Play Dynasty!), 2000, video
projection, DVD, color, stereo sound, 6',
edition of 6 and 1 artist's proof

2002

New Museum of Contemporary Art,
New York

The Kiss (Let's Play Dynasty!), 2000, video
projection, DVD, color, stereo sound, 6
edition of 6 and 1 artist's proof

Center for Contemporary Art, Tel Aviv

The Kiss (Let's Play Dynasty!), 2000, video
projection, DVD, color, stereo sound, 6',
edition of 6 and 1 artist's proof

2003

La Fémis, Ecole nationale supérieure
des métiers de l'image et du son,
Centre national des arts plastiques,
Paris

The Kiss (Let's Play Dynasty!), 2000, video
projection, DVD, color, stereo sound, 6',
edition of 6 and 1 artist's proof

2006

Witte de With, Center for
Contemporary Art, Rotterdam

The Kiss (Let's Play Dynasty!), 2000, video
projection, DVD, color, stereo sound, 6',
edition of 6 and 1 artist's proof

Le Consortium, Dijon

The Kiss (Let's Play Dynasty!), 2000, video
projection, DVD, color, stereo sound, 6',
edition of 6 and 1 artist's proof

GC. AC Galleria Comunale d'Arte
Contemporanea, Monfalcone

The Kiss (Let's Play Dynasty!), 2000, video
projection, DVD, color, stereo sound, 6',
edition of 6 and 1 artist's proof

2007

Arcos – Museo d'Arte Contemporanea
del Sannio, Benevento

The Kiss (Let's Play Dynasty!), 2000, video
projection, DVD, color, stereo sound, 6',
edition of 6 and 1 artist's proof

2008

MAMbo, Museo d'Arte Moderna,
Bologna

*Il ragazzo che ha freddo (H. Berger e
L. Visconti)*, 2000 – 2001, laser print
on canvas with metallic embroidery,
15 elements, Ø 24 cm 33 × 45.5 cm ea.
(framed)

2009

Moderna Museet, Stockholm

*Romy Schneider Was Elisabeth of Bavaria
in Ludwig: Sissi & Franz Joseph*, 2002,
laser print on canvas with metallic
embroidery, 51.5 × 43.5 cm

2011

MAXXI – National Museum of XXI
Century Arts, Rome

The Kiss (Let's Play Dynasty!), 2000,
video projection, DVD, color, stereo
sound, 6', edition of 6 and 1 artist's proof,
collection MAXXI – National Museum
of XXI Century Arts

V

VERUSCHKA
WAS
HERE

V

VERUSCHKA WAS HERE

The project, which includes a performance, photography and embroidery was inspired by the cover of the fashion magazine *Stern* (1969), dedicated to the famous model Veruschka. The aim of the performance *Veruschka Was Here* is to recreate that image with maniacal philological loyalty, an ironic tribute to the top model that is turned into a grotesque consecration of the fashion icon in those years.

*Self-portrait with Vera Lehndorff
as Veruschka,* 2001
digital print on aluminum,120 × 125 cm

Is Veruschka in Paris?, 2001
laserprint on canvas with metallic
embroidery, 52 × 45 cm

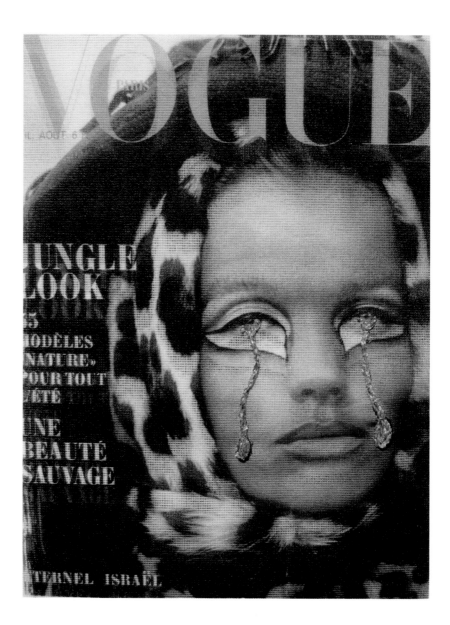

Veruschka has not arrived yet, 2001
laserprint on canvas with
metallic embroidery, 45 × 38 cm

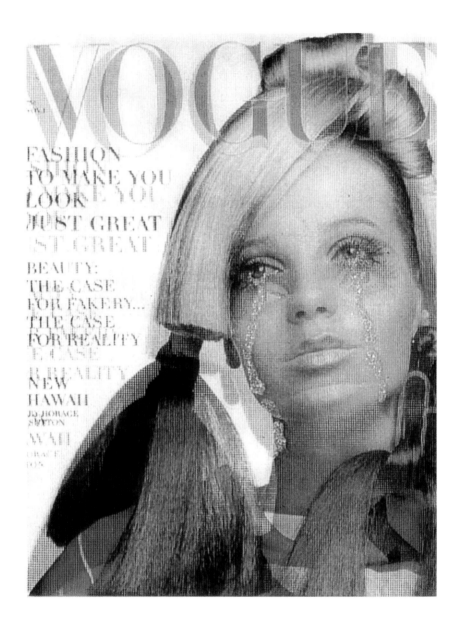

Exhibitions
Veruschka Was Here

2000

Anthony D'Offay Gallery, London

Joan Crawford Was an Embroiderer, 2000, laser print on canvas with metallic embroidery, 18 elements, 33 × 43.5 ea. (framed)

2001

La Biennale di Venezia, Venice

Embroidery of a Book: Young at Any Age, 2000, laser print on canvas with metallic embroidery, 33 elements, 33 × 43.5 cm ea. (framed)

Veruschka Was Here, 2001, performance

Young Joan Old Crawford, 2001, cotton embroidery on canvas, 2 elements, 46.5 × 45.5 cm ea.

Sunset Boulevard, 2001, cotton embroidery on canvas, 2 elements, 61 × 63 cm ea. (framed)

Joan Crawford Embroidered Her Own Tears, 2001, laser print on canvas with metallic embroidery, 9 elements, 35 × 35 cm ea.

Joan Crawford Embroidered Bleeding Tears to Gloria Swanson, 2001, laser print on canvas with metallic embroidery, 9 elements, 35 × 35 cm ea.

Baluardo di San Regolo, Lucca

Joan & Joan, 2001, laser print on canvas with metallic embroidery, 3 elements, 58 × 50 cm ea.

2001-2002

Courtauld Institute of Art Gallery, London

Cyd Charisse Was an Embroiderer, 2001, laser print on canvas with metallic embroidery, 2 elements, 59 × 49 cm ea. (framed)

2002

Palazzo delle Papesse, Siena

Embroidery of a Book: Young at Any Age, 2000, laser print on canvas with metallic embroidery, 33 elements, 33 × 43.5 cm ea. (framed)

Friedrich Petzel and Marianne Boesky Gallery, New York

Embroidering Veruschka Was Here, 2001, laser print on canvas with metallic embroidery, 59 × 49 cm (framed)

Self-Portrait with Vera Lehndorff as Veruschka, 2001, digital print on aluminum, 120 × 125 cm, Edition of 6 and 3 artist's proofs

Veruschka Is Expected to Be Here, 2001, laser print on canvas with metallic embroidery, 54 × 43,5 cm (framed)

Galleria Comunale d'Arte Contemporanea, Monfalcone

Self-Portrait with Vera Lehndorff as Veruschka, 2001, digital print on aluminum, 120 × 125 cm, Edition of 6 and 3 artist's proofs

Galleria Roma, Roma, Roma, Rome

Smoking Diva, (Mildred Pierce), 2002, cotton embroidery on canvas, 64 × 52 cm (framed)

Museo del Corso, Rome

Veruschka Was Here, 2001, laser print on canvas with metallic embroidery, 120 × 100 cm (framed), Edition of 6 and 3 artist's proofs

2006

MADRE, Museo d'Arte Contemporanea Donna Regina, Naples

Embroidering Veruschka Was Here, 2001, laser print on canvas with metallic embroidery, 59 × 49 cm (framed)

2009

Moderna Museet, Stockholm

Self-Portrait with Vera Lehndorff as Veruschka, 2001, digital print on aluminum, 120 × 125 cm, Edition of 6 and 3 artist's proofs

2010 – 2011

MAGA – Museo d'Arte di Gallarate, Gallarate

Four Fabulous Faces: Joan & Marlene, 2001, laser print on canvas with metallic embroidery, 9 elements, 35 × 35 cm ea.

VI

THE END
OF THE
HUMAN VOICE

VI

THE END OF
THE HUMAN VOICE

Inspired by *La voix humaine* (1930) by Jean Cocteau as well as by the movie *L'amore* (1948) by Roberto Rossellini, the project consists of a video and multiple embroideries. The video *The End of "The Human Voice"* presents the last dramatic monologue of the unrequited love between Bianca Jagger and Francesco Vezzoli, who interprets the lover who betrays her. Using a procedure the artist is fond of the work combines various citations and transforms the original Neo-Realist atmospheres into languid and sumptuous Hollywood settings.

The Human Voice: Thank You For Calling Me Back, 2002
laser print on canvas with metallic embroidery, 57 × 47 cm (framed)

Embroidering Orpheus:
Jean Cocteau through the eyes
of Francesco Vezzoli, 2002
laser print on canvas with metallic
embroidery, 2 elements,
61 × 83 cm (framed)

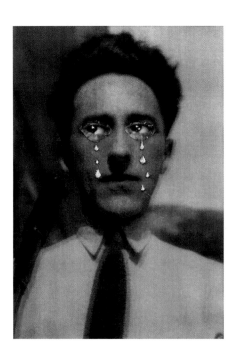

43

Framed! (Jean Cocteau Embroidered Tears on the Face of the Muse), 2002
laser print on canvas with metallic
embroidery, 60 × 50 cm (framed)

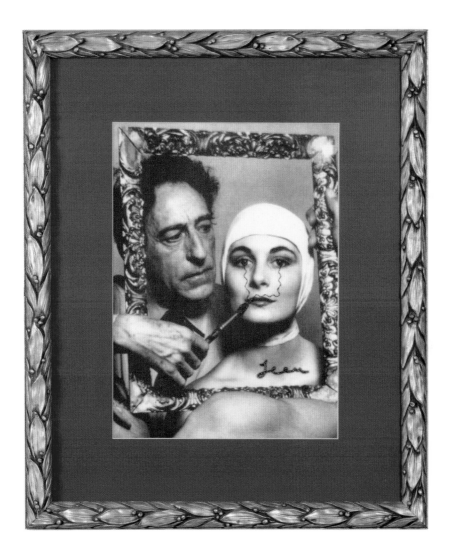

Exhibitions
The End of the Human Voice

2002

 Castello di Rivoli, Museo di Arte
Contemporanea, Rivoli

The End of "The Human Voice", 2001,
double video projection, DVD,
b/w and color, stereo sound, 15',
Edition of 6 and 2 artist's proofs,
collection Castello di Rivoli Museo d'Arte
Contemporanea, Rivoli-Turin

Homage a Jean Cocteau: Le livre blanc,
2002, drawing on canvas with metallic
embroidery, 2 elements, 64 × 52 cm ea.

Homage a Jean Cocteau: Marin, 2002,
drawing on canvas with metallic
embroidery, 64 × 52 cm (framed)

Homage a Jean Cocteau: Querelle de Brest,
2002, drawing on canvas with metallic
embroidery, 5 elements, 64 × 52 cm ea.

*Homage a Jean Cocteau: Raymond
Radiguet et le Poète*, 2002, drawing
on canvas with metallic embroidery,
2 elements, 64 × 52 cm ea. (framed)

Homage a Jean Cocteau: Toulon,
2002, drawing on canvas with metallic
embroidery, 64 × 52 cm

 New Museum of Contemporary Art,
New York

The End of "The Human Voice", 2001,
double video projection, DVD, b/w and
color, stereo sound, 15', Edition of 6
and 2 artist's proofs

 Liverpool Biennial, Liverpool

The End of "The Human Voice", 2001,
double video projection, DVD, b/w and
color, stereo sound, 15', Edition of 6
and 2 artist's proofs

2003

 College of Art, Edinburgh

The End of "The Human Voice", 2001,
double video projection, DVD, b/w and
color, stereo sound, 15', Edition of 6
and 2 artist's proofs

 Academiegalerie, Utrecht

The End of "The Human Voice", 2001,
double video projection, DVD, b/w and
color, stereo sound, 15', Edition of 6
and 2 artist's proofs

2005

 Fundação de Serralves, Museu de
Arte Contemporânea, Porto

The End of "The Human Voice", 2001,
double video projection, DVD, b/w and
color, stereo sound, 15', Edition
of 6 and 2 artist's proofs

The "Livre Blanc" Series Introduction,
2002, drawing on canvas with metallic
embroidery, 34 × 46 cm ea. (framed)

The "Livre Blanc" Series – Book I,
2002, drawing on canvas with metallic
embroidery, 34 × 46 cm ea. (framed)

The "Livre Blanc" Series – Book II,
2002, drawing on canvas with metallic
embroidery, 34 × 46 cm ea. (framed)

The "Livre Blanc" Series – Book III,
2002, drawing on canvas with metallic
embroidery, 34 × 46 cm ea. (framed)

The "Livre Blanc" Series – Book IV,
2002, drawing on canvas with metallic
embroidery, 34 × 46 cm ea. (framed)

The "Livre Blanc" Series – Book V,
2002, drawing on canvas with metallic
embroidery, 34 × 46 cm ea. (framed)

The "Livre Blanc" Series-Book VI,
2002, drawing on canvas with metallic
embroidery, 34 × 46 cm ea. (framed)

The "Livre Blanc" Series – Book VII,
2002, drawing on canvas with metallic
embroidery, 34 × 46 cm ea. (framed)

The "Livre Blanc" Series – Book VIII,
2002, drawing on canvas with metallic
embroidery, 34 × 46 cm ea. (framed)

The "Livre Blanc" Series – Book IX,
2002, drawing on canvas with metallic
embroidery, 34 × 46 cm ea. (framed)

The "Livre Blanc" Series – Book X,
2002, drawing on canvas with metallic
embroidery, 34 × 46 cm ea. (framed)

The "Livre Blanc" Series – Book XI,
2002, drawing on canvas with metallic
embroidery, 34 × 46 cm ea. (framed)

The "Livre Blanc" Series – Book XII,
2002, drawing on canvas with metallic
embroidery, 34 × 46 cm ea. (framed)

2006

 Spazio Oberdan, Milan

The End of "The Human Voice", 2001,
double video projection, DVD, b/w and
color, stereo sound, 15', Edition of 6
and 2 artist's proofs

 Le Consortium, Dijon

The End of "The Human Voice", 2001,
double video projection, DVD, b/w and
color, stereo sound, 15', Edition of 6
and 2 artist's proofs

2009

 Moderna Museet, Stockholm

*Embroidering Orpheus: Jean Cocteau
through the Eyes of Francesco Vezzoli*,
2002, laser print on canvas with metallic
embroidery, 2 elements, 61 × 83 cm
(framed)

VII

FRANCESCO
BY
FRANCESCO

VII

FRANCESCO
BY FRANCESCO

The project, created in collaboration with
the fashion photographer Francesco Scavullo,
includes a series of photographs and embroi-
deries portraying the artist before and after
a professional makeup session, and in a third
phase, called "forever." With these ironic
transformations Vezzoli ponders the theme
of narcissism and unveils the ambitious nature
of the fashion and entertainment world. Also
part of the project are numerous embroideries
in which the artist pays tribute to the inter-
national star system.

Francesco by Francesco:
Before & After, 2002
gelatin silver print, 2 elements,
77 × 59 cm ea. (framed)

Francesco by Francesco:
Happily more than ever, 2002
laser print on canvas with
metallic embroidery, 2 elements,
64 × 52 cm ea. (framed)

Francesco by Francesco:
Happily more than ever, 2002
laser print on canvas with
metallic embroidery, 2 elements,
64 × 52 cm ea. (framed)

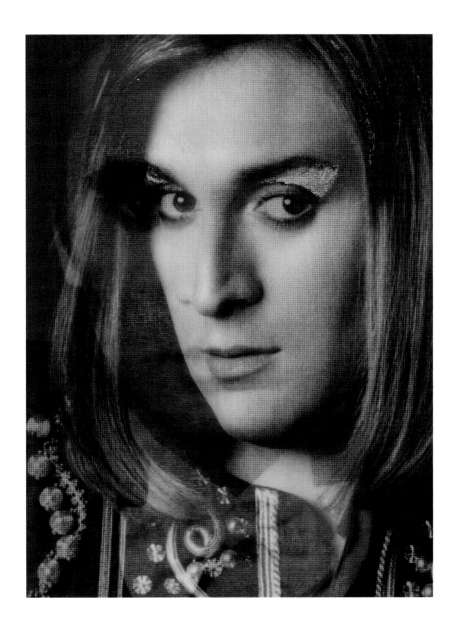

Oh, My Darling (Homage to Francesco Scavullo's men), 2003
laser print on canvas with metallic embroidery, 62 × 51 cm (framed)

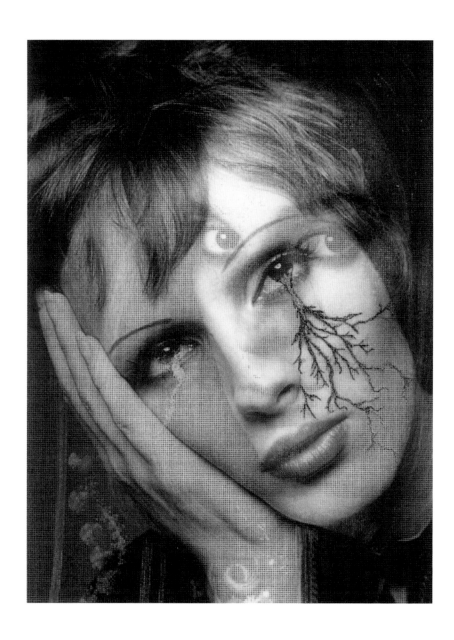

51

*Pink Flamingo Road (Homage
to Francesco Scavullo's men),* 2003
laser print on canvas with metallic
embroidery, 62 × 51 cm (framed)

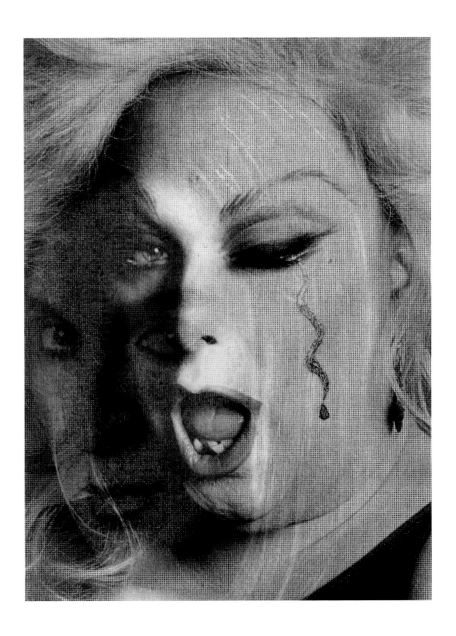

Exhibitions
Francesco by Francesco

2002

Galerie für Zeitgenössische Kunst,
Leipzig

Francesco by Francesco: Before &After,
2002, gelatin silver print, 2 elements,
61 × 83 cm (framed), Edition of 6 and
2 artist's proofs

*Francesco by Francesco: Before &
Ever After*, 2002, gelatin silver print,
2 elements, 77 × 59 cm ea. (framed),
Edition of 6 and 1 artist's proof

*Francesco by Francesco: Happily Ever
After*, 2002, laser print on canvas
with metallic embroidery, 2 elements,
66 × 54 cm ea. (framed)

Francesco by Francesco: Scavullo Beauty,
2002, laser print on canvas with metallic
embroidery, 3 elements, 64 × 52 cm ea.
(framed)

*Homage to Francesco Scavullo: Brooke
Shields (Before & After)*, 2002, laser print
on canvas with metallic embroidery,
2 elements, 61 × 83 cm (framed)

*Homage to Francesco Scavullo:
Gia (Before & After)*, 2002, laser print
on canvas with metallic embroidery,
2 elements, 61 × 83 cm (framed)

*Homage to Francesco Scavullo: No More
Tears (Enough is Enough)*, 2002, laser
print on canvas with metallic embroidery,
2 elements, 61 × 83 cm (framed)

Palazzo dello Sport, La Spezia

*Francesco by Francesco: Before &
Ever After*, 2002, gelatin silver print,
2 elements, 77 × 59 cm ea. (framed),
Edition of 6 and 1 artist's proof

Galleria Giò Marconi, Milan

Francesco by Francesco: Before &After,
2002, gelatin silver print, 2 elements,
61 × 83 cm (framed), Edition of 6 and 2
artist's proofs

*Francesco by Francesco: Before &
Ever After*, 2002, gelatin silver print,
2 elements, 77 × 59 cm ea. (framed),
Edition of 6 and 1 artist's proof

*Francesco by Francesco: Happily Ever
After*, 2002, laser print on canvas with
metallic embroidery
2 elements, 66 × 54 cm ea. (framed)

2004

MACI – Museo arte contemporanea
Isernia, Isernia

*Francesco by Francesco: Happily Ever
After*, 2002, laser print on canvas
with metallic embroidery, 2 elements,
66 × 54 cm ea. (framed)

2008

Palazzo Nicolosio Lomellino, Milan

Francesco by Francesco: Before & After,
2002, gelatin silver print, 2 elements,
61 × 83 cm (framed), Edition of 6 and 2
artist's proofs, Acacia Collection

*Francesco by Francesco: Before &
Ever After*, 2002, gelatin silver print,
2 elements, 77 × 59 cm ea. (framed),
Edition of 6 and 1 artist's proof, Acacia
Collection

*Francesco by Francesco: Happily
More Than Ever*, laser print on canvas
with metallic embroidery, 2 elements,
64 × 52 cm ea. (framed), Acacia
Collection

2009

Moderna Museet, Stockholm

*Francesco by Francesco: Before &
Ever After*, 2002, gelatin silver print,
2 elements, 77 × 59 cm ea. (framed),
Edition of 6 and 1 artist's proof

*Francesco by Francesco: Crying Self-
Portrait*, 2002, laser print on canvas with
metallic embroidery, 64 × 52 cm (framed)

*Francesco by Francesco: Self-Portrait
as Halston*, 2002, laser print on canvas
with metallic embroidery, 2 elements,
61 × 83 cm (framed)

*Francesco by Francesco: The Mirror Has
Two Faces*, 2003, laser print on canvas
with metallic embroidery, 2 elementi,
62 × 51 cm cad. (framed)

*Homage to Francesco Scavullo: Gia
(Before & After)*, 2002, laser print
on canvas with metallic embroidery,
2 elements, 61 × 83 cm (framed)

In Cold Blood, 2003, laser print
on canvas with metallic embroidery,
66 × 49 cm (framed)

2012

Palazzo Reale, Milan

Francesco by Francesco: Before &After,
2002, gelatin silver print, 2 elements,
61 × 83 cm (framed), Edition of 6
and 2 artist's proofs, Acacia Collection

*Francesco by Francesco: Before &
Ever After*, 2002, gelatin silver print,
2 elements, 77 × 59 cm ea. (framed),
Edition of 6 and 1 artist's proof,
Acacia Collection

*Francesco by Francesco: Happily
More Than Ever*, laser print on canvas
with metallic embroidery,
2 elements, 64 × 52 cm ea. (framed),
Acacia Collection

2012 – 2013

Galleria Nazionale Palazzo Arnone,
Cosenza

*Female Monster (Homage to Francesco
Scavullo's Woman)*, 2003, laser print
on canvas with metallic embroidery,
64 × 52 cm (framed)

VIII

DISCO DEPERO

VIII

DISCO DEPERO

The project consists of a neon work and an installation of embroideries, presented inside a prefabricated wooden house. By reproducing the covers designed by the artist for the American magazines *Vanity Fair* and *Vogue*, Vezzoli intends to deconstruct the legend of Fortunato Depero and reread his works in an ironic and light version. The sarcastic effect of the works is exasperated by the garden house, a reworking of Mario Botta's architecture in Tyrolean style.

55 *Omaggio a Fortunato Depero: Bozzetto
di copertina per Vogue 1930*, 2003
cotton embroidery on canvas, 45 × 39 cm
(framed)

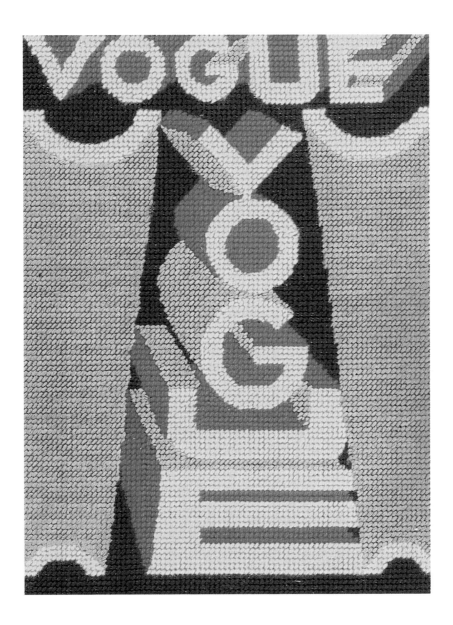

Omaggio a Fortunato Depero: Bozzetto
di copertina per Vanity Fair 1931, 2003
wool embroidery on canvas,
45,5 × 40,5 cm (framed)

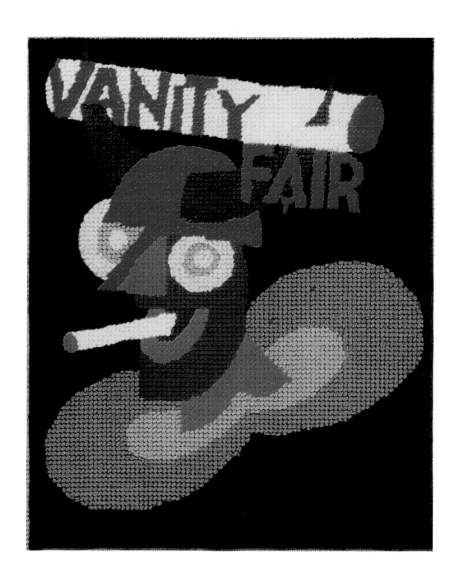

Omaggio a Fortunato Depero:
La dentelliere (Cover), 2003
laser print with metallic embroidery,
46 × 39 cm (framed)

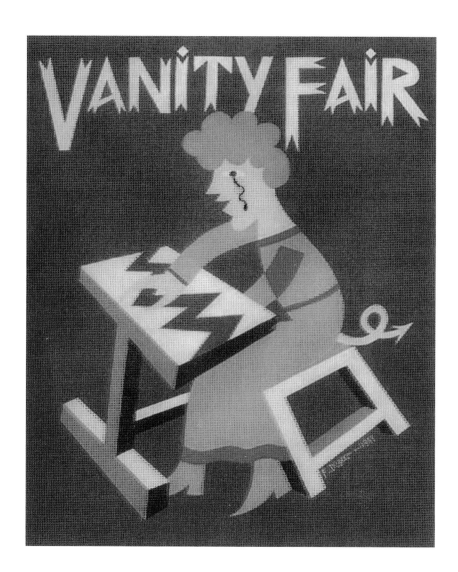

MART, Museo d'Arte Moderna e
Contemporanea di Trento e Rovereto,
Rovereto

Disco Depero, 2003, neon sign, metal,
wood, 100 × 80 cm

*Omaggio a Fortunato Depero: Bozzetto
di copertina per Vanity Fair 1929*, 2003,
wool embroidered on canvas, 45 × 37 cm
(framed)

*Omaggio a Fortunato Depero: Bozzetto
di copertina per Vanity Fair 1930*, 2003,
wool embroidered on canvas, 46 × 39 cm
(framed)

*Omaggio a Fortunato Depero: Bozzetto
di copertina per Vanity Fair 1931*,
2003, wool embroidered on canvas,
45.5 × 40.5 cm (framed)

*Omaggio a Fortunato Depero: Bozzetto
di copertina per Vogue 1930*, 2003,
cotton embroidered on canvas,
45 × 39 cm (framed)

*Omaggio a Fortunato Depero: La
dentelliere (Cover)*, 2003, laser print with
metallic embroidery, 46 × 39 cm (framed)

*Omaggio a Fortunato Depero: Studio
di ricamatrice 1921*, 2003, metallic
embroidery on canvas, 59.5 × 44 cm
(framed)

*Omaggio a Fortunato Depero con
lacrima (Bozzetto di copertina per Vanity
Fair: la ricamatrice)*, 2003, wool and
metallic thread embroidered on canvas,
57 × 46 cm (framed)

IX

TRILOGIA DELLA MORTE

IX

TRILOGIA
DELLA MORTE

Inspired by the films of Pier Paolo Pasolini, the project consists of the reality show *Comizi di non amore*, mounted based on the canons of Pop television, and the installation *120 sedute di Sodoma*, a movie theater made up of seats embroidered by the artist that portray the faces of the characters in the movies *Salò, or the 120 Days of Sodom* (1975) and *Oedipus Rex* (1967). The aim of the Trilogy is to create a continuous slipping and sliding of various genres and languages. To this regard the artist's words are: "I work like an editor who mixes and blends in order to mold a language, either film or television, and place it out of context".[1]

1 G. Celant, *Francesco Vezzoli*, exhibition catalogue (Milan, Fondazione Prada), Progetto Prada Arte, Milan 2004, p.281.

Le 120 sedute di Sodoma, 2004,
laser print on canvas with metallic
embroidery, Argyle chairs in wood,
120 elements, 136 × 47 × 48 cm ea.,
exhibition view, Fondazione Prada,
Milan, detail

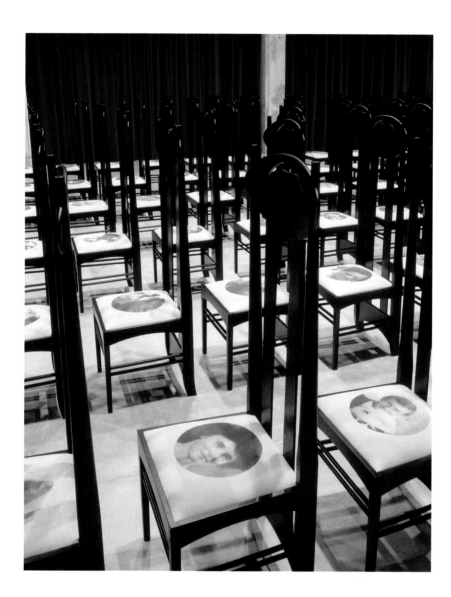

62

Le 120 sedute di Sodoma, 2004
laser print on canvas with metallic
embroidery, Argyle chairs in wood,
120 elements, 136 × 47 × 48 cm ea.

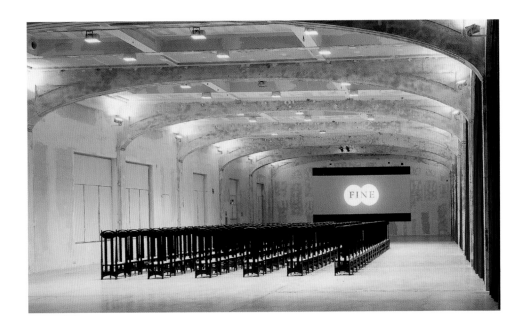

63

Comizi di non amore, 2004
film, DVD, color, stereo sound, 63'50'',
exhibition view, Fondazione Prada, Milan

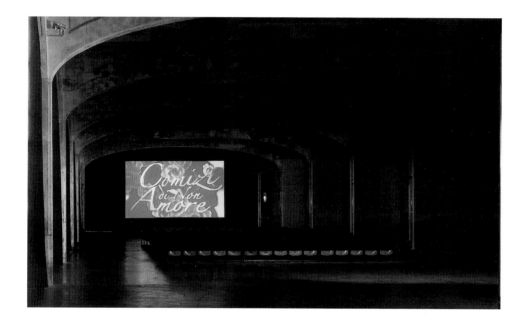

Comizi di non amore, 2004
film, DVD, color, stereo sound, 63'50''

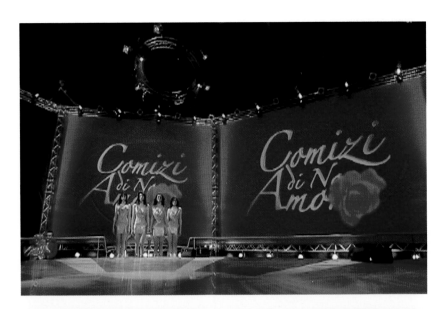

Comizi di non amore, 2004
film, DVD, color, stereo sound, 63'50''

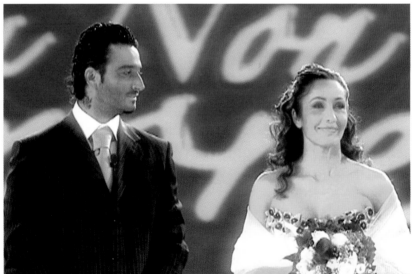

Exhibitions
Trilogia della morte (Trilogy of Death)

Fine, 2004, laser print on canvas with
metallic embroidery, 40 × 43 cm (framed)

Fine, 2004, laser print on canvas
with metallic embroidery, 44.5 × 48 cm
(framed)

2004

Fondazione Prada, Milan

Comizi di non amore, 2004, film, DVD,
color, stereo sound, 63', 50'', Edition
of 1 and 1 artist's proof, collection
Fondazione Prada, Milan

La fine di Edipo Re, 2004, silkscreen
on canvas with cotton embroidery,
430 × 780 cm, collection Fondazione
Prada, Milan

Le 120 sedute di Sodoma, 2004,
laser print on canvas with metallic
embroidery, Argyle chairs in
wood,120 elements, 136 × 47 × 48 cm ea.,
collection Fondazione Prada, Milan

2005

Fondazione Giorgio Cini, Venice

Comizi di non amore, 2004, film, DVD,
color, stereo sound, 63', 50'', Edition
of 1 and 1 artist's proof, collection
Fondazione Prada, Milan

Le 120 sedute di Sodoma, 2004, laser
print on canvas with metallic embroidery,
Argyle chairs in wood,120 elements,
136 × 47 × 48 cm ea., collection
Fondazione Prada, Milan

La fine di Canterbury, 2005, Gobelin
tapestry in handwoven wool,
410 × 700 cm, collection Fondazione
Prada, Milan

2006

Galeries Nationales du Grand
Palais, Paris

Comizi di non amore, 2004, film, DVD,
color, stereo sound, 63', 50'', Edition
of 1 and 1 artist's proof, collection
Fondazione Prada, Milan

La fine di Edipo Re, 2004, silkscreen
on canvas with cotton embroidery,
430 × 780 cm, collection Fondazione
Prada, Milan

Le 120 sedute di Sodoma, 2004, laser
print on canvas with metallic embroidery,
Argyle chairs in wood,120 elements,
136 × 47 × 48 cm ea., collection
Fondazione Prada, Milan

2009

Moderna Museet, Stockholm

Fine, 2004, laser print on canvas with
metallic embroidery, 45 × 49.5 (framed)

X

AMÁLIA TRAÏDA

X

AMÁLIA TRAÏDA

The project consists of several embroideries and a video which tell the story of the life of the famous Fado singer Amália Rodrigues. Starring Brazilian actress Sonia Braga, the video is produced like a musical trailer, a soap opera characterized by a strongly emotional and dramatic tone. The aim of the work is to emulate the language heard on TV, imitate the techniques and contents to deconstruct the strategies of contemporary media culture.

Ai esta pena de mim (Amália Traïda vs. Dancin' Days – episode 5), 2004
laser print and watercolor on canvas with metallic embroidery, 59 × 59 cm (framed), detail (back)

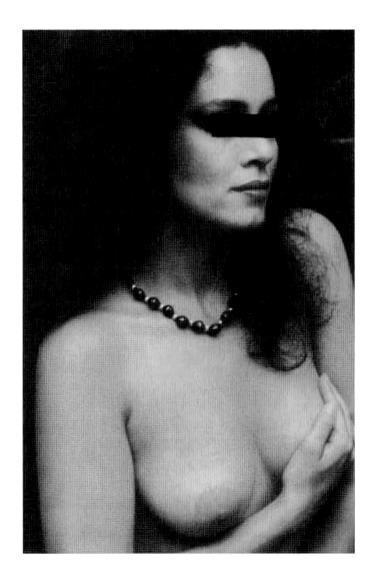

Amália Traïda, 2004
video projection, DVD, b/w and color,
stereo sound, 10'

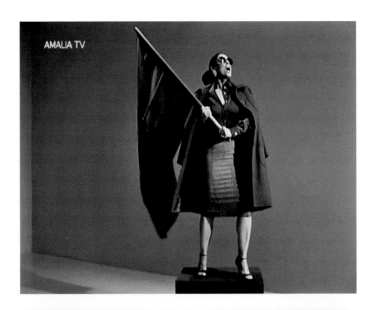

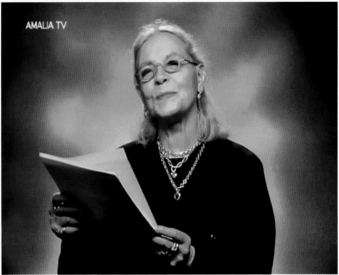

Amália Traïda, 2004
video projection, DVD, b/w and color,
stereo sound, 10'

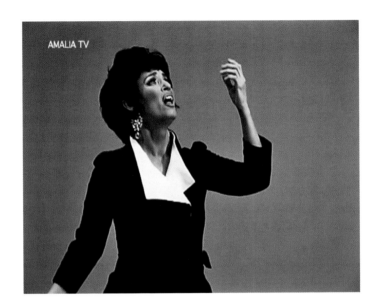

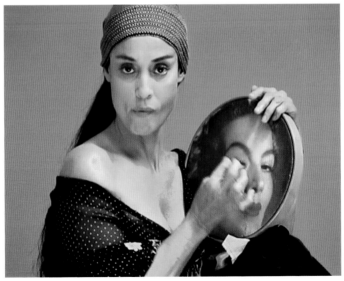

Exhibitions
Amália Traïda

2001

National Gallery and Chinese
Pavillion, Tirana

Che?, 2001, cotton embroidery on
canvas, Ø 24, 38 × 38 cm, collection
Nadace Prague Biennale Foundation,
Prague

2005

Fundaçao de Arte Contemporanea,
Porto

Lauro Corona, 1994, etching, 15 × 19 cm

Che?, 2001, cotton embroidery on
canvas, Ø 24, 38 × 38 cm, collection
Nadace Prague Biennale Foundation,
Prague

Doña Diabla (The Devil Is a Woman),
2002, print on canvas with metallic
embroidery, 60 × 49 cm

Enamorada, (Woman in love), 2002, laser
print on canvas with metallic embroidery,
60 × 49 cm (framed)

La Devoradora (Evil Woman), 2002, print
on canvas with metallic embroidery,
60 × 49 cm

*La Diosa Arrodillada (The Kneeling
Goddess)*, 2002, print on canvas with
metallic embroidery, 60 × 49 cm

La Escondida (The Hidden One), 2002,
print on canvas with metallic embroidery,
60 × 49 cm

The End – La Bandida (The Bandit), 2002,
laser print on canvas with metallic
embroidery, 60 × 49 cm

Amália Traïda, 2004, video projection,
DVD, b/w and color, stereo sound,
10', Edition of 2 and 2 artist's
proofs, collection Fundação
de Serralves – Museu de Arte
Contemporânea, Porto.

*Amália Rodrigues Embroidered Maria
Felix*, 2004, laser print with metallic
embroidery, wood, embroidery, Ø 26 cm

Capas Negras, 2004, laser print with
metallic embroidery, 45 × 34.5 cm
(framed)

*The Singles Collection - Asì canta...
Amália Rodrigues*, 2004, print on
canvas with metallic embroidery, 7 vinyls,
17.5 × 17.5 cm

2006

Galeria Fortes Vilaça, São Paulo

O Retrato de Julia de Souza Matos,
2004, laser print on canvas with metallic
embroidery, 83 × 78 cm (framed)

Le Consortium, Dijon

Amália Traïda, 2004, video projection,
DVD, b/w and color, stereo sound, 10',
Edition of 2 and 2 artist's proofs,

2007

MAXXI – National Museum of XXI
Century Arts, Rome

Amália Traïda, 2004, video projection,
DVD, b/w and color, stereo sound,
10', Edition of 2 and 2 artist's proofs,
collection MAXXI – National Museum
of XXI Century Arts, Rome

XI

THE
GORE VIDAL
TRILOGY

XI

THE GORE VIDAL
TRILOGY

The *Trilogy,* which is made up of a video and several embroideries, draws from the controversial project on Emperor Caligula staged by Gore Vidal in the 1970s. In *Trailer for a Remake of Gore Vidal's Caligola* Vezzoli realizes a film preview for a movie that does not exist interpreted by international stars, personalities from the world of television and independent cinema. The result of this is a parody that focuses on the sex-power binomial, a scathing deconstruction of the strategies used by the entertainment world.

Trailer for a Remake of Gore Vidal's Caligula, 2005
video projection, DVD, color, stereo, sound, 5'; production still

76

*Suddenly Last Summer'
Walk Of Fame (Elizabeth Taylor as
Catherine Holly)*, 2006
tempera on canvas with metallic
embroidery, 78 × 84 cm

77

Untitled (Spencer Tracy), 2006
tempera on canvas with metallic
embroidery, 78 × 84 cm

Trailer for a Remake of Gore Vidal's
Caligula, 2005
video projection, DVD, color, stereo,
sound, 5'; production still

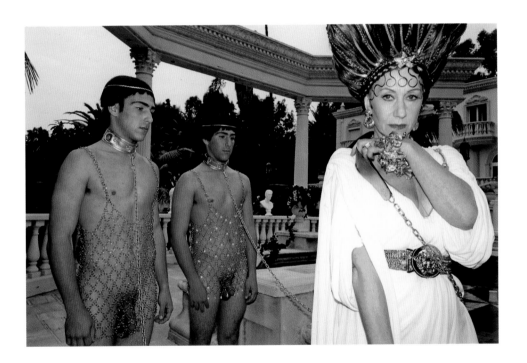

*Trailer for a Remake of Gore Vidal's
Caligula*, 2005
video projection, DVD, color, stereo,
sound, 5'; production still

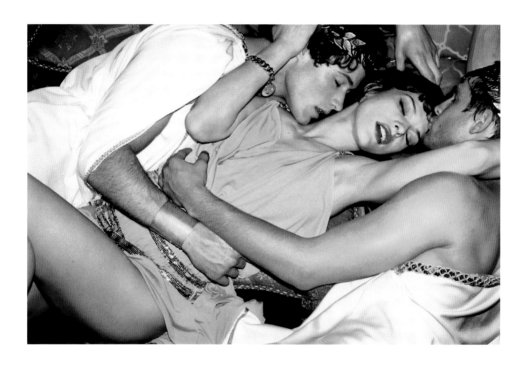

Exhibitions
Gore Vidal Trilogy

2005

La Biennale di Venezia, Venice

Trailer for a Remake of Gore Vidal's Caligula, 2005, video projection, DVD, color, stereo, sound, 5', variable dimensions, Edition of 3 and 2 artist's proofs

Castello di Rivoli, Museo d'Arte Contemporanea, Rivoli

Poster for a Remake of Gore Vidal`s Caligula, 2005, silkscreen on paper, variable dimensions, Edition of 6 and 2 artist's proofs, collection Castello di Rivoli Museo d'Arte Contemporanea, Rivoli (Turin)

Trailer for a Remake of Gore Vidal's Caligula, 2005, video projection, DVD, color, stereo, sound, 5', variable dimensions, Edition of 3 and 2 artist's proofs, collection Castello di Rivoli, Museo d'Arte Contemporanea, Rivoli (To)

2006

Whitney Museum of American Art, New York

Trailer for a Remake of Gore Vidal's Caligula, 2005, video projection, DVD, color, stereo, sound, 5', variable dimensions, Edition of 3 and 2 artist's proofs

The Adelaide Festival of Arts, Adelaide

Trailer for a Remake of Gore Vidal's Caligula, 2005, video projection, DVD, color, stereo, sound, 5', variable dimensions, Edition of 3 and 2 artist's proofs

Whitechapel Art Gallery, London

Trailer for a Remake of Gore Vidal's Caligula, 2005, video projection, DVD, color, stereo, sound, 5', variable dimensions, Edition of 3 and 2 artist's proofs

Gagosian Gallery, Beverly Hills

Poster For Suddenly Last Summer II – The Return Of Sebastian, 2006, poster, variable dimensions

Trailer for a Remake of Gore Vidal's Caligula, 2005, video projection, DVD, color, stereo, sound, 5', variable dimensions, Edition of 3 and 2 artist's proofs

Casting Call for the New Myra Breckinridge, 2006, live performance, variable dimensions

'Suddenly Last Summer' Walk of Fame (Albert Dekker as Dr. Lawrence J. Hockstader), 2006, tempera on canvas with metallic embroidery, 78 × 84 cm ea. (framed)

'Suddenly Last Summer' Walk of Fame (Costumes for Elizabeth Taylor: Jean Louis), 2006, tempera on canvas with metallic embroidery, 78 × 84 cm ea. (framed)

'Suddenly Last Summer' Walk of Fame (David Cameron as Young Blonde Intern), 2006, tempera on canvas with metallic embroidery, 78 × 84 cm ea. (framed)

'Suddenly Last Summer' Walk of Fame (Eddie Fisher – Uncredited), 2006, tempera on canvas with metallic embroidery, 78 × 84 cm ea. (framed)

'Suddenly Last Summer' Walk of Fame (Elizabeth Taylor as Catherine Holly), 2006, tempera on canvas with metallic embroidery, 78 × 84 cm ea. (framed)

'Suddenly Last Summer' Walk of Fame (Gary Raymond as George Holly), 2006, tempera on canvas with metallic embroidery, 78 × 84 cm ea. (framed)

'Suddenly Last Summer' Walk of Fame (Katharine Hepburn as Mrs. Violet Venable), 2006, tempera on canvas with metallic embroidery, 78 × 84 cm ea. (framed)

'Suddenly Last Summer' Walk of Fame (Mavis Villiers as Miss Foxhill), 2006, tempera on canvas with metallic embroidery, 78 × 84 cm ea. (framed)

'Suddenly Last Summer' Walk of Fame (Mercedes McCambridge as Mrs. Grace Holly), 2006, tempera on canvas with metallic embroidery, 78 × 84 cm ea. (framed)

'Suddenly Last Summer' Walk of Fame (Montgomery Clift as Dr. Cukrowicz), 2006, tempera on canvas with metallic embroidery, 78 × 84 cm ea. (framed)

'Suddenly Last Summer' Walk of Fame (Patricia Marmont as Nurse Benson), 2006, tempera on canvas with metallic embroidery, 78 × 84 cm ea. (framed)

'Suddenly Last Summer' Walk of Fame (Rita Webb as Asylum Inmate), 2006, tempera on canvas with metallic embroidery, 78 × 84 cm ea. (framed)

'Suddenly Last Summer' Walk of Fame (Roberta Woolley as a Patient), 2006, tempera on canvas with metallic embroidery, 78 × 84 cm ea. (framed)

'Suddenly Last Summer' Walk of Fame (Sugar, Elizabeth Taylor's Dog), 2006, tempera on canvas, with metallic embroidery, 78 × 84 cm ea. (framed)

Untitled Gore Vidal, 2006, tempera on canvas with metallic embroidery, 78 × 84 cm ea. (framed)

Untitled Spencer Tracy, 2006, tempera on canvas with metallic embroidery, 78 × 84 cm ea. (framed)

KW Institute of Contemporary Art, Berlin

Trailer for a Remake of Gore Vidal's Caligula, 2005, video projection, DVD, color, stereo, sound, 5', variable dimensions, Edition of 3 and 2 artist's proofs

Museum of Contemporary Art, Belgrade

Trailer for a Remake of Gore Vidal's Caligula, 2005, video projection, DVD, color, stereo, sound, 5', variable dimensions, Edition of 3 and 2 artist's proofs

2007

Kino im Museum Ludwig, Cologne

Poster for a Remake of Gore Vidal`s Caligula, 2005, silkscreen on paper, variable dimensions, Edition of 6 and 2 artist's proofs

Trailer for a Remake of Gore Vidal's Caligula, 2005, video projection, DVD, color, stereo, sound, 5', variable dimensions, Edition of 3 and 2 artist's proofs collection Museum Ludwig, Cologne

Braga, Mário Sequeira Gallery

"Suddendly Last Summer" Walk of Fame (Rita Webb as asylum inmate), 2006, tempera on canvas with metallic embroidery, 78 × 84 cm ea. (framed)

"Suddendly Last Summer" Walk of Fame (Roberta Woolley as a patient), 2006, tempera on canvas with metallic embroidery, 78 × 84 cm ea. (framed)

2009

Moderna Museet, Stockholm

Poster for a Remake of Gore Vidal`s Caligula, 2005, silkscreen on paper, variable dimensions, Edition of 6 and 2 artist's proofs

Trailer for a Remake of Gore Vidal's Caligula, 2005, video projection, DVD, color, stereo, sound, 5', variable dimensions, Edition of 3 and 2 artist's proofs

Every Point in Human History is Dark, 2005, color print and watercolor on canvas with metallic embroidery, 52 × 40 cm (framed)

'Suddenly Last Summer' Walk of Fame (Elizabeth Taylor as Catherine Holly), 2006, tempera on canvas with metallic embroidery, 78 × 84 cm ea. (framed)

2012

Castello di Rivoli, Rivoli

Poster for a Remake of Gore Vidal`s Caligula, 2005, silkscreen on paper, variable dimensions, Edition of 6 and 2 artist's proofs, collection Castello di Rivoli Museo d'Arte Contemporanea, Rivoli (Turin)

Trailer for a Remake of Gore Vidal's Caligula, 2005, video projection, DVD, color, stereo, sound, 5', variable dimensions, Edition of 3 and 2 artist's proofs, collection Castello di Rivoli Museo d'Arte Contemporanea, Rivoli (Turin)

XII

THE
BRUCE NAUMAN
TRILOGY

XII

THE BRUCE NAUMAN
TRILOGY

Conceived as an ironic tribute to Bruce Nauman, the Trilogy harks back to some of the works by the American artist, cross-pollinating their meaning via references to contemporary media culture. Hence, *Greatest Hits: Milva Canta Bruce Nauman: Vattene dalla mia mente! Vattene da questa stanza,* is Vezzoli's rereading in a melodramatic key of the installation *Get Out of My Mind, Get Out of This Room,* (1968), while in *Flower Arrangement,* he replaces the flour in Nauman's work with red roses. Similarly, in *The Return of Bruce Nauman's Bouncing Balls,* he abandons the conceptual coldness of the original work to present a patinated video based on the canons of pornographic filmography.

Greatest Hits – Milva Canta Bruce
Nauman: "Vattene dalla mia mente!
Vattene da questa stanza!", 2005
neon sign, sound, laser print on canvas
with metallic embroidery, variable
dimensions (detail)

The Return of Bruce Nauman's "Bouncing Balls", 2006
video, color, stereo sound, 8'

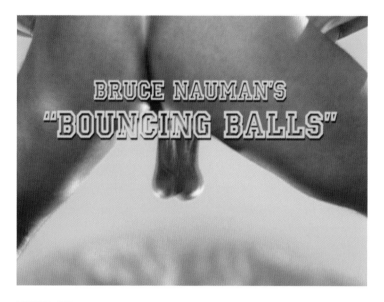

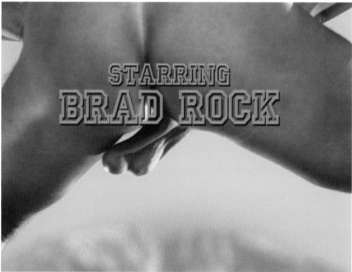

Exhibitions
The Bruce Nauman Trilogy

2005

 Fundação de Serralves – Museu de
Arte Contemporânea, Porto

*Flower Arrangement – Homage to Bruce
Nauman,* 2005, roses, wicker basket,
wooden base, b/w prints on aluminum,
variable dimensions, Edition of 3 and
1 artist's proof

*Greatest Hits Milva Canta Bruce Nauman:
"Vattene dalla mia mente! Vattene da
questa stanza!",* 2005, neon sign, sound,
laser print on canvas with metallic
embroidery, variable dimensions, Edition
of 3 and 2 artist's proofs

2006

 Galerie Neu, Berlin

*Flower Arrangement – Homage to Bruce
Nauman,* 2005, roses, wicker basket,
wooden base, b/w prints on aluminum,
variable dimensions, Edition of 3 and
1 artist's proof

*Greatest Hits Milva Canta Bruce Nauman:
"Vattene dalla mia mente! Vattene
da questa stanza!",* 2005, neon sign,
sound, laser print on canvas with
metallic embroidery, variable dimensions
Edition of 3 and 2 artist's proofs

*The Return of Bruce Nauman's "Bouncing
Balls",* 2006, 8', video, color, stereo
sound, Edition of 3 and 2 artist's proofs

 Le Consortium, Dijon

*The Return of Bruce Nauman's "Bouncing
Balls",* 2006, video, color, stereo sound,
8', Edition of 3 and 2 artist's proofs

 Zwirner and Wirth Gallery, New York

*The Return of Bruce Nauman's "Bouncing
Balls",* 2006, video, color, stereo sound,
8', Edition of 3 and 2 artist's proofs

 Apexart, New York
 The British School, Rome

*The Return of Bruce Nauman's "Bouncing
Balls",* 2006, video, color, stereo sound,
8', Edition of 3 and 2 artist's proofs

2007

 Mambo, Museo d'Arte Moderna,
Bologna

*Flower Arrangement – Homage to Bruce
Nauman,* 2005, roses, wicker basket,
wooden base, b/w prints on aluminum,
variable dimensions, Edition of 3 and
1 artist's proof

*Greatest HitsMilva Canta Bruce Nauman:
"Vattene dalla mia mente! Vattene da
questa stanza!",* 2005, neon sign, sound,
laser print on canvas with metallic
embroidery, variable dimensions
Edition of 3 and 2 artist's proofs

*The Return of Bruce Nauman's "Bouncing
Balls",* 2006, video, color, stereo sound,
8', Edition of 3 and 2 artist's proofs

2008 – 2009

 Castello di Rivoli, Museo d'Arte
Contemporanea, Rivoli

*Greatest Hits Milva Canta Bruce Nauman:
"Vattene dalla mia mente! Vattene
da questa stanza!",* 2005, neon sign,
sound, laser print on canvas with
metallic embroidery, variable dimensions
Edition of 3 and 2 artist's proofs

2012

 Sztuki Wspólkzesnej, Torun

*The Return of Bruce Nauman's "Bouncing
Balls",* 2006, 8', video, color, stereo
sound, Edition of 3 and 2 artist's proofs

XIII

MARLENE REDUX

XIII

MARLENE REDUX

Inspired by the American TV series *E! A True Hollywood Story!*, the project focuses on the creation of a fiction version of the biography of Francesco Vezzoli. In the video *Marlene Redux: A True Hollywood Story* fake interviews with friends, clips from the archive and taken from his works are alternated, giving way to a sensationalistic and grotesque parody of American TV documentaries. Mixing truth and fiction, the work delineates the portrait of an unhappy, tormented artist who attempts to make it big in Hollywood with a documentary about Marlene Dietrich and Anni Albers, but all to no avail.

*All About Anni – Anni vs. Marlene
(The Saga Begins)*, 2006
poster, digital print on glossy paper,
variable dimensions

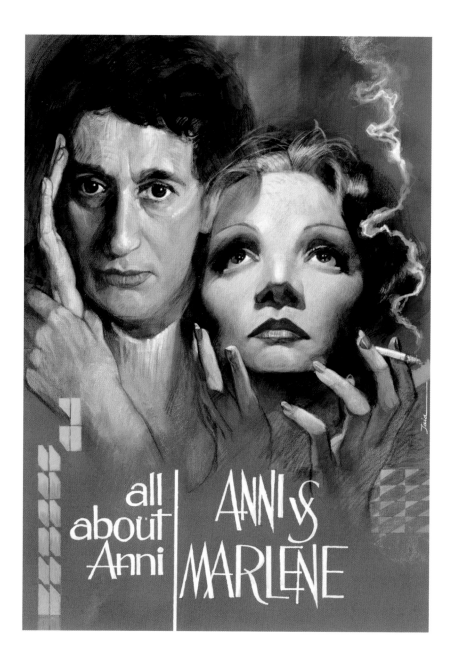

Emmanuelle, 2007
poster, digital print on glossy paper,
variable dimensions

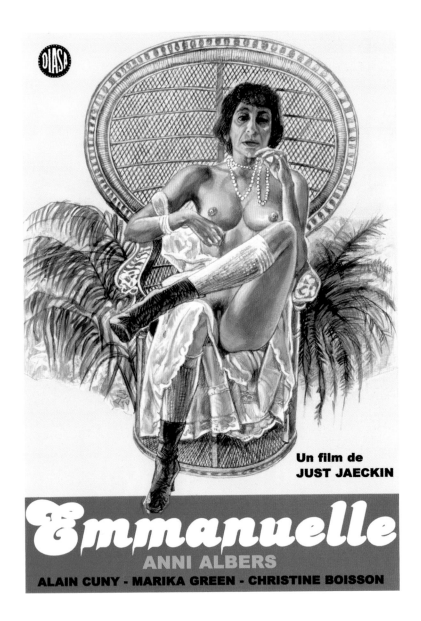

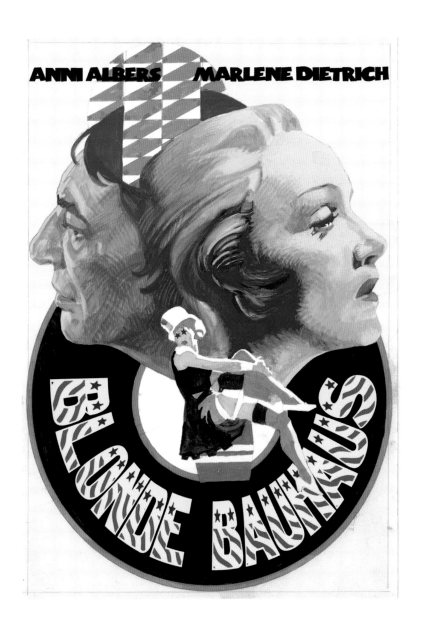

Blonde Bauhaus, 2007
poster, digital print on glossy paper,
variable dimensions

Marlene Redux:
A True Hollywood Story!, 2006
video projection, DVD, color,
stereo sound, 15'

MARGARET SCHECTER
MUSEUM CURATOR

RE-ENACTMENT

Marlene Redux:
A True Hollywood Story!, 2006
video projection, DVD, color,
stereo sound, 15'

Untitled (Marlene Redux: A True Hollywood Story! Part two), 2006-2007
Gobelin tapestry, cotton embroidery on wool canvas, metal needle, 300 × 300 cm

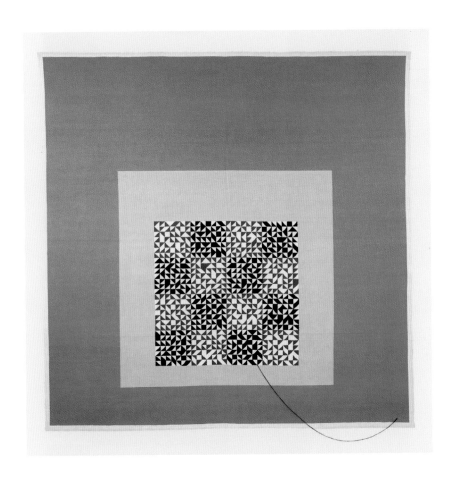

Untitled (Marlene Redux: A True Hollywood Story! Part four), 2006-2007
Gobelin tapestry, cotton embroidery on wool canvas, metal needle, 300 × 300 cm

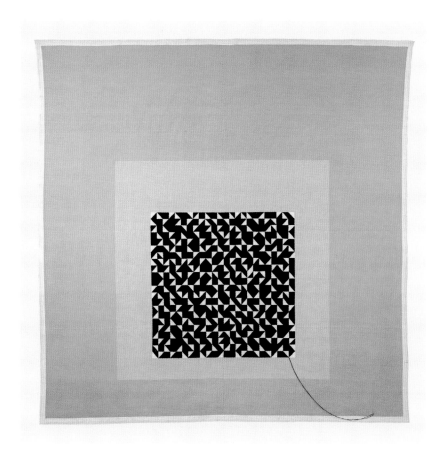

Exhibitions
Marlene Redux

2006

Tate Modern, London

Marlene Redux: A True Hollywood Story!,
2006, video projection, DVD, color, stereo
sound, 15', variable dimensions, Edition
of 1 and 1 artist's proof

Shangai Biennial, Shangai

Anni & Marlene in Hollywood – Coming
Soon, 2006, poster, digital print on glossy
paper, variable dimensions

Anni vs. Marlene (Double Feature), 2006,
poster, digital print on glossy paper,
2 elements, variable dimensions

Taipei Biennial, Taipei

Marlene Redux: A True Hollywood Story!,
2006, video projection, DVD, color,
stereo sound, 15', variable dimensions,
Edition of 1 and 1 artist's proof

2007

The Power Plant, Toronto

All About Anni – Anni vs. Marlene (The
Saga Begins), 2006, poster, digital print
on glossy paper, variable dimensions

Anni & Marlene in Hollywood—Coming
Soon, 2006, poster, digital print on glossy
paper, variable dimensions

Anni vs. Marlene (Double Feature), 2006,
poster, digital print on glossy paper,
2 elements, variable dimensions

Der Bauhaus Engel – Anni vs. Marlene
(The Prequel), 2006, poster, digital print
on glossy paper, variable dimensions

Marlene Redux: A True Hollywood Story!,
2006, video projection, DVD, color,
stereo sound, 15', variable dimensions,
Edition of 1 and 1 artist's proof

Self-Portrait as a Movie Poster, 2006,
poster, digital print on glossy paper,
3 elements, variable dimensions

Untitled (Marlene Redux: A True
Hollywood Story! Part two), 2006-2007,
Gobelin tapestry, cotton embroidery on
wool canvas, metal needle, 300 × 300 cm,
collection François Pinault Foundation

Untitled (Marlene Redux: A True
Hollywood Story! Part three), 2006-2007,
Gobelin tapestry, cotton embroidery on
wool canvas, metal needle, 300 × 300 cm,
collection François Pinault Foundation

Untitled (Marlene Redux: A True
Hollywood Story! Part four), 2006-2007,
Gobelin tapestry, cotton embroidery on
wool canvas, metal needle, 300 × 300 cm,
collection François Pinault Foundation

Emmanuelle, 2007, poster, digital print on
glossy paper, variable dimensions

Gigolo, 2007, poster, digital print on
glossy paper, variable dimensions

Querelle, 2007, poster, digital print on
glossy paper, variable dimensions

François Pinault Foundation, Tri
Postal, Lille

Marlene Redux: A True Hollywood Story!,
2006, video projection, DVD, color, stereo
sound, 15', variable dimensions, Edition
of 1 and 1 artist's proof

Untitled (Marlene Redux: A True
Hollywood Story! Part two), 2006-2007,
Gobelin tapestry, cotton embroidery on
wool canvas, metal needle, 300 × 300 cm,
collection François Pinault Foundation

Untitled (Marlene Redux: A True
Hollywood Story! Part three), 2006-2007,
Gobelin tapestry, cotton embroidery on
wool canvas, metal needle, 300 × 300 cm,
collection François Pinault Foundation

Untitled (Marlene Redux: A True
Hollywood Story! Part four), 2006-2007,
Gobelin tapestry, cotton embroidery on
wool canvas, metal needle, 300 × 300 cm,
collection François Pinault Foundation

P.S.1. Contemporary Art Center,
New York

All About Anni – Anni vs. Marlene (The
Saga Begins), 2006, poster, digital print
on glossy paper, variable dimensions

Marlene Redux: A True Hollywood Story!,
video projection, DVD, color, stereo
sound, 15', variable dimensions, Edition
of 1 and 1 artist's proof

2009

The Garage, Center for Contemporary
Art, Moscow

All About Anni – Anni vs. Marlene (The
Saga Begins), 2006, poster, digital print
on glossy paper, variable dimensions

Anni & Marlene in Hollywood—Coming
Soon, 2006, poster, digital print on glossy
paper, variable dimensions

Der Bauhaus Engel – Anni vs. Marlene
(The Prequel), 2006, poster, digital print
on glossy paper, variable dimensions

Moderna Museet, Stockholm

All About Anni – Anni vs. Marlene (The
Saga Begins), 2006, poster, digital print
on glossy paper, variable dimensions

Marlene Redux: A True Hollywood Story!,
2006, video projection, DVD, color,
stereo sound, 15', variable dimensions,
Edition of 1 and 1 artist's proof

Self-Portrait as a Movie Poster, 2006,
poster, digital print on glossy paper,
3 elements, variable, dimensions

Kunsthalle, Vienna

All About Anni – Anni vs. Marlene (The
Saga Begins), 2006, poster, digital print
on glossy paper, variable dimensions

Anni & Marlene in Hollywood—Coming
Soon, 2006, poster, digital print on glossy
paper, variable dimensions

Anni vs. Marlene (Double Feature), 2006,
poster, digital print on glossy paper,
2 elements, variable dimensions

Der Bauhaus Engel – Anni vs. Marlene
(The Prequel), 2006, poster, digital print
on glossy paper, variable dimensions

Marlene Redux: A True Hollywood Story!,
2006, video projection, DVD, color,
stereo sound, 15', variable dimensions,
Edition of 1 and 1 artist's proof

Self-Portrait as a Movie Poster, 2006,
poster, digital print on glossy paper,
3 elements, variable dimensions

2011

Fondazione François Pinault, Punta
della Dogana, Venice

Marlene Redux: A True Hollywood Story!,
2006, video projection, DVD, color,
stereo sound, 15', variable dimensions,
Edition of 1 and 1 artist's proof

Just a Gigolo, 2011, poster, digital print
on glossy paper, variable dimensions,
Edition of 3 and 1 artist's proof

XIV

DEMOCRAZY

XIV

DEMOCRAZY

The projects consists of several posters, embroidery and two video projections that present fake campaign messages played by Sharon Stone and Bernard-Henri Lévy. Reproducing fake strategies of political communication, the aim of the work is to mock the spectacularization of U.S. election campaigns. In the words of the artist, the purpose of the work is "to infiltrate the systems in power today, observe them as though I were an invisible spectator and then snatch their secrets".[1]

1 M. Beccaria, "Francesco Vezzoli ritratto dell'artista come giovane uomo" in M. Beccaria, ed., *Francesco Vezzoli. Democrazy*, exhibition catalogue (Venice, Venice Biennale), Electa, Milan 2007, p. 17.

Democrazy, 2007
double video installation, video
projection, color, stereo sound, 1',
installation view, MAXXI – National
Museum of XXI Century Arts, Rome

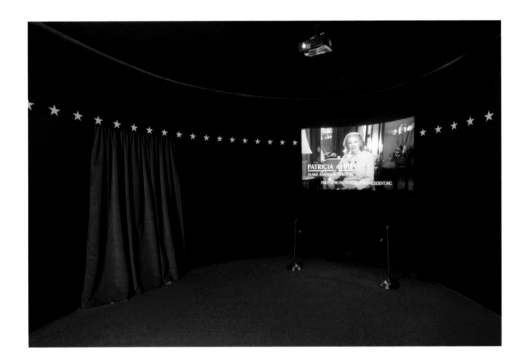

Democrazy, 2007
double video installation, video
projection, color, stereo sound, 1',
production still

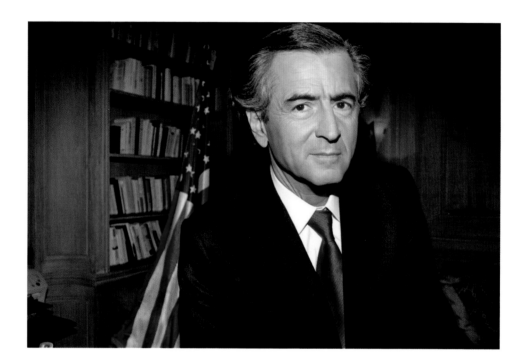

Democrazy, 2007
double video installation, video
projection, color, stereo sound, 1',
production still

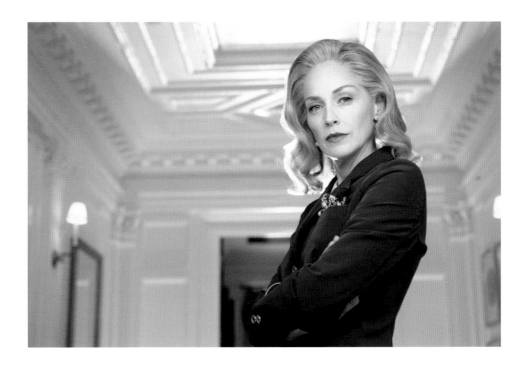

Hillary & Socks Clinton, 2007
digital print and watercolour on canvas,
metallic embroidery, 82 × 64 cm

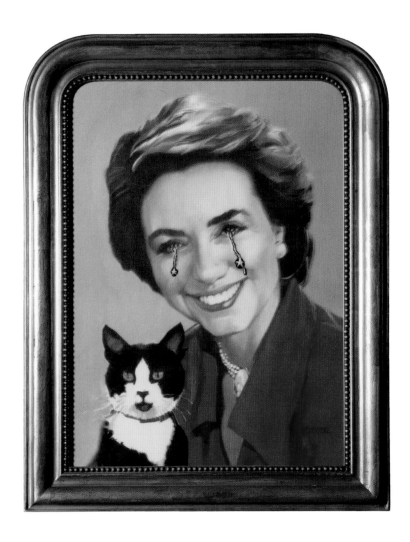

Rosalynn & Grits Carter, 2007
inkjet print and watercolor on canvas
with metallic embroidery, 72 × 63 cm

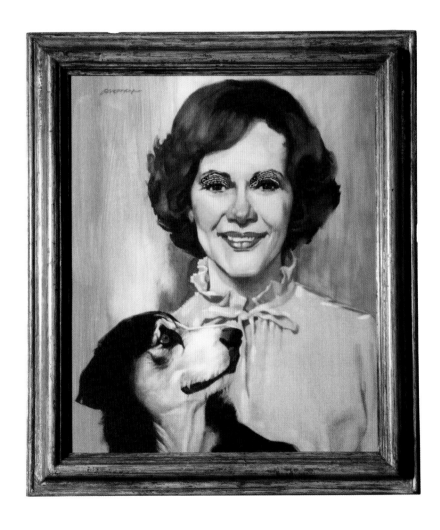

Exhibitions
Democrazy

2007

 La Biennale di Venezia, Venice

Democrazy, 2007, double video installation, video projection, color, stereo sound, 1', Edition of 3 and 2 artist's proofs

Untitled (Embroidering 50 Stars), 2007, inkjet print on Ida canvas embroidered with metallic thread, 60 × 80 cm, collection of MAXXI, National Museum of XXI Century Arts, Rome

2008

 Barbican Centre, London

Media Frenzy – Patricia Hill on Vanity Fair, 2007, print on canvas with metallic embroidery, 27.5 × 25 cm

 The Wolfsonian Institute, Miami

Democrazy, 2007, double video installation, video projection, color, stereo sound, 1', Edition of 3 and 2 artist's proofs

Barbara & Millie Bush, 2007, inkjet print and watercolor on canvas with metallic embroidery, 82 × 63 cm, (framed)

Laura & Miss Beazley Bush, 2007, print and watercolor on canvas, metallic embroidery, 75 × 62 cm, (framed)

 Museum Fur Gestaltung, Zurich

Democrazy, 2007, double video installation, video projection, color, stereo sound, 1', Edition of 3 and 2 artist's proofs

Poster for Democrazy (Bernard-Henri Lévy vs. Sharon Stone), 2007, digital print on paper, 2 elements, variable dimensions

Poster for Democrazy (Sharon Stone vs. Bernard-Henri Lévy), 2007, digital print on paper, 2 elements, variable dimensions

 Pinakothek der Moderne, Munich

Democrazy, 2007, double video installation, video projection, color, stereo sound, 1', Edition of 3 and 2 artist's proofs

Barbara & Millie Bush, 2007, inkjet print and watercolor on canvas with metallic embroidery, 82 × 63 cm, (framed)

Elizabeth & Liberty Ford, 2007, inkjet print and watercolor on canvas with metallic embroidery, 81.5 × 64.5 cm, (framed)

Hillary & Socks Clinton, 2007, digital print and watercolour on canvas, metallic embroidery, 82 × 64 cm, (framed)

Laura & Miss Beazley Bush, 2007, print and watercolor on canvas, metallic embroidery, 75 × 62 cm, (framed)

Nancy & Rex Reagan, 2007, inkjet print and watercolor on canvas with metallic embroidery, 77 × 63 cm, (framed)

Rosalynn & Grits Carter, 2007, inkjet print and watercolor on canvas with metallic embroidery, 72 × 63 cm, (framed)

Poster for Democrazy (Bernard-Henri Lévy vs. Sharon Stone), 2007, digital print on paper, 2 elements, variable dimensions

Poster for Democrazy (Sharon Stone vs. Bernard-Henri Lévy), 2007, digital print on paper, 2 elements, variable dimensions

2009

 Moderna Museet, Stockholm

Barbara & Millie Bush, 2007, inkjet print and watercolor on canvas with metallic embroidery, 82 × 63 cm, (framed)

Elizabeth & Liberty Ford, 2007, inkjet print and watercolor on canvas with metallic embroidery, 81.5 × 64.5 cm, (framed)

Nancy & Rex Reagan, 2007, inkjet print and watercolor on canvas with metallic embroidery, 77 × 63 cm, (framed)

2010 – 2011

 MAXXI, National Museum of XXI Century Arts, Rome

Democrazy, 2007, double video installation, video projection, color, stereo sound, 1', Edition of 3 and 2 artist's proofs

Untitled (Embroidering 50 Stars), 2007, inkjet print on Ida canvas embroidered with metallic thread, cm 60 × 80, collection of MAXXI, National Museum of XXI Century Arts, Rome

2011

 Fondazione Pinault, Venice

Democrazy, 2007, double video installation, video projection, color, stereo sound, 1', Edition of 3 and 2 artist's proofs

2012

 Fondazione Sandretto Re Rebaudengo, Turin

Democrazy, 2007, double video installation, video projection, color, stereo sound, 1', Edition of 3 and 2 artist's proofs

XV

RIGHT YOU ARE (IF YOU THINK YOU ARE)

XV

RIGHT YOU ARE
(IF YOU THINK YOU ARE)

The project focuses on the premiere of Luigi
Pirandello's play *Così è se vi pare*. It is a
Hollywood version of the performance which
involves famous international actors inside the
Guggenheim in New York. In this visionary
approach Vezzoli aims at subverting the pub-
lic's expectations by suggesting a provocative
reflection on the world of contemporary art,
considered by the artist to be "an entertain-
ment industry" aimed at self-promotion.

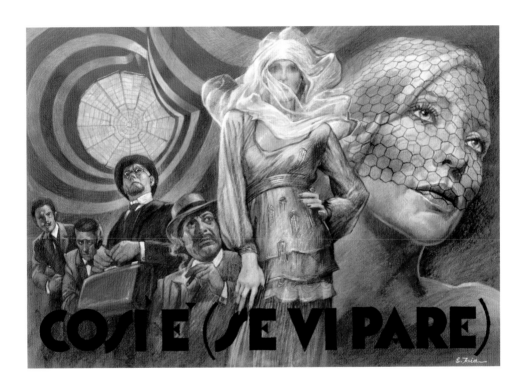

The Premiere of a Play That Will
Never Run, 2007
poster, digital print on glossy paper,
variable dimensions

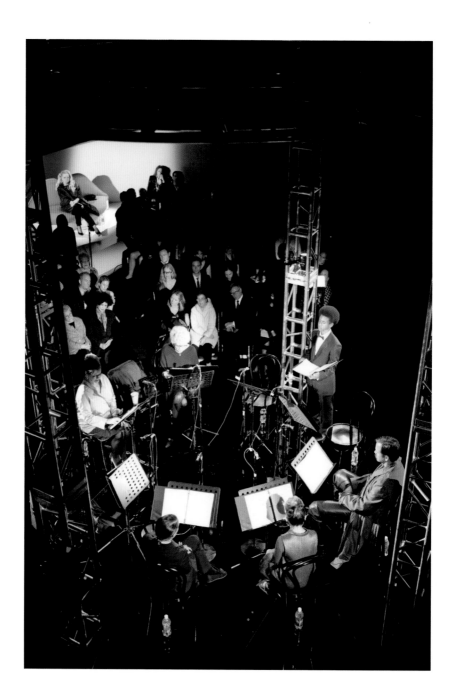

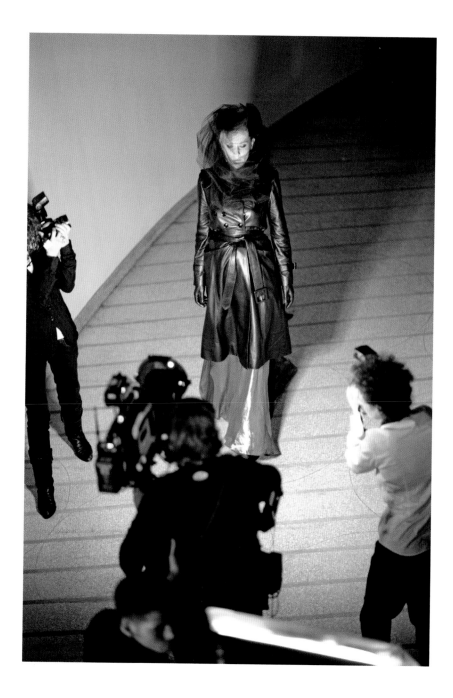

2007

Solomon R. Guggenheim Museum,
New York

Right You Are (If You Think You Are), 2007,
performance

XVI

DALÍ DALÍ FEATURING FRANCESCO VEZZOLI

XVI

DALÍ DALÍ FEATURING
FRANCESCO VEZZOLI

Vezzoli's interest in Surrealism is a recurring
element in his research, and it is especially
apparent in these works, which are charac-
terized by a direct reference to the works
of Dalí, Magritte, Ingres and de Chirico.
Combinations never before imagined arouse
awe and bewilderment, such as in the case of
the *Surrealiz* embroideries, or the Surrealist
portraits which combine the faces Hollywood
stars with images from various contexts. In
this triumph of hybridization there are no
rules, and the masterpieces from Antiquity
lend themselves to ironic rereadings, such as
in *Tua,* a portrait by Palma Vecchio replaced
by the platinized face of the American singer
Dolly Parton.

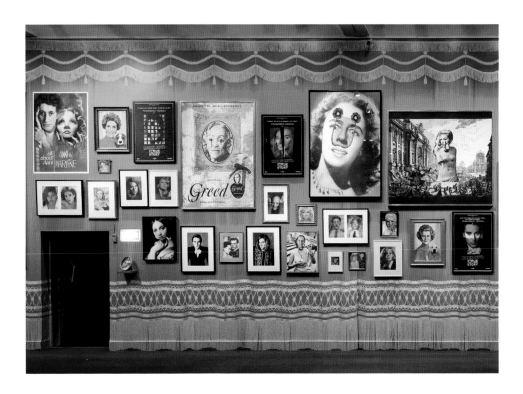

*Tua (Portrait of Dolly Parton
After Palma il Vecchio and Ambrosius
Bosschaert)*, 2010
laserprint on canvas, make-up, metallic
embroidery, 80 × 68,5 cm

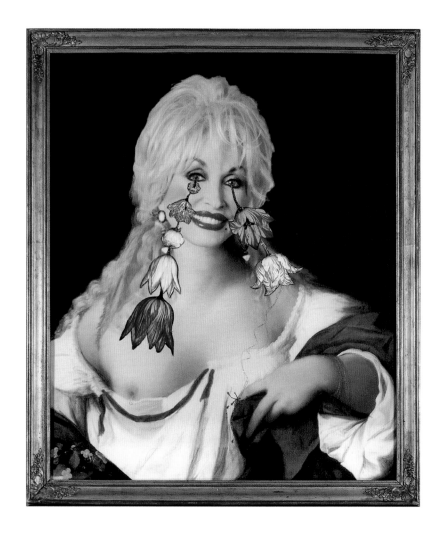

*Surrealiz (Lucio Fontana as
Marco Antonio)*, 2008
inkjet print on canvas with metallic
embroidery, paper, 152 × 113 cm

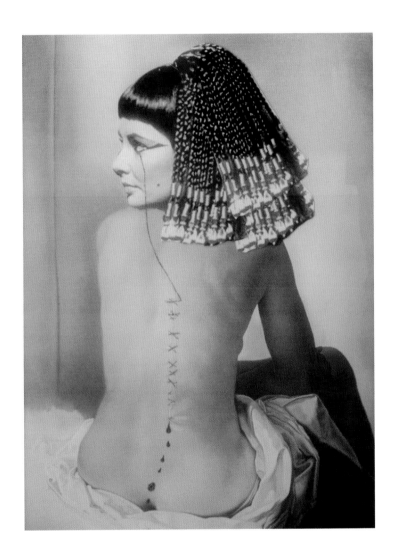

Exhibitions
Dalí Dalí featuring Francesco Vezzoli

2002 – 2003

 1st Public School of Hydra, Hydra

The Eyes of Camille, 2002, laser print on canvas, embroidered collage and metallic thread, 62 × 51 cm

The Eyes of Maria Walewska, 2002, laser print and watercolor on canvas, embroidered collage and metallic thread, 62 × 51 cm

The Eyes of Queen Christina, 2002, laser print and watercolor on canvas, embroidered collage and metallic thread, 62 × 51 cm

2008

 Asia Song Society, New York

Portrait of Mae West (Spellbound by the Eyes of Anita Ekberg), 2007, laser print on canvas with metallic embroidery, 44 × 34 cm

2009

 Moderna Museet, Stockholm

Salvador Dalí, 1998, cotton embroidery on canvas, 15.5 × 15.5 cm

The Eyes of Camille, 2002, laser print on canvas, embroidered collage and metallic thread, 62 × 51 cm

The Eyes of Queen Christina, 2002, laser print and watercolor on canvas, embroidered collage and metallic thread, 62 × 51 cm

Portrait of Mae West (Spellbound by the Eyes of Anita Ekberg), 2007, laser print on canvas with metallic embroidery, 44 × 34 cm

Surrealist Portrait of Mae West Crying her Own Autograph (with Anita Ekberg's Eye), 2007, laser print on canvas with metallic embroidery, 54 × 43.5 cm (framed)

Surrealist Portrait of Anita Ekberg, 2007, laser print and watercolor on canvas with metallic embroidery, 67 × 54 cm (framed)

Gala Picasso, 2008, Handwoven Gobelin tapestry, embroidery, 300 × 400 cm

Gala as Sylvia in La Dolce Vita, 2008, print on canvas, metallic embroidery, paper, 76 × 58 cm (framed)

Surrealist Portrait of Anita Ekberg (Before & After La Dolce Vita), 2008, print on canvas, metallic embroidery, paper, 120.6 × 96.5 cm (framed)

Surrealiz (Le Sommeil in Hollywood), 2008, print on canvas, metallic embroidery, paper, 113 × 173 × 8 cm (framed)

Surrealiz (Who's Afraid of Salvador Dalí?), 2008, print on canvas, metallic embroidery, paper, 185 × 132 × 8 cm (framed)

Time, Clock of Heart (after Ingres), 2008, inkjet print on canvas, paper, metallic embroidery, 76 × 58 cm (framed)

Untitled (La Dolce Vita Featuring René Magritte), 2008, laser print on canvas with metallic embroidery, paper, 160 × 190 cm (framed)

Amant Dalí: Diamonds for Breakfast, 2009, laser print on canvas with metallic embroidery, 32 × 32 cm (framed)

Amant Dalí, I Am a Photograph, 2009, laser print on canvas with metallic embroidery, 32 × 32 cm (framed)

Portrait of H. R. H. The Princess of Hanover (Before & After Salvador Dalí), 2009, print on canvas, glicée print on cotton paper, viscose embroidery, metallic embroidery, makeup, 2 elements, 234 × 176 cm ea. (framed), collection Moderna Museet, Stockholm, 2009 Donation by Moderna Museets Vänner

Sister Sister (Ouragan), 2009, laser print on canvas with metallic embroidery, 22 × 22 cm (framed)

2010 – 2011

 Centre National d'Art Contemporain, Grenoble

Tua (Portrait of Dolly Parton after Palma il Vecchio and Ambrosius Bosschaert), 2010, laser print on canvas with metallic embroidery, 80 × 68.5 cm

 Avignon, Musée d'Art Contemporain

Time, Clock of Heart (after Ingres), 2008, inkjet print on canvas, paper, metallic embroidery, 76 × 58 cm (framed)

2011

 Kunsthalle, Vienna

Surrealiz (Le Sommeil in Hollywood), 2008, print on canvas, metallic embroidery, paper, 113 × 173 × 8 cm (framed)

Surrealiz (Who's Afraid of Salvador Dalí?), 2008, print on canvas, metallic embroidery, paper, 185 × 132 × 8 cm (framed)

Surrealiz (Lucio Fontana as Marco Antonio), 2008, inkjet print on canvas with metallic embroidery, paper, 152x 113 cm

Le Surrealisme, C'est Moi (Portrait of Salvador Dalí with Jewels and Tears, after Horst), 2009, inkjet print on canvas, cotton, metallic embroidery, costume jewelry, 106 × 77 × 4 cm

XVII

BALLETS
RUSSES
ITALIAN STYLE

XVII

BALLETS RUSSES
ITALIAN STYLE

The project combines embroidery, photographs
and a musical performance by Lady Gaga at
the MOCA in Los Angeles. The starting point
for the work is *Le Bal* (1929), the famous
ballet russe, born out of the collaboration
between George Balanchine and Giorgio de
Chirico. Akin to a surrealistic dream, Vezzoli's
work mixes different registers: the body of
the classical ballet of the Bolshoi with Lady
Gaga, the new icon of teenagers, a symbol
of contemporary Pop culture. The aim of the
performance is to create a grandiose social
ritual, a show involving the public in a non-
stop game of estrangement and participation.

Le gant d'amour (after de Chirico & Jean Genet), 2010
inkjet print on canvas, metallic embroidery, costume jewelry, makeup, paper, 74.5 × 61.5 × 2.5 cm (framed)

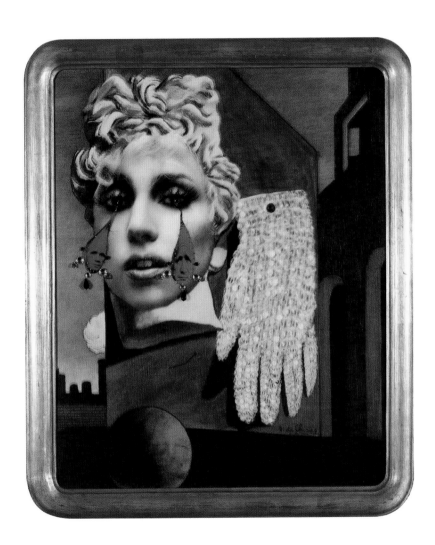

Propa-Ga-Ganda
(after Rodchenko), 2009
silkscreen on paper, 2 elements,
140 × 100 cm

121

Ballets Russes Italian Style (The Shortest Musical You Will Never See Again), 2009
performance, MOCA – Museum
of Contemporary Art, Los Angeles

2009

MOCA – Museum of Contemporary
Art, Los Angeles

*Francesco Vezzoli – Ballets Russes Italian
Style (The Shortest Musical You Will Never
See Again)*, 2009, performance

Propa-Ga-Ganda (after Rodchenko),
2009, silkscreen on paper, 2 elements,
variable dimensions, Edition of 3 and
1 artist's proof

2010

The Garage, Center for Contemporary
Culture, Moscow

*Head of Lady Gaga as minerva Crying
Apollinaire (after de Chirico)*, 2009,
print on canvas, metallic and cotton
embroidery, paper, 70 × 58 cm (framed)

*Poker Face (Self-Portrait with Mother
Gaga – after de Chirico)*, 2009,
inkjet print on canvas, metallic and
cotton embroidery, costume jewelry,
82 × 71.5 cm (framed) The Ella Fontanals-
Cisneros Collection, Miami

Propa-Ga-Ganda (after Rodchenko),
2009, silkscreen on paper, 2 elements,
variable dimensions, Edition of 3 and
1 artist's proof

*Le gant d'amour (after de Chirico &
Jean Genet)*, 2010, inkjet print on canvas,
metallic embroidery, costume jewelry,
makeup, paper, 74.5 × 61.5 × 2.5 cm
(framed)

*Love Game (Orestes and Pylades Were
Lovers)*, 2010, print on canvas, metallic
embroidery, costume jewelry, makeup,
79 × 64 × 64 cm (framed)

*Portrait of Lady Gaga as Crying Smiling
Daphne (after de Chirico)*, 2010, print
on canvas, metallic embroidery, costume
jewelry, makeup, 59 × 48 cm (framed),

*Portrait of Sergej Diaghilev as the Poetical
Dreamer (after De Chirico)*, 2010, print
on canvas, metallic embroidery, costume
jewelry, makeup, 52.5 × 42 cm (framed)

XVIII

GREED

XVIII

GREED

Inspired by Marcel Duchamp's *Belle Haleine: Eau de Violette,* (1921), *Greed* advertises an empty bottle of perfume, whose label portrays Vezzoli's face photographed by Francesco Scavullo. In the video *Greed, a New Fragrance by Francesco Vezzoli,* directed by Roman Polanski and starring Michelle Williams and Natalie Portman, the artist reproduces the launch of a commercial product that does not exist for the purpose of pondering the ephemeral nature of contemporary media culture.

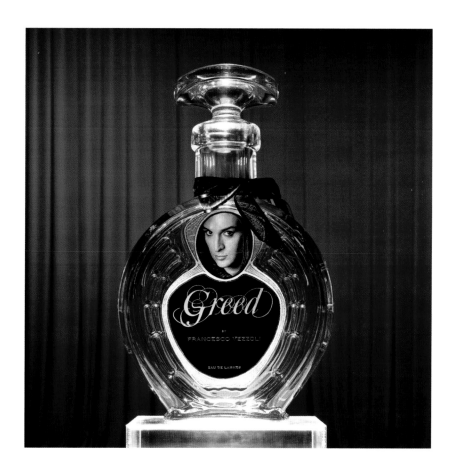

*Greed, a New Fragrance by
Francesco Vezzoli*, 2009
video projection HD, color,
stereo sound, 1', production still

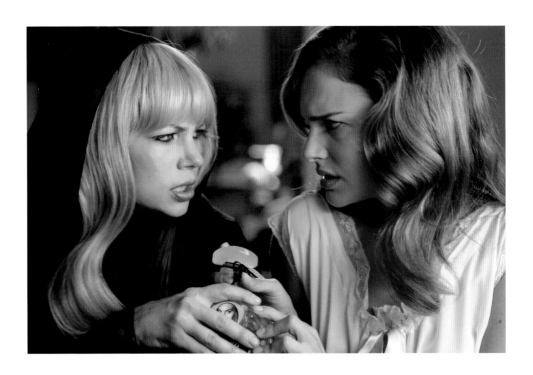

Greed, a New Fragrance by Francesco Vezzoli, 2009
video projection HD, color,
stereo sound, 1', production still

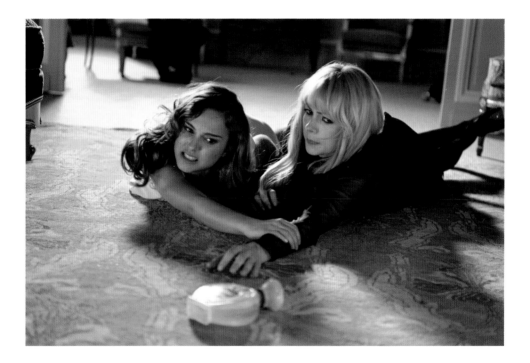

Exhibitions
Greed

2009

Gagosian Gallery, Rome

Enjoy the New Fragrance (Eva Hesse for Greed), 2009, ink on brocade, wood, cotton and metallic embroidery, costume jewelry, 180 × 130 × 5 cm

Enjoy the New Fragrance (Frida Kahlo for Greed), 2009, ink on brocade, wood, cotton and metallic embroidery, costume jewelry, 180 × 130 × 5 cm

Enjoy the New Fragrance (Georgia O'Keeffe for Greed), 2009, ink on brocade, wood, cotton and metallic embroidery, costume jewelry, 180 × 130 × 5 cm

Enjoy the New Fragrance (Leonor Fini for Greed), 2009, ink on brocade, wood, cotton and metallic embroidery, costume jewelry, 180 × 130 × 5 cm

Enjoy the New Fragrance (Lee Miller for Greed), 2009, ink on brocade, wood, cotton and metallic embroidery, costume jewelry, 180 × 130 × 5 cm

Enjoy the New Fragrance (Louise Nevelson for Greed), 2009, ink on brocade, wood, cotton and, metallic embroidery, costume jewelry, 180 × 130 × 5 cm

Enjoy the New Fragrance (Meret Oppenheim for Greed), 2009, ink on brocade, wood, cotton and metallic embroidery, costume jewelry, 180 × 130 × 5 cm

Enjoy the New Fragrance (Niki de Saint Phalle for Greed), 2009, ink on brocade, wood, cotton and metallic embroidery, costume jewelry, 180 × 130 × 5 cm

Enjoy the New Fragrance (Sonia Delaunay for Greed), 2009, ink on brocade, wood, cotton and, metallic embroidery, costume jewelry, 180 × 130 × 5 cm

Enjoy the New Fragrance (Tamara de Lempicka for Greed), 2009, ink on brocade, wood, cotton and metallic embroidery, costume jewelry, 180 × 130 × 5 cm

Enjoy the New Fragrance (Tina Modotti for Greed), 2009, ink on brocade, wood, cotton and metallic embroidery, costume jewelry, 180 × 130 × 5 cm

Greed, a New Fragrance by Francesco Vezzoli, 2009, video projection HD, color, stereo sound, 1', Edition of 3 and 1 artist's proof

Greed, The Perfume That Doesn't Exit, 2009, crystal, paper, ribbon, 40 × 27 × 13 cm, Edition of 1 and 2 artist's proofs

Museum Boijmans Van Beuningen, Rotterdam

Greed, The Perfume That Doesn't Exit, 2009, crystal, paper, ribbon, 40 × 27 × 13 cm, Edition of 1 and 2 artist's proofs

Moderna Museet, Stockholm

Enjoy the New Fragrance (Meret Oppenheim for Greed), 2009, ink on brocade, wood, cotton and metallic embroidery, costume jewelry, 180 × 130 × 5 cm

Greed, a New Fragrance by Francesco Vezzoli, 2009, video projection HD, color, stereo sound, 1', Edition of 3 and 1 artist's proof

2010

Kölnischer Kunstverein, Cologne

Greed, a New Fragrance by Francesco Vezzoli, 2009, video projection HD, color, stereo sound, 1', Edition of 3 and 1 artist's proof

La Conservera, Centro de Arte Contemporaneo, Ceuti

Greed, a New Fragrance by Francesco Vezzoli, 2009, video projection HD, color, stereo sound, 1', Edition of 3 and 1 artist's proof

Greed, The Perfume That Doesn't Exit, 2009, crystal, paper, ribbon, 40 × 27 × 13 cm, Edition of 1 and 2 artist's proofs

Enjoy the New Fragrance (Eva Hesse for Greed), 2009, ink on brocade, wood, cotton and metallic embroidery, costume jewelry, 180 × 130 × 5 cm

Enjoy the New Fragrance (Frida Kahlo for Greed), 2009, ink on brocade, wood, cotton and metallic embroidery, costume jewelry, 180 × 130 × 5 cm

Enjoy the New Fragrance (Georgia O'Keeffe for Greed), 2009, ink on brocade, wood, cotton and metallic embroidery, costume jewelry, 180 × 130 × 5 cm

Enjoy the New Fragrance (Leonor Fini for Greed), 2009, ink on brocade, wood, cotton and metallic embroidery, costume jewelry, 180 × 130 × 5 cm

Enjoy the New Fragrance (Lee Miller for Greed), 2009, ink on brocade, wood, cotton and metallic embroidery, costume jewelry, 180 × 130 × 5 cm

Enjoy the New Fragrance (Louise Nevelson for Greed), 2009, ink on brocade, wood, cotton and, metallic embroidery, costume jewelry, 180 × 130 × 5 cm

Enjoy the New Fragrance (Meret Oppenheim for Greed), 2009, ink on brocade, wood, cotton and metallic embroidery, costume jewelry, 180 × 130 × 5 cm

Enjoy the New Fragrance (Niki de Saint Phalle for Greed), 2009, ink on brocade, wood, cotton and metallic embroidery, costume jewelry, 180 × 130 × 5 cm

Enjoy the New Fragrance (Sonia Delaunay for Greed), 2009, ink on brocade, wood, cotton and, metallic embroidery, costume jewelry, 180 × 130 × 5 cm

Enjoy the New Fragrance (Tamara de Lempicka for Greed), 2009, ink on brocade, wood, cotton and metallic embroidery, costume jewelry, 180 × 130 × 5 cm

Enjoy the New Fragrance (Tina Modotti for Greed), 2009, ink on brocade, wood, cotton and metallic embroidery, costume jewelry, 180 × 130 × 5 cm

2011

Kunsthalle, Vienna

Greed, a New Fragrance by Francesco Vezzoli, 2009, video projection HD, color, stereo sound, 1', Edition of 3 and 1 artist's proof

2012

MAMbo, Museo d'Arte Moderna di Bologna, Bologna

Enjoy the New Fragrance (Lee Miller for Greed), 2009, ink on brocade, wood, cotton and metallic embroidery, costume jewelry, 180 × 130 × 5 cm

XIX

LA
NUOVA
DOLCE VITA

XIX

LA NUOVA
DOLCE VITA

The project focuses on the video *Jeu de Paume, je t'aime! (Advertisement for an exhibition that will never open)*, a movie preview that advertises an exhibition that does not exist at the Jeu de Paume in Paris. Based on a procedure that the artist is particularly fond of, truth and fiction overlap in ths work, and the famous Fellinian muse is replaced by Eva Mendes, a new icon of the contemporary age. The work is completed by a series of lightboxes that reread the masterpieces of Classical art with the faces of the Hollywood actress.

Jeu de Paume, je t'aime!
(Advertisement for an exhibition that
will never open), 2009
video HD, color, stereo sound, 20''

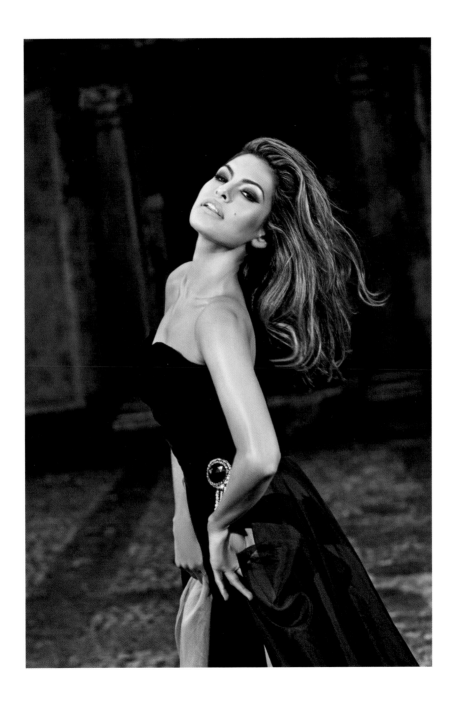

La nuova Dolce Vita (from the Birth of Venus Ludovisi to Eva Mendes), 2009
neon-lit lightbox, 2 elements,
145 × 235 cm ea.

La nuova Dolce Vita (from the Birth of Venus Ludovisi to Eva Mendes), 2009
neon-lit lightbox, 2 elements,
145 × 235 cm ea..

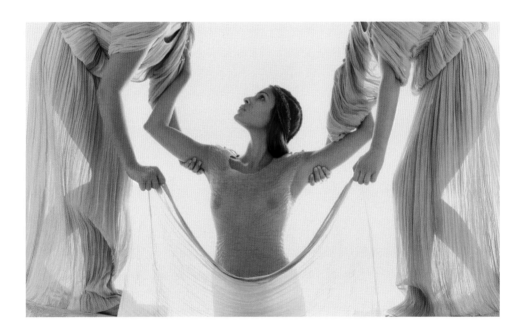

134

La nuova Dolce Vita (from the Triumph
Paolina Borghese to Eva Mendes), 2009
neon-lit lightbox, 2 elements,
150 × 190 cm ea.

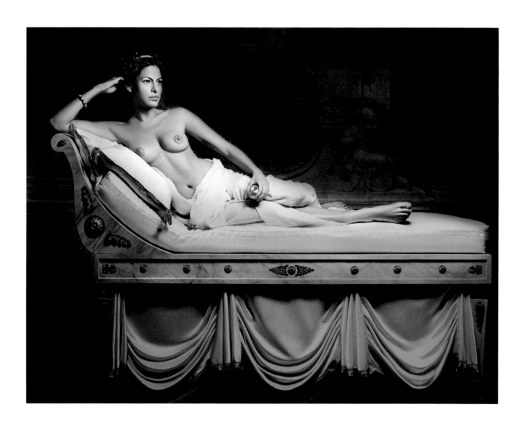

*La nuova Dolce Vita (from the Triumph
Paolina Borghese to Eva Mendes)*, 2009
neon-lit lightbox, 2 elements,
150 × 190 cm ea.

2009

Jeu de Paume, Paris

Jeu de Paume, Je t'aime! (Advertisement for an Exhibition That Will Never Open), 2009, video HD, color, stereo sound, 20'', Edition of 3 and 1 artist's proof

La Nuova Dolce Vita (Eva de Milo), 2009, Cut-out cardboard, 200 × 125 cm

La Nuova Dolce Vita (from the Birth of Venus Ludovisi to Eva Mendes), 2009, neon-lit lightbox, 2 elements, 145 × 235 cm ea., Edition of 3 and 1 artist's proof

La Nuova Dolce Vita (from the Ecstasy of Santa Teresa to Eva Mendes), 2009, neon-lit lightbox, 2 elements, 150 × 234 cm ea., Edition of 3 and 1 artist's proof

La Nuova Dolce Vita (from the Triumph of Paolina Borghese to Eva Mendes), 2009, neon-lit lightbox, 2 elements, 145 × 235 cm ea., Edition of 3 and 1 artist's proof

Wo-Man Ray, 2008, laser print on canvas, paper, metallic embroidery, 78 × 87 cm

2011

Fondazione Prada, Venice

La Nuova Dolce Vita (from the Birth of Venus Ludovisi to Eva Mendes), 2009, neon-lit lightbox, 2 elements, 145 × 235 cm ea., Edition of 3 and 1 artist's proof

La Nuova Dolce Vita (from the Ecstasy of Santa Teresa to Eva Mendes), 2009, neon-lit lightbox, 2 elements, 150 × 234 cm ea., Edition of 3 and 1 artist's proof

La Nuova Dolce Vita (from the Triumph of Paolina Borghese to Eva Mendes), 2009, neon-lit lightbox, 2 elements, 145 × 235 cm ea., Edition of 3 and 1 artist's proof

XX

SACRILEGIO

XX

SACRILEGIO

The projects transforms the Gagosian Gallery
in New York into a silent cathedral shrouded
in a half-light, a mystic space inhabited by the
embroideries of the series entitled *Sacrilegio*,
reproductions of famous Renaissance paint-
ings but with the faces of some of today's
models. High culture and Pop citations are
juxtaposed in the works, breathing life into
a shocking visual short circuits, an irreverent
revisitation of Classical iconography. Sensual
and flirtatious, Vezzoli's Virgins are enclosed
in golden frames that seem to melt, clearly a
nod to Dalí and Surrealism.

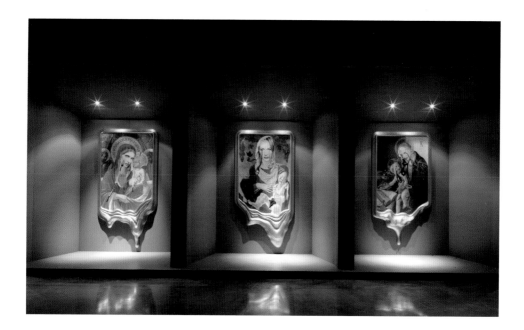

*Crying Portrait of Naomi Campbell as
a Renaissance Madonna With Holy Child
(After Cima Da Conegliano)*, 2010
print on canvas, metallic and cotton
embroidery, fabric, costume jewelry,
watercolor, makeup, artist's frame,
236 × 135 × 12 cm (framed)

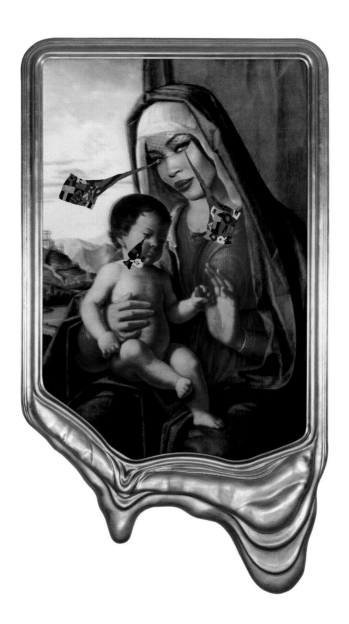

141

*Crying Portrait of Stephanie Seymour
as a Renaissance Madonna With
Holy Child (After Benozzo Gozzoli)*, 2010 print on canvas, metallic and cotton embroidery, fabric, costume jewelry, watercolor, makeup, artist's frame, 252 × 135 × 10 cm

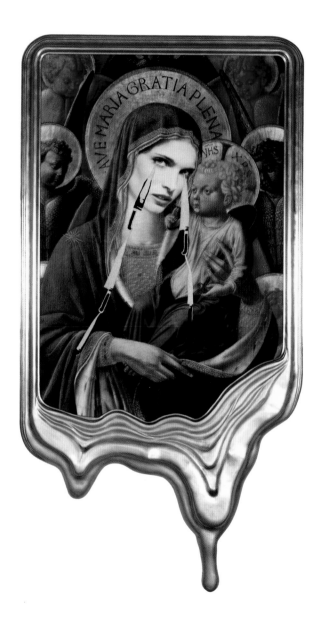

Exhibitions
Sacrilegio (Sacrilege)

2011

Gagosian Gallery, New York

*Crying Portrait of Amber Valletta as a
Renaissance Madonna With Holy Child
(after Cosme' Tura)*, 2010, print on
canvas, metallic and cotton embroidery,
fabric, costume jewelry, watercolor,
makeup, artist's frame, 252 × 135 × 8 cm

*Crying Portrait of Cindy Crawford as
a Renaissance Madonna With Holy Child
(after Andrea Mantegna)*, 2010, print on
canvas, metallic and cotton embroidery,
fabric, costume jewelry, watercolor,
makeup, artist's frame, 244 × 135 × 12 cm

*Crying Portrait of Claudia Schiffer as
a Renaissance Madonna With Holy Child
(after Bellini)*, 2010, print on canvas,
metallic and cotton embroidery, fabric,
costume jewelry, watercolor, makeup,
artist's frame, 240 × 134 × 16 cm

*Crying Portrait of Christie Brinkley as
a Renaissance Madonna With Holy Child
(after Giovanni Bellini)*, 2010, print on
canvas, metallic and cotton embroidery,
fabric, costume jewelry, watercolor,
makeup, artist's frame, 224 × 135 × 10 cm
(framed)

*Crying Portrait of Kim Alexis as a
Renaissance Madonna With Holy Child
(after Giovanni Bellini)*, 2010, print on
canvas, metallic and cotton embroidery,
fabric, costume jewelry, watercolor,
makeup, artist's frame, 232 × 135 × 14 cm

*Crying Portrait of Linda Evangelista as
a Renaissance Madonna With Holy Child
(after Botticelli)*, 2010, print on canvas,
metallic and cotton embroidery, fabric,
costume jewelry, watercolor, makeup,
artist's frame, 242 × 135 × 12 cm

*Crying Portrait of Naomi Campbell as
a Renaissance Madonna With Holy Child
(after Cima Da Conegliano)*, 2010, print on
canvas, metallic and cotton embroidery,
fabric, costume jewelry, watercolor,
makeup, artist's frame, 236 × 135 × 12 cm
(framed)

*Crying Portrait of Stephanie Seymour as
a Renaissance Madonna With Holy Child
(after Benozzo Gozzoli)*, 2010, print on
canvas, metallic and cotton embroidery,
fabric, costume jewelry, watercolor,
makeup, artist's frame, 252 × 135 × 10 cm

*Crying Portrait of Tatjana Patitz as a
Renaissance Madonna With Holy Child
(after Raffaello)*, 2010, print on canvas,
metallic and cotton embroidery, fabric,
costume jewelry, watercolor, makeup,
artist's frame, 236 × 135 × 15 cm,
collection The Museum of Contemporary
Art, Los Angeles

Jesus Christ Superstar, 2011, metal and
light box, 388 × 101 × 25 cm, Edition of
3 and 1 artist's proof

*Portrait of the Artist's Mother (after
Pinturicchio)*, 2011, HD Video, 2' 20'' ea.,
Edition of 3 and 1 artist's proof

*The Immaculate Conception (Barbie
as The Holy Virgin)*, 2010, white
marble and aquamarine, wrought iron,
185 × 60 × 58 cm

XXI

PIAZZA D'ITALIA

XXI

PIAZZA D'ITALIA

In this bronze sculpture, which revisits Giorgio
de Chirico's muses, Vezzoli replaces Ariadne's
face with that of the famous Italian actress.
The result of this is a shocking combination
that joins various cultural references in a
provocative rereading of the Classical. As the
ideal completion of the work, the artist installs
the sculpture at the center of Piazza d'Italia in
New Orleans (1979), the Postmodern architec-
tural masterpiece by Charles Moore.

Portrait of Sophia Loren as the Muse of
Antiquity (after Giorgio de Chirico), 2011
bronze sculpture, 190 × 60 × 60 cm,
installation view, Piazza d'Italia,
New Orleans

*Portrait of Sophia Loren as the Muse of
Antiquity (after Giorgio de Chirico)*, 2011
bronze sculpture, 190 × 60 × 60 cm,
installation view, Galleria Franco Noero,
Turin

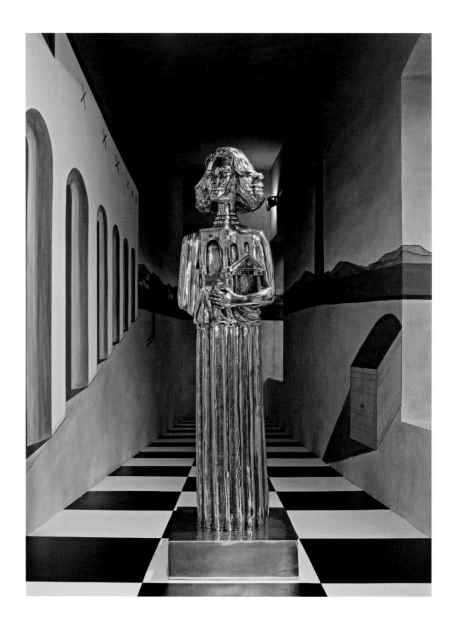

147

*Portrait of Sophia Loren as the Muse of
Antiquity (after Giorgio de Chirico)*, 2011
bronze sculpture, 190 × 60 × 60 cm, detail

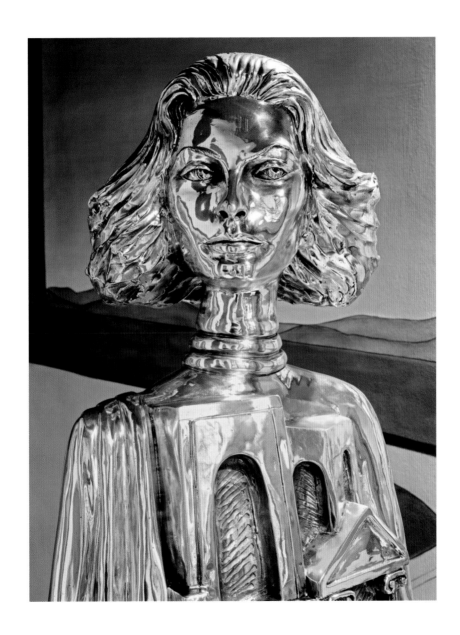

*Portrait of Sophia Loren starring
in "Presente e Passato"
(After de Chirico)*, 2012
collage on paper, Inkjet print
on canvas, metallic embroidery,
54 × 44 cm (framed)

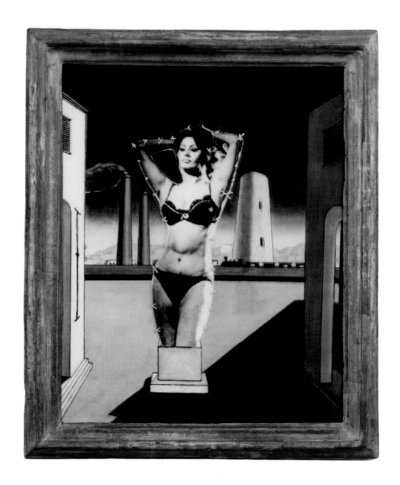

*Portrait of Sophia Loren starring
in "Piazza d'Italia – Souvenir d'Italie"
(After de Chirico)*, 2012
collage on paper, Inkjet print on
canvas, metallic and cotton embroidery,
60 × 72 cm (framed)

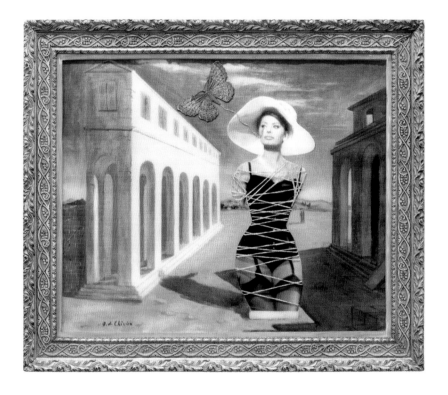

2011 – 2012

Piazza d'Italia, New Orleans

*Portrait of Sophia Loren as the Muse
of Antiquity (after Giorgio de Chirico),*
2011, bronze sculpture, 190 × 60 × 60 cm,
Edition of 3 and 1 artist's proof

2012 – 2013

Galleria Franco Noero, Turin

*Portrait of Sophia Loren as the Muse
of Antiquity (after Giorgio de Chirico),*
2011, bronze sculpture, 190 × 60 × 60 cm,
Edition of 3 and 1 artist's proof, Rennie
Collection, Vancouver

XXII

ANTIQUE
NOT
ANTIQUE

XXII

ANTIQUE
NOT ANTIQUE

Born from the yearning to reread the Classical,
the works stage an ironic dialogue between
ancient sculptures and the artist's recent self-
portraits. Representing emperors, satyrs and
other mythological figures, Vezzoli looks to
Antiquity with playful irreverence, triggering
off a universe of creative cross-pollinations
that ironically mix past with present.

Self-portrait as Antinous loving
Emperor Hadrian, 2012
marble head of the Emperor Hadrian,
self-portrait as Antinous in Carrara
marble, 2 elements, head of Emperor
Hadrian 40 × 19 × 20 cm, self-portrait
42 × 24 × 21 cm

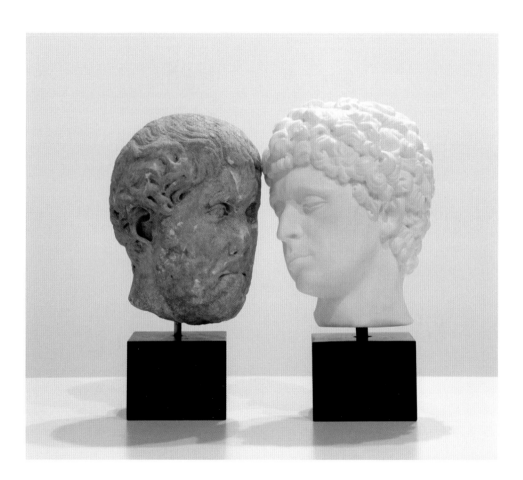

154

Self-portrait as Apollo del Belvedere's Lover, 2011
marble bust (19th c.), self-portrait in marble, 2 elements 76 × 51 × 50 cm and 85 × 52 × 50 cm

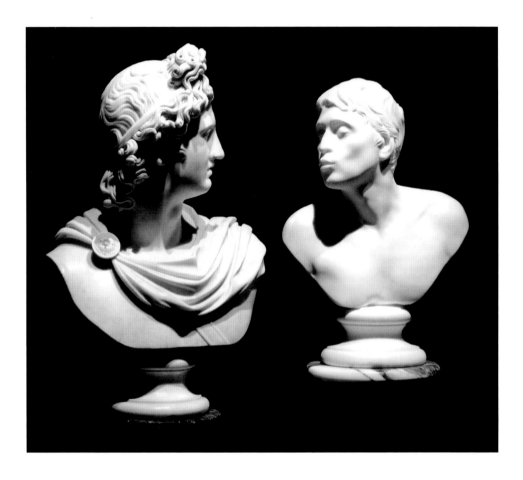

Self-portrait as Helios vs Selene
by Jean-Léon Gérôme, 2011
marble bust (19th c.), self-portrait in
marble, 145 × 145 × 210 cm

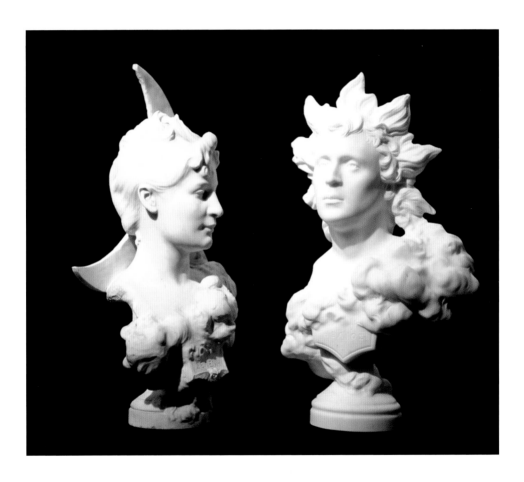

2011

Venezia Fondazione Prada, Venice

Self-Portrait as Apollo Del Belvedere's
Lover, 2011, marble bust (19th c.),
self-portrait in marble, 2 elements
76 × 51 × 50 cm and 85 × 52 × 50 cm

2012

Yvon Lambert, Paris

Self-Portrait as Helios vs. Selene by Jean-
Léon Gérôme, 2011, 19th-c. marble bust,
self-portrait in marble,145 × 145 × 210 cm

Villa Adriana, Tivoli

Self-Portrait as Emperor Hadrian Loving
Antinous, 2012, bust of Antinous in
Carrara marble (19th c.), self-portrait
as Emperor Hadrian in statuary
marble, 2 elements: bust of Antinous
46 × 39 × 20 cm; self-portrait as Emperor
Hadrian 45 × 45 × 19 cm

XXIII

24 HOURS MUSEUM

XXIII

24 HOURS MUSEUM

A new museum open to the public 24 hours a
day, a space that celebrates the female universe
by turning movie stars into sculptural icons, a
Pop revisitation of some of the most famous
masterpieces. Designed by Rem Koolhaas's
well-known AMO architectural firm, *24 Hours
Museum* is an ephemeral museum, destined to
consume its own rituality in a single day, and
then to vanish forever.

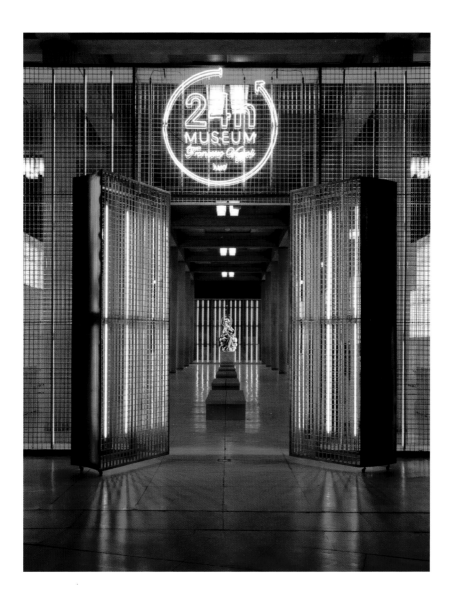

*Portrait of a Diva as the Triumph
of Virtue over Vice with the Eyes
of my Mother*, 2012, lightbox sculpture,
350 × 120 × 80 cm

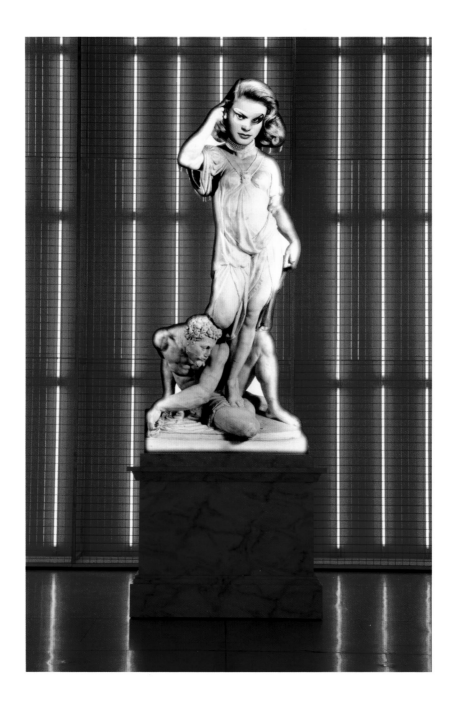

24Hours Museum, 2012
installation view, Palais d'Iéna, Paris

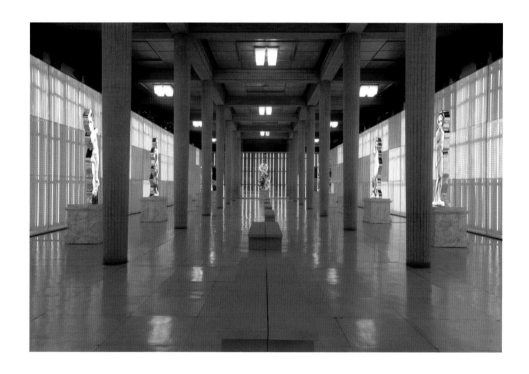

Palais d'Iéna, Paris

*Portrait of a Diva as Aphrodite Sosandra
with the Eyes of My Mother*, 2012, lightbox
sculpture, 350 × 120 × 80 cm

*Portrait of a Diva as a Roman Dancer
with the Eyes of My Mother*, 2012, lightbox
sculpture, 350 × 120 × 80 cm

*Portrait of a Diva as Dancing Venus with
the Eyes of My Mother*, 2012, lightbox
sculpture, 350 × 120 × 80 cm

*Portrait of a Diva as Florence
Triumphant over Pisa with the Eyes of
My Mother*, 2012, lightbox sculpture,
350 × 120 × 80 cm

*Portrait of a Diva as La Frileuse with
the Eyes of My Mother*, 2012, lightbox
sculpture, 350 × 120 × 80 cm

*Portrait of a Diva as the Allegory of the
Earth with the Eyes of My Mother*, 2012,
lightbox sculpture, 350 × 120 × 80 cm

*Portrait of a Diva as the Callipygian Venus
with the Eyes of My Mother*, 2012, lightbox
sculpture, 350 × 120 × 80 cm

*Portrait of a Diva as the Goddess of
Nature with the Eyes of My Mother*, 2012,
lightbox sculpture, 350 × 120 × 80 cm

*Portrait of a Diva as the Triumph of
Virtue over Vice with the Eyes of My
Mother*, 2012, lightbox sculpture,
350 × 120 × 80 cm

*Portrait of a Diva as Venus Drying
Herself after the Bath with the Eyes of
My Mother*, 2012, lightbox sculpture,
350 × 120 × 80 cm

*Portrait of a Diva as Venus Italica with
the Eyes of My Mother*, 2012, lightbox
sculpture, 350 × 120 × 80 cm

*Portrait of a Diva as the Venus from
Cnidos with the Eyes of My Mother*, 2012,
lightbox sculpture, 350 × 120 × 80 cm

*Portrait of a Diva as Venus Medici with
the Eyes of My Mother*, 2012, lightbox
sculpture, 350 × 120 × 80 cm

*Portrait of a Diva as Vibia Sabina with
the Eyes of My Mother*, 2012, lightbox
sculpture, 350 × 120 × 80 cm

*Portrait of My Mother as the Madonna
of the Milk*, 2012, lightbox sculpture,
350 × 120 × 80 cm

*Portrait of My Mother as a Winged
Goddess (I Like)*, 2012, lightbox
sculpture, 350 × 120 × 80 cm

Salon des Refusés, 2012, installation,
9 elements, variable dimensions

XXIV

OLGA FOREVER!

XXIV

OLGA FOREVER!

The project focuses on the enigmatic Russian ballet dancer Olga Khokhlova, first wife of Picasso, later spurned by her husband. Forced to abandon dancing before getting married, Olga embodies a complex personality, a mass of passions and obsessions that enthrall Vezzoli's creative imaginary. By combining photographs from the dancer's personal archive and prints and collages from various contexts, the artist celebrates the memory of this fragile figure, forgotten by history.

165

Olga Forever (Olga Picasso, ca. 1930), 2012
oil on canvas, laser print,
embroidered collage, 121 × 84 cm

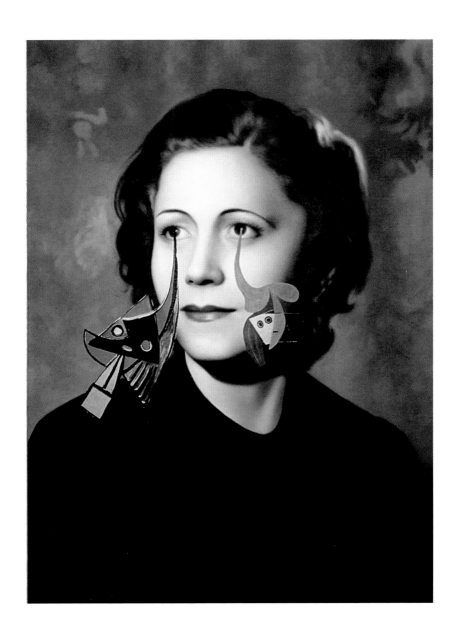

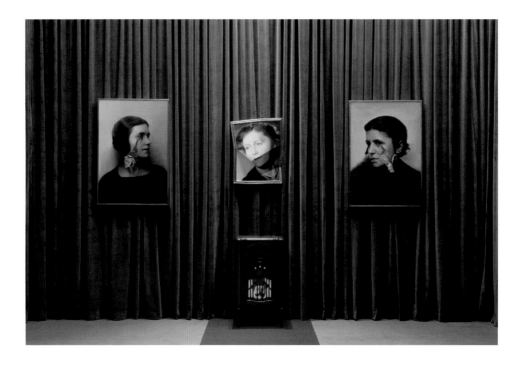

Olga Forever! The Olga Picasso Family Album, 2012
Installation view, Almine
Rech Gallery, Bruxelles

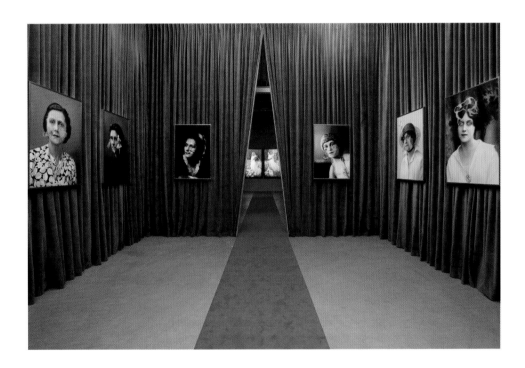

2012 – 2013

Almine Rech Gallery, Brussels

Olga Forever (Deconstructing Olga),
2012, oil on canvas, 77.5 × 63 × 14 cm
(framed)

*Olga Forever (Olga Khokhlova en nymphe
dans le ballet L'Après-midi d'un faune,
1916)*, 2012, oil on canvas, laser print,
collage on wood, 121 × 84 cm

*Olga Forever (Olga Khokhlova, ca.
1917)*, 2012, oil on canvas, laser print,
embroidered collage, 121 × 84 cm

*Olga Forever (Olga Picasso, London, ca.
1919)*, 2012, oil on canvas, laser print,
embroidered collage, 121 × 84 cm

*Olga Forever (Olga Picasso, Paris ca.
1923)*, 2012, oil on canvas, laser print,
embroidered collage, 121 × 84 cm

*Olga Forever (Olga Picasso, Bal des
Beaumont, 1924)*, 2012, oil on canvas,
laser print, embroidered collage,
121 × 84 × 3.5 cm

*Olga Forever (Olga Picasso, Villa Belle
Rose, Juan les Pins, 1925)*, 2012, oil
on canvas, cotton and silk embroidery,
embroidered collage, 48 × 30 cm

Olga Forever (Olga Picasso, ca. 1930),
2012, oil on canvas, laser print,
embroidered collage, 121 × 84 cm

Olga Forever (Olga Picasso, ca. 1930 I),
2012, oil on canvas, laser print,
embroidered collage, 121 × 84 cm

Olga Forever (Olga Picasso, ca. 1930 II),
2012, oil on canvas, laser print,
embroidered collage, 121 × 84 cm

Olga Forever (Olga Picasso, ca. 1930 III),
2012, oil on canvas, laser print,
embroidered collage, 121 × 84 cm

Olga Forever (Olga Picasso, 1940s I),
2012, oil on canvas, laser print,
embroidered collage, 121 × 84 cm

Olga Forever (Olga Picasso, ca. 1945 I),
2012, oil on canvas, laser print,
embroidered collage, 121 × 84 cm

Olga Forever (Olga Picasso, ca. 1945 II),
2012, oil on canvas and embroidered
collage, 121 × 84 cm

*Olga Forever (Olga Picasso en mariée,
Boisgeloup)*, 2012, oil on canvas,
laser print, collage, 2 elements,
206 × 143 × 7 cm ea.

Radio Diaghilev, 2012, 1920 walnut radio
case, laser print on canvas, selection
of music from Diaghilev's Ballets Russes,
42 × 100 × 54 cm

INTRODUCTION

Only a kaleidoscopic artist of international fame like Francesco Vezzoli could have imagined mounting an old-style gallery in the basic, futuristic and fluid spaces of the MAXXI. And so, on the occasion of this exhibition of his works, the museum designed by Zaha Hadid has been turned into a nineteenth-century museum, covered in precious velvet drapery that serves as a frame for the pictorial work dedicated to Vezzoli's artistic celebration.

The *Galleria Vezzoli* show is part of the more ambitious project entitled *The Trinity*, the first large international retrospective dedicated to Francesco Vezzoli's work, organized in collaboration with the MoMA PS1 in New York and the MOCA in Los Angeles. The project comprises three distinct and closely interrelated events that celebrate and delve deeply into the past fifteen years of research conducted by this remarkable artist. With regard to this opportunity for collaboration and synergy with other major contemporary art institutions, the MAXXI is at the cutting edge in its preparation of this exhaustive as well as in-depth project focusing on one of the most original internationally acclaimed personalities of the past decade.

The exhibition route wavers between the glamor of the video, the Hadrian-like syncretism of the styles, and the private dimension of the embroideries, the emblems of a domestic nostalgia for the past. The result is an ambient that combines irony with the rigor of the choices made,

thus transforming the museum rooms into a space for the artist's very personal style. The MAXXI has taken on the difficult but stimulating task of letting Vezzoli (an artist whose vision involves places and languages) completely overturn the design of the display rooms to the point of absorbing the inside of the museum within his own work, examining not just the issue of installations and expository expression, but of those particular places, spaces, volumes and especially those furnishings. This exhibition is not just the opportunity for delving further; it is the image and the exemplification of the artist's exploration, which has made references to elements of fashion, the present and the past, and Pop and high culture, its signature style.

To complete the work on the exhibition, the MAXXI along with Electa, has published a catalogue which seeks to be a complete product, combining research, documentation and information. The exhibition along with the catalogue thus present the public with a thorough examination of the Brescia-born artist's career, starting from his earliest embroideries—his short stitch teardrops on the faces of well-known personalities are by now famous and celebrated here—down to his most recent projects, telling us more about his work in a specific section dedicated to the self-portrait, the theme that merges the different phases of his output. The exhibition catalogue—by way of the essays connecting Vezzoli's activity to the theme of the Classical and the history of cinema, the entries concerning his projects, and the appendices—serves to complete the overall project, a true gallery in the sense of a display route, but also of a space for the representation of work that combines study—with serious focus on the details, the figures involved, the images—with the richness of melodrama. Vezzoli's is a gaze upon the present, which on this occasion is confirmed to be both biting and sincere,

the fruit of more than fifteen years of conscientious work combining different languages and genres, Pop icons, classic films, the history of art and customs, thus offering the public the main drivers of a personal obsession, combining glamor and culture. All of this takes shape at the MAXXI and becomes the collective experience of a whole environment signed Vezzoli.

Giovanna Melandri, President of Fondazione MAXXI

GALLERIA VEZZOLI

Anna Mattirolo

"Galleria Vezzoli," which is the title chosen for the exhibition, is a play on words, a semantic short circuit based on the union of realities that are distant from one another: the term "Galleria" recalls the eighteenth-nineteenth-century museum collections, while the artist's surname immediately propels us toward the contemporary scene. This strident adjacency is ideally corroborated in the exhibition that focuses on turning the MAXXI into a nineteenth-century gallery dedicated to Vezzoli's works. Multiple levels of interpretation are interwoven and juxtaposed, while the chronological arrangement of the works exhibited is combined with an in-depth analysis of the theme of the self-portrait and a reflection on the role of the contemporary museum. The aim is not just to offer a complete itinerary, but to reconstruct a more complex profile of the artist, to go more deeply into his creative universe in order to grasp the wealth of cultural references that can be viewed in his works.

It should come as no surprise that an exhibition design with a particular connotation has been chosen for the event, characterized by the use of red damask, boiserie, niches and sculptures in Classical style which redesign the spaces of the MAXXI, echoing the majestic redundancy of nineteenth-century galleries, the "museums as temples," which were being built in that period in many European cities.[1] By exploiting the pliable nature of Zaha Hadid's

fluid lines it was possible to create a completely different ambient, a "museum within a museum," which subverts the public's expectations, determining a provocative overturning of reality.

The exhibition soon reveals Vezzoli's interest in museum institutions, an attraction that encourages him to act upon the spaces, to modify them, to cross-pollinate them with his own work until they are no longer recognizable.

The artist's attention to the installation and the environmental connotation of his works can be traced back to his early works, and one of the first examples in this sense can be seen in his contribution to the group show entitled *Il racconto del filo. Cucito e ricamo nell'arte contemporanea*, held at the MART in 2003.[2] The aim of the project was to create a satirical, ironic effect, to mock the museum and the famous architect Mario Botta, by turning the MART's architecture into a prefabricated garden house in Tyrolean style. This "playful dislocation"[3] which is translated into the profanation of the exhibition space, represents a recurring element in Vezzoli's poetics, and one that characterizes all his subsequent works in different ways. Examples of this are the solo shows held at Le Consortium in Dijon in 2006, where Vezzoli modified the interior of the exhibition gallery to make it look like a gymnasium, as well as the further shows held at the Guggenheim in New York, the MOCA in Los Angeles, and the Moderna Museet in Stockholm. From the outset Vezzoli has revealed the need to establish a direct dialogue with the museums that host his works, seeking to involve the public which also becomes a character of the works, the object of mockery or an unwitting accomplice to his pranks. Everything is possible in this clever role-swapping, and no one can avoid getting involved somehow in the artist's brazen sarcasm. Hence, *Right You Are (If You*

Think You Are), the theatrical performance based on the play by Luigi Pirandello, realized for the Guggenheim in New York in 2007, reproduced the mindless "schizophrenia"[4] and stress that come with exhibitions. The target is the world of contemporary art, but also the international star system, with people forced to wait in a line for hours for the show to begin. In this case as well, the museum architecture, with its ample space at the center, holds a key role in determining this surprise effect among the public, that overturning of reality that is one of the main aspects of the artist's work.

The cross-pollination of the museum space reached a peak in the solo show at the Moderna Museet in Stockholm in 2009, a project that transformed the interior of the modernist building into a Baroque theater. As the artist himself emphasizes in a video interview, it meant modifying the perception of the environment completely, "subverting its appearance and the way in which it is viewed (...) converting it into something it isn't."[5]

In these peculiar alterations the public is constantly encouraged to react to the provocations aroused by the works, such as in the musical performance by Lady Gaga entitled *Ballets Russes Italian Style,* realized for the MOCA in Los Angeles in 2009. Vezzoli remarks: "It challenges people and makes people cringe. The reaction (...) was amazing. People didn't clap very much. They were a bit petrified."[6]

His reflection on the system of contemporary art becomes even more overt in *24 Hours Museum* (2012), a temporary museum set up at the Palais d'Iena in Paris, which hosted a retrospective in a space that was only open for 24 hours. On that occasion the artist transformed the interior of the building into a collage consisting of three distinct moments: the experimental museum, characterized by psychedelic lights, the traditional one with a monumental

staircase dominated by a sculpture, and the Salon de Refusés, a sort of personal archive of his works. It is precisely this impossible "total museum" that sums up Vezzoli's sarcastic approach to museum institutions; his objective is indeed that of unmasking the social ritual that hides behind the work of art by mounting a grandiose Baroque festival lasting just one day.[7] It is the triumph of the ephemeral and the superfluous that transforms the museum institution into a discothèque dominated by revisitations of Classical sculptures with the faces of Hollywood icons. Similar to a games machine, to a performance industry, the museum absorbs the contradictions of the contemporary age and for the artist it becomes a "stopover in global social life".[8] With lucid irony Vezzoli thus raises a crucial dilemma for artistic debate: the spectacularization of the museum space, increasingly poised between the "secular cathedral and the shopping center (...), a theater of group rites."[9]

In the age of globalization the identity of a museum becomes conflictual and fleeting: crushed by merchandizing, it risks neglecting scientific research and conservation as it keeps moving toward entertainment. The monumental and celebratory ambients of nineteenth-century galleries, the neutral spaces of early-twentieth-century museums, have now been replaced by hybrid venues, ones capable of using media and spectacular events to capture throngs of visitors.[10] Salvatore Settis writes that "the museum cannot be considered as a pre-existing entity: on the contrary, a museum is a challenge that calls for continuous reinvention and full awareness of the prize at stake."[11]

Within this ever-changing scenario Vezzoli's approach is clearly provocative: "museum as temple" or "disposable museum," little does it matter to the artist, who asserts that "I do not judge, I only ponder the phenomenon. Like tossing

175

the hand grenade and watching the reaction." [12] What counts is not so much providing solutions, but intervening so as to create havoc, mixing up the citations referring to various contexts to turn "the sacred place into a profane one, the profane place into a sacred one." [13]

In this sense it is possible to interpret the MAXXI exhibition as a sort of impertinent violation, a project that disguises the contemporary art museum designed by Zaha Hadid to recreate the evocative atmospheres of nineteenth-century galleries. Of particular importance in the actual presentation of the works is the scenic element, just as is the meticulous orchestration of the ambient, aimed at rereading the works showcased in a wholly new way. So we should not be surprised to view the idea of playing videos inside frames held up by sculptures, an unprecedented installation that unifies the works, revealing the artist's new interest in the Classical culture. For the same reason, that is, so as to echo the painting galleries of previous museums, particular importance has been afforded to the self-portrait, bringing together in Gallery 3 a rich selection of works on this theme.

The narcissistic dynamic of looking and being looked at and artistic self-celebration are the essential themes of Vezzoli's exploration, which can be traced back to his works from the late 1990s. At first the artist's presence is fleeting and controversial, he would rather shy away from the works, and at the same time he cannot help but become a part of them, because, as the artist himself says, "I think it is more meaningful if I become the subject of my own critique." [14] Whereas in the video *Ok The Praz is Right* (1997) he is mute, intent on embroidering, in the following works he claims more importance, until he becomes the main character in the scene. So it is in *Self-Portrait with Marisa Berenson as Edith Piaf* (1999), where he plays the part of

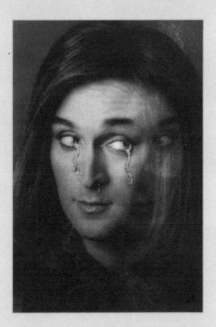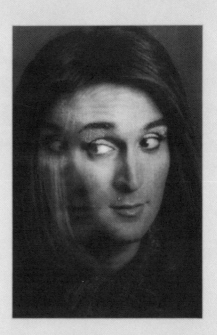

Francesco by Francesco: Self-portrait as the Kessler Twins, 2003, laser print on canvas with metallic embroidery, 2 elements, 62 × 83 cm (framed)

Francesco by Francesco: Self-portrait as Halston, 2002, laser print on canvas with metallic embroidery, 2 elements, 61 × 83 cm (framed)

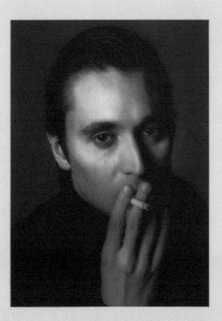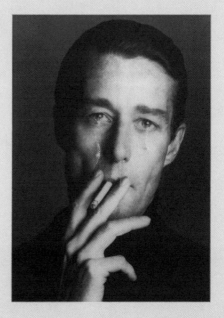

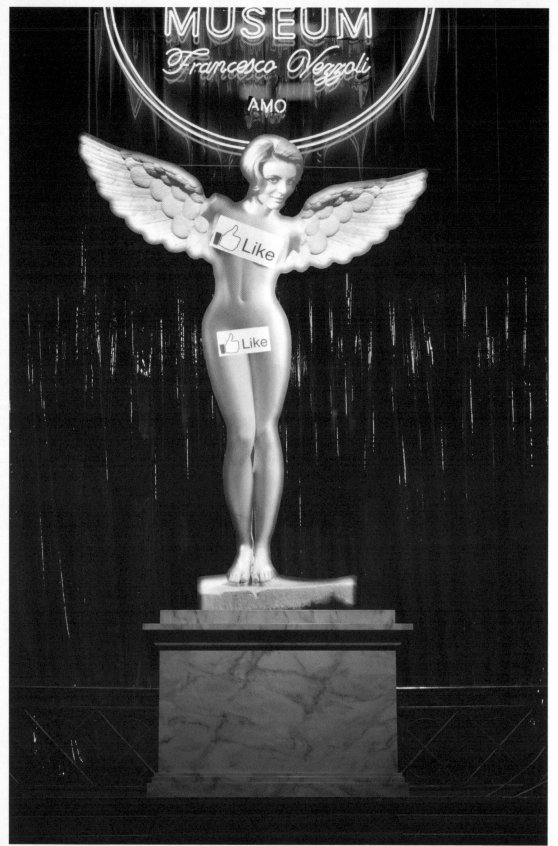

Portrait of my Mother as a Winged Goddess (I like), 2012, lightbox sculpture, 350 × 120 × 80 cm

Marisa Berenson's beloved bridegroom, and *The Kiss* (2000), where he stars alongside Helmut Berger as the son of the perfidious Alexis of Dynasty. This unceasing search for the fusion and identification with his videos seems to peak in *The End of the Human Voice* (2001), a double video projection inspired by the homonymous play by Jean Cocteau, a literary self-portrait in which Vezzoli impersonates Bianca Jagger's unfaithful lover. The natural consequence of this process of narcissistic appropriation is the creation of the photographs *Francesco by Francesco* (2002), a series of self-portraits realized in collaboration with the fashion photographer Francesco Scavullo. The images show the artist at different times: as his natural self, made-up to look like a gigolo, "a transvestite who's rather petit bourgeois, like a secretary from Illinois who's dressed up to the nines"[15]

The game of transformations and artifices triggered by the self-portrait goes far back in the history of photography and is interpreted with different languages by many contemporary artists. From the seductive masks of the Countess of Castiglione (1837–1913),[16] to Marcel Duchamp well-known dressed as a woman and portrayed by Man Ray,[17] to the pictures taken by Urs Lüthi, to Cindy Sherman's famous *Film Stills* (1977–1980), the declensions of this teme criss-cross the history of art, breathing life into true and proper theatrical performances. However, in respect to these experiments Vezzoli's research is distinguished by a greater melodrama, which is translated into an undeniable seduction for his own image. This taste for provocation is combined with his outright exhibitionism, a self-ironic narcissism that pushes him to don the clothing of models and famous Hollywood actors and actresses. From Veruschka, Halston, Jean Cocteau and down to the Kessler Sisters, the artist's identity is increasingly fleeting, it multiplies, becoming sublimed in an icon with

blurred contours. As Gianfranco Maraniello underscores in regard to these works: "The remake becomes a psychogenetic tool of his own fantasies; the analytics of his own vanity. Vezzoli becomes a voyeur of himself."[18] In some cases the artist's presence is more occult, it is disguised by different roles: he appears as Giorgio de Chirico next to Lady Gaga in the embroidery *Poker Face (Self-Portrait with Mother Gaga - after de Chirico)* (2009), and he has himself portrayed on the label of the perfume bottle in *Greed* (2009) for the launch of a nonexistent product.

This continuous transformation is eternalized in his latest works, the marble sculptures from 2011 and 2012 that represent the artist dressed as a satyr, a Roman togatus and an emperor. The works mark an important turn within his production: the world of cinema and TV which for many years occupied Vezzoli's creative imaginary give in to a revisitation of the masterpieces of Classical Antiquity. In citing the embroidery of the same name we find ourselves wondering *Che cosa è successo a Baby Francesco?* (2007). As the artist himself emphasizes "after having pursued the icons of time, I felt that road had run out. I looked behind me for a return to my roots. Now I prefer the Louvre to Hollywood."[19] This comparison with the Classical obviously passes through cross-pollination and the result is paradoxical and irreverent, such as in *Self-Portrait as Antinous Loving Emperor Hadrian* (2012), in which he contrasts his own marble self-portrait with a 2nd-century sculpture of Emperor Hadrian, and in *Satire of a Satyr* (2011), a bizarre combination with the face of a nineteenth-century satyr. In this triumph of hybridization everything is possible and the marble bust of a Roman togatus turns into a weeping self-portrait in the sculpture *Antique not Antique: Self-Portrait as a Crying Roman Togatus* (2012).

The aim is to create strident adjacencies that generate tension, "I force individuals or institutions to do something that goes against the grain."[20] In this continuous shift of perceptions distant realities dialogue with one another, such as in the case of the MAXXI exhibition that sums up different reflections: it encourages the public to interact in a new way with the works on display and raises an interesting discussion on the role of the museum institution today.

1 On nineteenth-century museums see K. Schubert, *Museo. Storia di un'idea* (Milan: Il Saggiatore, 2004), 20–34 and A. Mottola Molfino, *Il libro dei musei* (Turin: Umberto Allemandi, 1991), 28–40.

2 F. Pasini, G. Verzotti (ed.), *Il racconto del filo. Ricamo e cucito nell'arte contemporanea*, Trento, exh. cat. (Rovereto, MART–Museo d'Arte Moderna e Contemporanea, May 30–September 7) (Milan: Skira, 2003).

3 G. Celant, "Francesco Vezzoli," in *Francesco Vezzoli*, exh. cat. (Milan: Fondazione Prada, 2004), 259.

4 Vezzoli stresses the fact that the work was born after he read an article in artforum.com about an opening dinner held despite the fact the exhibition was not ready yet. The artist uses the term "Pirandellian" to describe the situation. N. Spector, "Francesco Vezzoli and Nancy Spector in conversation", in *Francesco Vezzoli Right You Are (If You Think You Are)*, exh. cat. (New York, Guggenheim) (Milan: Charta, 2009), 17–18.

5 F. Vezzoli, video interview realized on the occasion of the exhibition *Dalí Dalí Featuring Francesco Vezzoli* (Stockholm: Moderna Museet, 2009).

6 K. Biesenbach, "Conversation. Francesco Vezzoli and Klaus Biesenbach," in *Francesco Vezzoli. Ballets Russes Italian Style*, exh. cat. (Los Angeles, The Museum of Contemporary Art) (Los Angeles: n.p., 2009) 23.

7 *Ibid.*, 16.

8 In this regard it is worthwhile citing the volume by P. Wermer, *Museo S.p.a.*, a scathing essay that reveals the contorted mechanisms behind contemporary art with particular focus on the case of the Guggenheim.

9 V. Marini Clarelli, "I dilemmi del museo d'arte contemporanea," in S. Chiodi (ed.), *Le funzioni del museo, Proceedings* (Roma, Palazzo delle Esposizioni) (Florence: Le Lettere, 2009), 112–113.
10 On the role of contemporary museums see A. Bonito Oliva, *I fuochi dello sguardo. Musei che reclamano l'attenzione* (Rome: 2004); A. Polveroni, *This is contemporary! Come cambiano i musei d'arte contemporanea* (Milan: Franco Angeli, 2007); J. Clair, *La crisi dei musei* (Milan: Skira, 2008); M.V. Marini Clarelli, *Il museo nel mondo contemporaneo* (Rome: Carocci editore, 2011).
11 S. Settis, "Roma al futuro," in P. Baldi (ed.), *MAXXI Museo nazionale delle arti del XXI secolo*, (Milan: Electa, 2007), 30.
12 F. Vezzoli, *24 Hours Museum: Vezzoli vs Koolhaas*, domusweb.it.
13 G. Celant, *Francesco Vezzoli*, op. cit., 259.
14 L. Yablonsky, 'Caligula Gives a Toga Party (But No One's Really Invited)', *The New York Times*, New York, February 26, 2006 PA34.
15 G. Celant, *Francesco Vezzoli*, op. cit., 242.
16 In these photographs taken by Pierre-Louis Pierson (1822–1913) the Countess wears different costumes for a revival of historical and mythological figures. For more on this theme see S. Bright, *Auto focus. L'autoritratto nella fotografia contemporanea* (Rome: Contrasto, 2010), 14.
17 In the 1920s Man Ray photographed Marcel Duchamp dressed as his female alter ego Rrose Sélavy.
18 G. Maraniello, *Vezzoli versus Vezzoli*, in *Francesco Vezzoli: A True Hollywood story!* exh. cat. (Toronto, The Power Plant) (Toronto: The Power Plant, 2008), 46.
19 V. Trione, 'Il museo istantaneo di Vezzoli', *Corriere della Sera*, January 23, 2012, 25.
20 G. Celant, *Francesco Vezzoli*, op. cit., 281.

FRANCESCO VEZZOLI
AND NEO-NEO CLASSICISM

Donatien Grau

Francesco Vezzoli's love for classical aesthetics is common knowledge. Anyone who ever watched one of his videos, attended one of his performances, or even read an interview he gave to a big circulation newspaper knows he does not believe in the demands and dreams of the modern, that he learned Latin at high school, like anyone of a good family, that this legacy is ever present to his mind, and that it is precisely this legacy with its shadowy areas, its explosions of desire, its successes of beauty, which he means to perpetuate by appropriating it and demonstrating its profound and acute validity to the contemporary world.

He falls out with the "new tradition" described by Harold Rosenberg—the fact that the desire for novelty has become in itself a historical fact. He claims to site himself after the new, in a return to the classical. *"Tornate all'antico e sarà un progresso,"* said Giuseppe Verdi in a famous sentence. At first sight, the adage could well have equally been phrased the visual artist himself. In this sense, he seems to go back to the founding moment of modernity, namely the Quarrel of the Ancients and the Moderns, whose applications in the field of the visual arts were, in fact, far more troubled that is often claimed—Jean-Antoine Watteau, for example, considered himself a supporter of the "Ancients" against the "Moderns," which, given the subjects he depicted and the way he represented them, can hardly fail to raise a few eyebrows.

Classical Francesco Vezzoli. But also neo-classical Francesco Vezzoli. His penchant for French 19th century aestheticism is also well known, as well as his admiration for Jean-Léon Gérôme and a sensibility parallel to the first avant-garde. But here a hypothesis can be offered: we could, and maybe should see Francesco Vezzoli as neo-neo-classical. We then have to agree on the meaning of terms as problematic as "classical" and "neo-classical". The first meaning of "classical," as used at the beginning of this text is that which corresponds to the "classical heritage", namely the legacy of Greco-Roman antiquity. The second is that of "classicism", understood as the aesthetic movement in modern sculpture and painting, especially in the late sixteenth and all through the seventeenth centuries, bringing together artists as different as a certain Annibale Carracci — who was, in his time, probably the most fascinating of masters, hewing to both the line of the purest classicism and that of the most powerful materiality, as evidenced by his *Bean Eater* (1583 – 1584) — Nicolas Poussin, naturally, and then, in a less personal, more institutional, way, Charles Le Brun, and the school gathered around Louis XIV at Versailles. "Classical" thus brings together an artistic perspective and temporal considerations, to which are added the layered meanings of the noun "classical": the "classical" itself is an ideal of purity of line, of clarity and accomplishment.

Neo-classicism is essentially an aesthetic movement — it lacks the hermeneutic and historical depth of the "classical world" and in many respects, it takes issue against the generally accepted perspective of the "classical." Neo-classicism takes its liberties with the classic, with the classical world, and with classicism. Following Joseph-Marie Vien, Jacques-Louis David and Antonio Canova, and then

Jean-Auguste-Dominique Ingres, albeit ambiguously in this last instance, then through the academicism of Thomas Couture, Théodore Aubanel and Jean-Léon Gérôme, there is a return to the themes of classicism: they profoundly distort its terms. The past cannot be recalled; it is lost forever and can only be redeemed in the creative acceptance of loss. So it is with neo-classicism, which takes the categories of classicism to an extreme — the outlines of bodies, the choice of themes from the ancient subject matter, until they are distorted and probing them inwardly, so making them completely heterogeneous to what they were at the beginning of the process of metamorphosis. Neo-classicism therefore incorporates categories of the classical and of classicism, it subverts them and, somehow, perverts them, thereby giving them a completely different content, a contemporary content, an aesthetic of the nineteenth century and no longer of antiquity or the Counter-Reformation. In each case, in classicism as in neo-classicism, it is the same phenomenon of recovery and transformation that is deployed.

Hence there is a twofold component in the classical and neo-classical legacy: one is inert and the other dynamic. The inert part is the material itself, as it constitutes a legacy. The dynamic part belongs to the process of reinvention that they both dramatize. Hence speaking of Francesco Vezzoli's neo-neo-classicism means measuring the part of the legacy as such, and that of its transformation. For if classicism claimed to hark back to antiquity, it was itself a mutation, hence a fiction, and in consequence it also embodied a form of innovation. Neo-classicism, which justly bears in its name the mark of this ongoing change, is certainly a manifestation of a desire to return to the old, but this desire is itself conceived as a novelty. There is an essential tension, which is found in this faithful form even in what it changes, the

paradigm that constitutes neo-neo-classicism, both a return to the inert material, activated, and the duplication of a process of transformation.

Classical?

The most obvious is thus the presence of classical and neo-classical artistic forms in the artist's work. It is therefore inert matter. It is significant, to make a first approach, to bring out the fact that he treats classical and neo-classical on a footing of absolute equality, as a common source before which he takes his stand. In his recent series *Antique Not Antique* (2012), he incorporates both a Roman marble torso dating from the second or third century A. D. (*Self-Portrait as a Crying Roman Togatus*), the foot of a statue dated to the first or second century also of our era, and a lekythos from the fourth century BCE. In his subsequent works, he also adopts a bust of Antinous sculpted in the eighteenth century (*Self-Portrait as Emperor Hadrian Loving Antinous*, 2012), and a bust of Hadrian dating from the second century (*Self-Portrait as Antinous Loving Emperor Hadrian*, 2012), and the head of a satyr from the nine-teenth century (*Satire of a Satyr*, 2011). In all these cases, it is striking that the classical – the ancient – and the neo-classical – the eighteenth century – are on exactly the same plane in the construction of the image. They represent the ancient, this past world, of references and art, against which contemporary iconography takes up a position. Each time, however, the thematic material is ancient: a satyr, the Emperor Hadrian, Antinous, a Greek vase, a foot and a bust are elements of visual language of the classical world, of classical culture. It is through their insertion in a broader

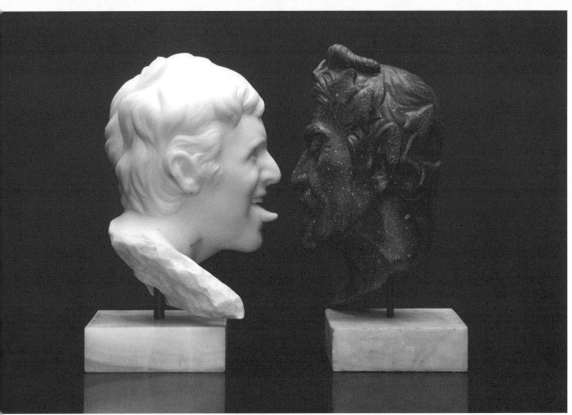

Satire of a Satyr, 2011, 19th century red porphyry satyr head, marble base; white marble self-portrait head, pink quartz base; porphyry head and base 46 × 24 × 22 cm, marble head and base 44 × 25 × 23 cm

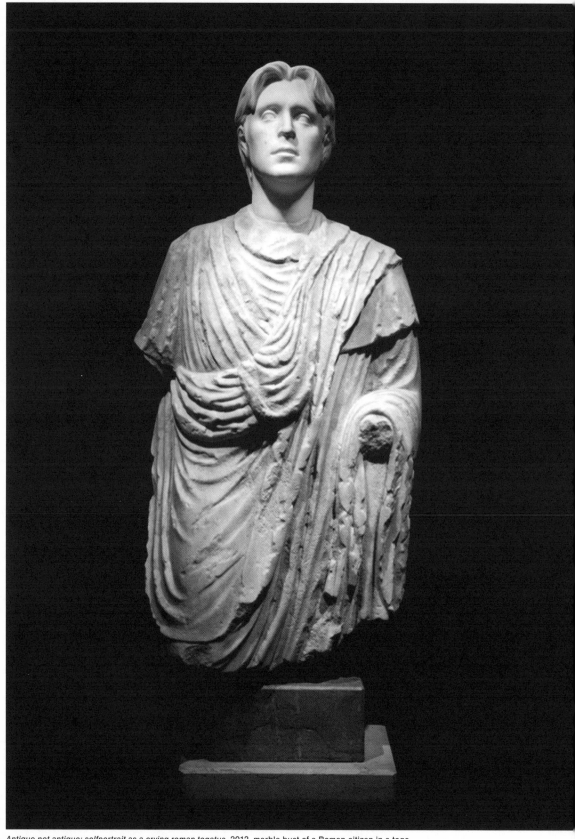

Antique not antique: selfportrait as a crying roman togatus, 2012, marble bust of a Roman citizen in a toga, white marble self-portrait, 100 × 45 × 40 cm

context of images identified by the subject, and through their value as sign, that Francesco Vezzoli produces in his own work an elaboration of the code which embodies the classical.

However, beyond this material creation of a common classical material, which, by the theme would blur the boundaries between the classical world, classicism and neo-classicism, there is, in the construction of the image, the presence of movement which lies at the heart of reinventions of the classical. It is never a case of the artist just taking a piece of antiquity and displaying it in a contemporary setting. His method is quite different: he takes the material to correlate it with a neo-neo-classical constituent. Neo-classicism had pushed classicism towards a certain form of Mannerism, which some have described as "kitsch." Already classicism had rejected its codes, making the hieraticism of the classical more marked, and also more brutal. Neo-neo-classicism develops the aesthetic codes of classicism and neo-classicism, while taking them *ad absurdum.*

In the spirit of neo-neo-classicism, there is an awareness of this absurdity and this extremism: the busts of Francesco Vezzoli included in duos embody a sort of hyperbolic version of the classical aesthetic. In white marble from Carrara, they play on the tactile beauty of this person who is also the artist, on the aesthetic types to which it is added, and on the perfect craftsmanship of the object itself. In this way, the self-portrait of the artist is always a more accomplished sculpture than its ancient counterpoint. It is actually so accomplished as to become surprising and problematic in its very accomplishment. It is there as a perfection too great to be truly taken seriously, just like neo-classicism, in its radical search for the attainment of forms and colors, at times takes on a tinge of the ridiculous. Sometimes, of course, the curved nose of the

artist is made more visible, more marked, and it has really nothing to do with Apollo, or at least not entirely with him. And when the sun god is actually the one represented, as in the double portrait with Delaroche's Selene, extremism is, in this case, fully respected, and one clearly understands the artist's desire to push an already extreme logic to its limits.

Neo-Neo-Classical Extremism

Neo-classical extremism — of the kind that inspired Winckelmann's formulation and motto *"edle Einfalt, stille Größe"* ("noble simplicity, calm grandeur") — is displayed by Francesco Vezzoli's sculptures. It is displayed as such, and pursued even in the awareness of its extremism. Artists like Aubanel and Gérôme, Couture, obviously knew quite well that there was a discrepancy between the forms they practiced and the period their world was entering. So they continued to cherish forms that were their own, leading them along the only path possible when faced with the rupture society imposed on them: hyperbole. At the same time that they took this path, they had pegged to their hearts the idea that they belonged to the end of an age. In this respect they did not fail to look at their attachment to the dead past with a certain distance, and sometimes even a certain humor, well aware of the despair inherent in their prospect. It is also Francesco Vezzoli's, whose features, present on his sculptures, are never devoid of some form of distance or parody. Of course there is the distance related to the extreme hieraticism, this vision so aestheticized that it loses all the qualities of accomplishment. This limit of perfection is particularly perceptible in his self-portrait as Apollo, in those as Hadrian and Antinous. By contrast, his self-portrait as a satyr, sticking out his tongue, and alternatively placing

it in the ear of another satyr, or in its mouth, cannot be conceived without taking into account the large element of play, even mockery, in the classical code. It has a playful, almost parodic, aspect. Moreover, the series "Antique or Not Antique" is the link between the ambiguity of the self-portraits, after all technically and explicitly perfect, and another facet, more openly and clearly rooted in the subversion of the code: putting the flowers in a lekythos from the fourth century BC means playing humorously on the prestige of an archaeological object which is at any rate only a vase, in which the ancients might also, had they lived today, put flowers to decorate a living room.

Likewise, covering the nails of an ancient statue with scarlet varnish is indeed a way to bring out what this usage, both sculpture and the lipstick, embodies of the codified and decorative. One might then think that this humor and this parodic distance of "Antique or Not Antique," would dissociate self-portraits, apparently more imbued with a spirit of seriousness. This is not so, because a sculpture in this series is added to the self-portraits, making it possible to establish a community of inspiration between the works: the most telling example is the *Self–Portrait as Crying Roman Togatus*, which joins a bust of Francesco Vezzoli himself to the body of a Roman citizen in a toga. The face is contemporary, the body ancient, and they evidently belong to two individuals completely unlike in age, status and identity. This unlikeness is all the more clearly perceptible because the self-portrait includes specifically Vezzolian signs: the tear, which is present in many of the portraits he has produced. Though it may happen that Homeric heroes sometimes weep, the usual image of a Roman citizen is not of a sensitive man, one who gives vent to his feelings. So there is an effect of hybridism and tension, another signature theme of the artist, presented

as a microcosm of the gap between the ancient body and the recent face. Then this gap helps the viewer to distance from the work itself, and therefore heighten the feelings of estrangement before the fiduciary input of the image.

And even though they appeared to wildly reject the contemporary, and shut themselves up in the illusion of an outdated and dreamlike imagery, they instantly seized secret fragments of them, incorporating them in their works. There was, therefore, in neo-classicism as in classicism, even a knowledge of the present, which was undeniable. In classicism, Poussin's *Et in Arcadia Ego* actually evokes the theological debates of the day. In neo-classicism, Couture and his *Romans of the Decadence* (1847) is a portrait of an era in decline. It may well be the city on the Tiber, when the Gauls were at the gates, but it could equally be contemporary France. Francesco Vezzoli's work is not extremely different from this; he is historically known for playing on the ailments of the hyper-contemporary: the fascination for the celebrities of popular culture. In this way he finds and plays on one of the markers of classicism and neo-classicism, which is a certain relevance to contemporary while also playing on its distance from it. We can find a trace of this in a transitional work, which marked the changeover between his early works and this ensemble which belongs to the artist's greater maturity: *La Nuova Dolce Vita* (2009) therefore stands at the crossing of the ways and displays a number of vital signs of Vezzoli's art.

First of all, the reference to the cinema was obviously also powerfully revealing and polysemic: there is, of course, Italian cinema, and therefore the Italianism of the artist himself, engaged, just like the film's heroes, in a dialogue with the foreign myth of Italy, hence in conversation with the outside world. There are, at the same time, some shadows in the "sweet

life," brought out magnificently by Federico Fellini. Finally, it conceals the cult of celebrity, of which Fellini composed an allegorical chronicle at the same time as he was elaborating its myth. All these elements of reference can be found in the work of the artist, who again plays both with the source itself, at its reinterpretation, as well as its title indicates — where is then the novelty in this Dolce Vita which bears within it the stigmata of the old and the brands of the most vibrantly contemporary? It arises from the spark that constitutes the confrontation between the older and the newer — meaning *older* than *La Dolce Vita* and *more recent*, too.

The work brings together a bust of the model of the *Apollo Belvedere*, a photo of the *Ludovisi Throne* depicting the birth of Venus, an image of Bernini's *Ecstasy of St. Theresa*, and another of the Venus of Canova. The Apollo sees attached to it a self–portrait of the artist, while the female figures are each associated with a reconstruction of the scene through photography, with Eva Mendes as Venus, Saint Theresa, and Venus again. We thus rediscover in this urge to combine the most contemporary — the celebrity Eva Mendes, the celebrity that is also, in his way, Francesco Vezzoli himself — and the classical sources of art.

Hence this confirms the placing on the same plane, by the artist, of an ancient genesis and contemporary life: after all, the artist seems to say, there must definitely have been — we have a trace of it, one of them is named Phryne — celebrated sources of ancient art when it was conceived. At the same time that it creates an effect of time lag, it nevertheless requires the unity of an ensemble, the unity of a work, which compels the coherence of the whole, of ancient and contemporary — meaning in denial of the modern — while at the same time structuring what may appear very remote.

This neo-neo-classicism thus plays the game of neo-classicism and of classicism before it: namely that of updating forms — photography — along with a surreptitious updating of the contents, under the guise of conservatism in the choice of the immediate themes.

The Ethics and Politics of
Neo-Neo-Classicism

There is also a trace of the Catholicism that profoundly impregnates the Italian identity in this archaeological plunge undertaken by the artist. The religion of Francesco Vezzoli harbors an extreme tension, which reveals the extent of the moral problem inherent in his work: this idea itself of the democracy of the sources, putting on the same level classical Antiquity and the Christian world, which appear equally materials for its creation, may seem both sacrilegious and eminently Catholic. The idea itself of equality before God lies at the center of worship, and the artist is basically its heir, belated and perhaps audacious. But there is definitely, in this parallel between the materials, a form of piety — a concept whose meaning has not been adequately explored in Francesco Vezzoli's work.

When, as in *The Kiss* (2000), he dramatizes a gay kiss, when he represents the perversions of Caligula, when he presents the viewer with something that diverges from the norm, in a way it fits into the continuity of the Christian concept of the "strength of the weak." One might say: "This Catholicism is not an aesthetic criterion, and it has, basically, nothing to do with this question of neo-neo-classicism." This position is essentially false: in fact, classicism and neo-classicism were humanisms, in their own way, true, but they

were less focused on the representation of human figures in the world—whence the scandal of *Et in Arcadia Ego*, which is also, in its way, a portrait. Francesco Vezzoli's work is humanistic: it is centered on mankind, on mankind today in what it shares with mankind in the past, and in this sense it is not irrelevant to speak of a "Vezzolian humanism." And this humanism shares certain primitive basics with Christianity.

His "Sacrilegio," to borrow the title of his exhibition at the Gagosian Gallery in New York in 2011, was not really sacrilege: these Renaissance portraits, transformed, updated, did nothing but similarly play the game of faith, a faith modernized, but also real. Likewise the video where his mother sang the song "Dominique" could be considered a sacrilege, in particular because of the fact of the stories that accompany the despoiling of its interpreter by the Church. This "Sacrilegio" is an artifice, because ultimately it is still a voice, singing homage to the saint—as if, in the end, there still remained something of the dream of faith. Indeed, if one experiences the work without even knowing the context, it appears to be a manifesto of faith; then this manifesto is subverted by background knowledge, and we can no longer believe it; finally, in a third moment, once again we open the ears of the spirit, listen to the song, and it enters the heart.

However, there is more than just Christian humanism in the artist's approach. There is also a fervent affirmation of paganism. The iconography he draws on in his works is essentially pagan: Helios, Apollo, Hadrian (who was deified after his death), a satyr and Venus are all derived from ancient polytheism. There again the religious fact remains, but this time it is remote due to its distance in time. Nevertheless, these polytheistic images retain a certain power, a real strength from the fact of being so easily recognizable: all in their own way they are icons. In addition, all

of them are flamboyant expressions of desire – the obvious relation of Hadrian and Antinous is the explicit example of this, but Venus is the goddess of desire, while Apollo was known for his particularly intense love life. Finally the satyr's distinctive feature is its sexual license. In all these cases we have eroticism, desire and paganism. The play of desire is part of Vezzoli's iconography in *Antique not Antique* as in other works, like the *24Hours Museum* (2012), where the creation of an imaginary museum of nude sculptures, male and female, challenges the traditional representations of desire.

The question of paganism and Christianity is central to classicism and neo-classicism. In fact the classical world is essentially pagan. Now classicism, as an aesthetic movement, occurs in societies which have become Christian. There is, therefore, on the part of artists, an interplay of extremely clear hybridizations, in which we see arising numerous works that use a classicist aesthetic on Christian subjects, even resorting to the same classicist vision of the world in dealing with pagan themes, which one can nevertheless discern have a sort of Christian substrate. Neo-classicism, on the other hand, makes a very clear return to the truly pagan, ancient and mythological themes, rejecting all possibility of adaptation of Christianity. Examples abound, from David to Canova, passing through the later academicism of Jean-Léon Gérôme or Couture: the foundation has to be carefully sought in the heart once again beating to ancient paganism. Each time, it was a process of overcoming that took place: classicism sought in its day to transcend both the religious aesthetics of the age and the pagan mythology; neo-classicism aspired to return to pagan aesthetics and subjects – and in a certain form, even to pagan ethics. Francesco Vezzoli seeks, for his part, through his neo-neo-classicism, to present a dialectical synthesis of these ethical and aesthetic questions.

The issues then become moral. This democratization of the issues—which has been attributed, in a certain respect, to Christianity—itself becomes an ethical postulate, in which pagan and Christian sources, aesthetics and ethics, pagan and Christian, no longer appear contradictory, and may, on the contrary, be part of an active and creative coexistence. However, it is as well to understand what is provocative, and at the same time quite natural, about this ethic of synthetic fusion of contraries in art: this is about exposing the consequences of the chronological succession of conceptions of the world, and revealing the meanings they contain for the present and in relation to the contemporary.

Through the expression of this moral of common excess of morals, a question is rendered visible, and it is of the utmost importance. What is the status of the person who announces and makes possible such a perception of reality? It is the artist. And there we rediscover a crucial tension of the discourse underlying Francesco Vezzoli's works. On the one hand he anchors his works in times which did not know the figure of the artist—Antiquity knew the *great artist*, and not the artist as we understand its figure today, we post-romantics, with Francesco Vezzoli himself as such a figure.

However, this exhibition of his portrait in each of his male sculptures, his omnipresence in his videos, his photographs everywhere visible in the ballroom of the *24Hours Museum*, seem to indicate, beyond the obvious interpretation of narcissism, and consequently immediately to be rejected a hidden significance. The artist is everywhere in his own works, and they clearly stage references, obsessions and fascinations which are his own. Through this permanent exhibition of his image, he endangers it, and by endangering it, he performs the operation of art. We post-romantics believe that the artist is a person, endowed with an authority,

which he seizes, but which we allow him to seize, who takes it upon himself to carry a certain burden, to summon up a certain existential courage and create. Paradoxically, perhaps, given the multitude of references that his works assemble, it is undeniable that Francesco Vezzoli is at the helm of the century and advances firmly, courageously, to his mysterious artistic destiny. Even his fiercest enemies acknowledge his strength in taking risks. His famous book, *Contro Vezzoli*, whose title, moreover, shows it was inspired by antiquity, is simply a hyperbolic form of commitment.

So we have come full circle. Because it was one of the masters of classicism, Poussin, who painted two of the most important self-portraits in the history of art, those that, after Parmigianino, after Titian, after Tintoretto, really opened up the possibility of a pictorial genre. It was in the age of neo-classicism that a myth arose that is still alive, that of the "artist's life," according to which these beings of courage were also creatures of vice, in whom grandeur was compounded with weaknesses. In his neo-neo-classicism, Francesco Vezzoli is the heir to both. From classicism he draws the awareness that a mastery of tradition is completely meaningful only in conjunction with an acute awareness of the value of the person, of the donor, who creates art. From neo-classicism he receives the imagination of the artist, also a guarantee of his supremacy. And he mingles them with the common source of the classic while infusing them with the vibrations of the contemporary extreme. In doing this, he evokes a reality that remains largely hidden: the art of Francesco Vezzoli is not so much a personal sensation as a precisely articulated construct. His art is a system.

THE PROVOCATIVE WITNESS. FRANCESCO VEZZOLI, PIER PAOLO PASOLINI AND THE RADICAL POSSIBILITIES OF CINEMA

Chrissie Iles

"The movies are weird; you actually have to think about them when you watch them".[1]

In October 1975, two weeks before he was murdered, Pier Paolo Pasolini asked the Roman photographer Dino Pedriali to photograph him through the windows of his bedroom as he posed naked. The resulting eighteen images show Pasolini reclining on a bed reading, standing with one hand on his forehead, sitting in a chair, defiantly displaying his body, once virile and now ageing, as the visible, corporeal evidence of his role, in Italian society's eyes, as "a subversive, a troublemaker, a pervert, a corrupter, a homosexual."[2] Pasolini's assertion of an alternative model of masculinity within the intellectual heart of post-war Italy, in which he occupied a major position as a writer, poet, filmmaker and cultural figure, not only transgressed the rules of the social order, but suggested that culture could operate as a subversive tool for transformative social engagement. It is this radical possibility, and its manifestation through the language of cinema, that links the work of Pasolini to the project of Francesco Vezzoli.

For both Pasolini and Vezzoli, cinema is a site of unresolved conflicts; a discursive space which Pasolini, as Giuliana Bruno observes, used to "refigure...the politics of the body, and...reclaim...the inscription of the homosexual gaze in the filmic landscape."[3] Pasolini's cinema, Bruno argues, "emphasizes affects, passions, feelings and ideas", as a kind of

collective dimension of subjectivity. He used this subjectivity in a political way, to ask questions about who was controlling the dialogue around those feelings and ideas, adopting an architectural metaphor, the 'palazzo', to symbolize the institution and its dominance of culture. For Pasolini, Bruno continues, this dominance was personified in the complete takeover of social space by consumer culture, made evident in cinema by a shift from heroes borrowed from bourgeois literature to those of a more kitsch, decadent kind, catering to a broader, more democratic taste. Pasolini countered this oppressive normalcy by asserting cinema as a site of enquiry, negotiation and contradiction, using quotation, references to literature, and staged tableaux from art history and the historical past to interrogate the crisis of the present.

Francesco Vezzoli emerged as an artist twenty years after Pasolini's death, during another crisis in bourgeois culture in Italy and the rest of Europe, when the trauma of Italian Fascism and the Second World War had been overtaken by the fall of the Berlin Wall and the subsequent dramatic social and political changes that were occurring within the now fully-formed Postmodernist condition that Pasolini's work had so assiduously predicted. Vezzoli's training at St. Martin's School of Art in London exposed him to a specific cultural moment at the end of Thatcher's political reign, in which a young generation of artists was taking on cinema as a conceptual tool, influenced by Warhol's appropriation of the language of classic Hollywood film. In the background, living two streets from St. Martin's, was the film director Derek Jarman, dying of AIDS. The same age as Pasolini and deeply influenced by his political philosophy of the male body, Jarman's questioning of what he termed "the compulsory heterosexuality of modernity"[4] had overturned the normative values of British cinema, and his baroque,

flamboyant films, including his best known, *Caravaggio* (1986), remained an important influence on the younger generation of filmmakers and artists in London during Vezzoli's time there. Vezzoli's absorption of this cultural environment gave him a unique perspective on the possibilities for a new Pasolini-like enquiry into the body and masculinity. As he came of age as an artist, his Italian background and the example of Pasolini's assertion of the homosexual gaze fused with this early experience, in a series of elaborately staged video tableaux that articulate the apparent impending demise of cinema by parodying its collapse into television. Vezzoli's tableaux confirmed Pasolini's fear that cinema, the shared imaginary of the social body made visible, was becoming subsumed into the corrupted, homogenized space of commercialized spectacle and leisure. If Pasolini's work in film had been a powerful statement of resistance to that normative space, Vezzoli's video works articulate the poignancy of that resistance by demonstrating its failure to stop the crushing power of a rampant consumer culture to homogenize, and thus castrate, the increasingly anachronistic cultural forms of both cinema and television. As with Pasolini, for Vezzoli, cinema became a screen onto which the social, political and cultural struggles of postmodernity were projected.

Whilst Pasolini's struggle against the hegemony of a consumerist normalcy played itself out in film through archetypal themes and figures—the mother, the prostitute, the worker, biblical stories, folklore, Greek mythology—depicted through visual quotations from Renaissance, Baroque and Mannerist painting, Vezzoli's approach to the cinema as a site of engaged relationships has been to re-inscribe that site with its lost European heroes—Pasolini, Luchino Visconti, Rainer Werner Fassbinder, Roman Polanski—and to place those lost heroes at the center of the consumerist framework by which

they were originally 'contaminated'. In both cases, Pasolini and Vezzoli use the indisputable authority of Italian art history and cinema to articulate a current moment of crisis by quoting the artistic expression of a previous one – in Pasolini's case the turbulent social and political climate of Italy during the period of the High Renaissance, Baroque and Mannerism in painting, and in Vezzoli's, the period in which Pasolini himself emerged. Pasolini and Vezzoli's strategies project the historical back into an increasingly a-historical landscape during two related moments of technological, economic, political and cultural crisis, as though testing whether it might still be possible to experience history as history.

In both Pasolini and Vezzoli's assertions of the historical through past moments of Italian cultural power, America's culpability in the homogenization and domination of popular culture and in the collapse of old models of history is asserted, but never allowed to occupy center stage. Its presence is always couched in relation to how its influence has impacted Italian culture. Although Pasolini played the role of a revolutionary priest in Carlo Lissani's 1967 spaghetti Western *Requiescant*, significantly, the genre of the Western, perhaps the most powerful cinematic symbol of America's ubiquitous cultural presence, does not engage either Pasolini or Vezzoli. Vezzoli's relationship to American popular culture resides primarily in television, into which cinema had been collapsing, internationally, since the early 1950s. During Vezzoli's childhood, the most likely way to see a Visconti film in Italy was on TV. The tension between high and low culture in Vezzoli's work revolves around this paradox. As a child, his predilection for the game shows and soap operas around which his two grandmothers' lives revolved was reproved by his intellectual, left-wing parents. Until the internet dismantled "TV time" in the 2000s, television, as Lyn

Greed, a New Fragrance by Francesco Vezzoli, 2009, video projection HD, color, stereo sound, 1', production still

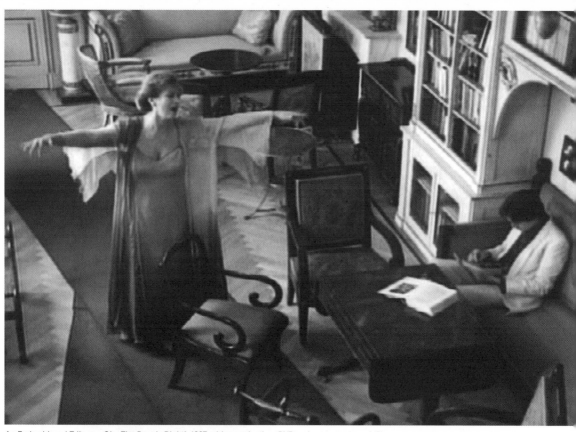

An Embroidered Trilogy – Ok – The Praz is Right!, 1997, video projection, DVD, color, stereo sound, 5',

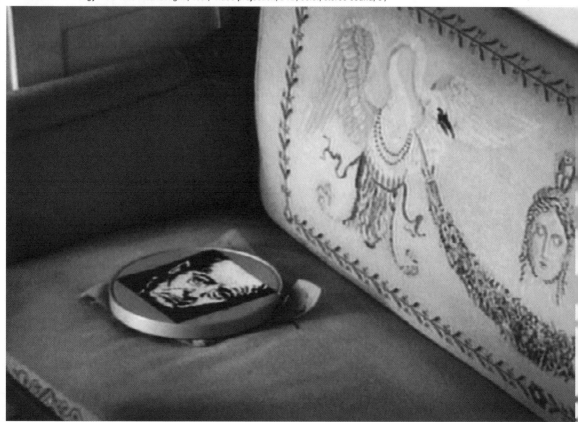

Spiegel points out,[5] revolved around a highly coded structure in which prime time evening television addressed the family, whilst day-time and late-night TV, the home of soap opera repeats, syndicated game shows and old or less accessible movies, was "fringe time", or queer time; the territory of grandmothers and people who stay up late at night. Spiegel observes that Warhol's involvement with television, including his own TV shows in the 1980s, was acted out through "a queer relation to the apparatus of TV."[6] Vezzoli similarly parodies the codes of mainstream television at the moment just before its disappearance into the larger popular cultural domain of the internet, in order to question its potential as a discursive space similar to that of cinema. Just as Pasolini predicted the collapse of bourgeois cultural forms into popular entertainment, Vezzoli anticipated the new narrative potential of TV that has recently emerged in American and British television series such as *Mad Men, Downton Abbey, The Wire* and *Homeland*, at the same moment that the old structure of television disappeared. Within this new narrative landscape, in which a grand Edwardian household, an advertising firm in the early 1960s and a working class black neighborhood in Baltimore in the 1990s are all paraphrased and glossed with a fake historical patina that covers every period with the same temporal and cultural sheen, Vezzoli's fake TV, theater and movie sets suddenly appear less ersatz, more 'real', and to possess an unlikely sense of authenticity that evokes Pasolini's attempt to create an antidote to the kitsch Hollywood depictions of biblical and mythical themes through the formal painterly language of art history.

Historical moments of authenticity appear throughout Vezzoli's video installations, always as a way of breaking the fourth wall and making the artifice of his tableaux evident through revealing his own participation in its making. *OK,*

The Praz is Right! (1997), a pastiche of Luchino Visconti's 1974 film *Conversation Piece*, was shot by the British film director John Maybury (a key figure in the firmament of Derek Jarman in the 1980s), in the house of literary scholar Mario Praz, the central character of Visconti's film, who, by coincidence, like Vezzoli, embroidered. Acting out the role of Praz, Vezzoli impassively embroiders Praz's image, seated on a couch that Praz embroidered himself. Vezzoli fortifies his camp parodic gesture by inviting Iva Zanicchi, the Italian pop singer and presenter of the Italian version of the TV programme *The Price is Right*, to play the role of the dowager. In yet another gesture of displacement, Zanicchi sings a 1971 popular song that featured in the soundtrack to Visconti's original film, re-inserting an authentic historical moment back into Vezzoli's pastiche of its container.

Vezzoli's relationship to the increasingly fluid form of television demonstrates the shifting relationship between television and cinema in *Trailer for the Re-make of Gore Vidal's Caligula* (2005), a fictional trailer for the re-make of one of the most scandalous films of the 1970s. Vezzoli places himself in the role of both film director (of the implied fictional re-make) and actor (appearing in the 'trailer' as Caligula himself), in a parody of the cult Italian-American co-production. Directed by Italian erotic filmmaker Tinto Brass, and originally written by Gore Vidal as a screenplay for Robert Rossellini's unrealized television series *Caligula*, the film, like Vezzoli's trailer, has impotence written into its origin. Produced during the climax of American economic excess in the mid-2000s, *Trailer for the Re-make of Gore Vidal's Caligula*, is perhaps Vezzoli's most acerbic critique of American cultural power. Gore Vidal, who introduces Vezzoli's trailer, was, from the 1940s until his death in 2012, America's answer to Pasolini. Asserting the

homosexual literary voice as early as 1948, Vidal became a bold voice of resistance, criticizing government foreign policy and challenging repressive sexual mores in his essays, novels and screenplays. His approach to Penthouse publisher Bob Guccione when other sources of funding failed indicated the potential for a dialogue between the liberal and libertarian voices in an otherwise sexually conservative America that offered the possibility of a challenge to the social order similar to what Pasolini was attempting in Italy, if at a considerably less complex, and radical, intellectual level. Made four years after Pasolini's *Salò, or the 120 Days of Sodom* (Pasolini's last film, completed in 1975 just before his death), *Caligula* was, by comparison, a pale imitation of Pasolini's hard-hitting, uncompromising attack on political corruption. Unanimously judged a flop, it demonstrated the failure of the American libertarian voice to deliver a credible cultural statement that was able to bridge the gap between the intellectual arena of cinema and the libertarian platform of the pornographic magazine. Yet its cult success, remaining the highest grossing Italian film in America, inserts it back into the popular culture which it failed to impact intellectually, by speaking its own language of kitsch spectacle.

Vezzoli's demonstration of 'Caligula's intellectual failure through a pastiche of its erotic spectacle is not a simplistic attack on the shortcomings of American liberalism. The subject of both the original *Caligula* and his fictional trailer for its re-make is the notorious Roman Emperor Gaius Julius Caesar Augustus Germanicus, known as Caligula, whose four year reign from 37–41AD was defined by his cruelty and propensity for sexual excess and scandal. Vezzoli's quotation of the 1979 attempt to critique political corruption in both America and Italy through a historical dramatization, or ghosting, of Caligula's life appeared at the height of Silvio

Berlusconi's political power in Italy. The endless sexual peca-
dilloes and nepotistic manipulation of the national network
of television channels that he owned had created a decadent,
corrupt political climate which Vezzoli's trailer echoes. The
trailer obliquely critiques the modern day leader by criti-
quing the film that critiques the corrupt ancient leader, in a
complex layering of identity in which one context or character
is exchanged with another. Like Hitchcock, Vezzoli appears
in his own work as part of a parodic device with which to
connect with the audience and create a thread between dif-
ferent moments within a cultural history. This device occurs
repeatedly in film, and is a well-known trope of cinema. It
appears throughout Vezzoli's work, as a conceptual tool with
which to elide a single identity, or meaning.

This layering of identity also occurs in both Pasolini and
Vezzoli's depiction of women, through whom they express
their own personal desire for love and acceptance. For both
men, their mothers provide a genuine, powerful source of
love, support and goodness, and both choose to express their
autobiographical voice through female characters. In the case
of Pasolini, his sense of cultural oppression was projected
onto the libidinous body and persona of Marilyn Monroe, to
whom he wrote a poetic eulogy after her death in 1963, and
whose destruction at the hands of the Hollywood machine
resonated, for Pasolini, as a tragic example of the alienating
cultural domination of which he, himself, also felt a victim.
His tribute to Monroe in the social documentary *La Rabbia*
(1963), a comment on the problems of modernity made
with the right wing intellectual Giovannino Guareschi,
depicted her in her early years, fresh-faced and innocent,
before her fame catapulted her into being, as Colleen Ryan-
Scheutz observes, "a rebellious shooting star in a celluloid
firmament"..."Monroe is, according to Pasolini, an unwitting

martyr in the etymological sense of 'witness'. In the imaginary tribunal of the 'new pre-history' that Pasolini was theorizing in these years, Monroe's martyrdom bears witness to the wreckage of the culture industry."[7]

In 1969 Pasolini chose another tragic female icon, Maria Callas, to play the role of Medea in his film of the same name. Callas, a controversial figure and the subject of scandal, had given her final performance five years earlier, at Covent Garden in London, and was past her prime as an opera singer, but still glamorous and charismatic. Pasolini's choice of Callas to play a female figure oppressed by a patriarchal society and betrayed by her lover placed Callas in the position of ghosting her own tragic life, at the end of her career, overwhelmed by the pressures of public life, including criticism of her once overweight body, and abandoned by Aristotle Onassis a year earlier. During a vacation in Greece with Callas a year later, Pasolini painted a number of portraits of the fading opera star, in a tender devotional gesture that evokes Vezzoli's painstakingly embroidered images of divas and movie stars. Opera has been described as "the story of women's undoing"[8], the stage upon which their suicide, murder, betrayal and suffering at the hands of men, and love, is played out at the highest octave. The personification of this undoing in the exaggerated tragic figure of the female opera singer renders Callas a kind of female transvestite; a screen onto whose suffering Pasolini projects his own.

Vezzoli's divas, by contrast, portray not the damage created by the celebrity machine that Pasolini critiqued so acutely, but the prurient interest in celebrity that created it in the first place. In Vezzoli's convoluted narratives, fact and fiction are deliberately elided in order to dislocate the focus of that voyeuristic desire, and thus reveal it further.

Stars find themselves in unlikely pairings: Marisa Berenson plays Edith Piaf; the game show hostess Iva Zanicchi plays Visconti film star Silvana Mangano; and Veruschka and Anita Ekberg plays themselves at the peak of their careers, now long past. Vezzoli's willing stars are all made vulnerable to displacement. If Pasolini identifies with the tragic figures of Monroe and Callas, in a chilling prediction of his own violent and untimely death, Vezzoli identifies with a very different model of feminine vulnerability: fragmented, dispersed, with a fluid sexual identity. This fluidity is epitomized in the photographic work *Francesco by Francesco* (2002), in which Vezzoli invited the Italian celebrity photographer Francesco Scavullo to make three portraits of him, titled "before" (as himself), "after" (made up as a gigolo), and "forever" (in which Vezzoli appears as a woman, in full make-up, coiffed hair and designer jacket). The three categories imply that Vezzoli's male self is in need of alteration, his gigolo persona an exaggerated fantasy, and his drag self to be his true self ("forever").

Vezzoli's feminine alter-ego demonstrates the difference between the way he and Pasolini inscribe autobiographical references in their work. The Italian public's fascination with Pasolini was channeled not only through the towering body of writing and film that he produced, but also by his masculine physique. Paparazzi photographs of the time show him playing football, or walking through Rome in a well-cut suit. His own commissioning of Pedriali's photographic portraits of him naked, in his own bedroom, as though observed surreptitiously through the window, acknowledges as much, asserting his self-image as an object of desire; a fading virile male whose homosexual body could nevertheless still produce both desire *and* intellectual thought. They are also eerily predictive of his violent fate two weeks later,

when the threat provoked by that transgressive body's erotic and cultural power was finally neutralized.

Vezzoli, by contrast, resists the conventions of hetero-sexual society through sexual ambiguity, appearing in his own work as both male and female, in interiors that belong to other people – the apartments of Visconti's screenwriter Suso Cecchi D'Amico, or the Italian literary writer Mario Praz. Each role he plays, whether as himself or in character, feminizes a masculine symbol of patriarchy. In *Il Sogno di Venere* ('The Dream of Venus', 1998), he appears in a transvestite nightclub in a leather jacket, astride a motorcycle. The allusion to the Pasolini-like masculine figure, or the gay, leather-clad bikers of Kenneth Anger's film *Scorpio Rising* (1966) is softened by the embroidery ring in his right hand. In his fake advertisement for a perfume, *Greed* (2009), directed by Roman Polanski, he depicts the surrender to consumerism that so preoccupied Pasolini by reducing himself to a roundel of his face, look-ing out from the label of a perfume bottle. The desired yet feared body of Pasolini becomes, in Vezzoli, the immate-rial, unthreatening image of sexually ambiguous beauty, not framed by the erotic context of his own bedroom into which the viewer is invited to glimpse, but trapped in a label like a fly in amber, his desirability reduced to that of a luxury commodity, fought over by two beautiful women in an expensive Parisian hotel bedroom. Vezzoli's elision of fixed roles, locations and identities is part of a larger, per-petually evolving sexual masquerade, within which he includes himself.

The difference in Pasolini and Vezzoli's approach to their physical image is partly an indication of the respec-tive moments in culture to which they both belong. Pasolini appeared at one of the most turbulent periods in Italian

history, following the trauma of the Second World War and the end of Italy's Fascist regime. The society that gave rise to the urgency of his cultural voice was in profound transition, still deeply traditional, but rapidly surrendering to the commercialized environment of consumerism and a popular culture that both homogenized and fragmented cultural experience. In his use of historical and art historical quotation, Pasolini was questioning the implications of what he felt was a dangerous loss of authentic experience, a loss that signified the end of history itself - a condition of postmodernity that Vezzoli's work forty years later accepts as fact. Vezzoli's own questions regarding history and authenticity articulate another revolutionary moment, appearing in the 2000s just as the internet began to engulf all aspects of social, cultural and political experience, dismantling the linearity of history to a degree that even Pasolini could not have anticipated. Vezzoli's engagement with Pasolini's model of cinema as a discursive site of collective fantasy, enquiry and desire reads, in the current post-cinema, internet-dominated culture, as the end-game of an intellectual project whose transgressive resistance to the established order is almost drowned by a commercial consumerism so overwhelming and complete that it has become almost impossible to determine where the boundaries of the established order lie. Pasolini's idea of cinema as "a structure in motion; a text in progress; a dynamic form striving to be another form"[9] could now describe the internet. The power of Vezzoli's work lies in its ability to move through this radical cultural transition and remain relevant, precisely because the core of its meaning is built on a fluid structure of identity. Just as Pasolini questioned the implications of the end of history, Vezzoli uses the open structure of cinema to question how this new period of what might be termed 'post-history' is transforming the

boundaries of what constitutes the self. Within his complex layering of meaning, in which one context, character, sexual identity and historical period can be exchanged for another, he reveals identity, and cinema itself, to be in a continual state of re-construction. As both Pasolini and Vezzoli have understood and demonstrated so acutely, the model of cinema thus continues to retain its power as a continually evolving discursive site within which cultural conflicts and cycles of technological obsolescence and renewal can be played out.

1 Britney Spears quoted at the Sundance Film Festival, 2003.
2 J. di Stefano, 'Picturing Pasolini: Notes from a Filmmaker's Scrapbook', *Art Journal*, vol. 56, no. 2, 'How Men Look: on the Masculine Ideal and the Body Beautiful' (Summer 1997), 19.
3 G. Bruno, "Heresies: the Body of Pasolini's Semiotics", *Cinema Journal*, vol. 30, no. 3 (University of Texas Press, Spring 1991), 37.
4 D. Hawkes, 'The Shadow of This Time: The Renaissance Cinema of Derek Jarman' in C. Lippard, ed., *By Angels Driven: The Films of Derek Jarman*, (Westport, Connecticut: Praeger Publishers, 1996) 107.
5 L. Spiegel, *TV by Modern Design: Modern Art and the Rise of Network Television* (University of Chicago Press, 2009), 270.
6 H. Grootenboer, *The Rhetoric of Perspective: Realism and Illusionism in Seventeen Century Dutch Still-Life Painting*, (University of Chicago Press, 2005), 110–111.
7 C. Ryan-Scheutz, *Sex, the Self and the Sacred: Women in the Cinema of Pier Paolo Pasolini* (University of Toronto Press, 2007), 41.
8 C. Clément, *L'Opéra ou la Défaite des femmes* (Paris: Grasset, 1979); *Opera: The Undoing of Women*. Trans. Betsy Wing (University of Minnesota Press, 1988).
9 G. Bruno, *Cinema Journal*, cit., 34.

ALWAYS CRASHING IN
THE SAME CAR

Douglas Fogle

"If he but fail to recognize himself,
a long life he may have, beneath the sun

Ovid, "Echo and Narcissus," *Metamorphoses*[1]

"Their boredom becomes more and more terrible.
They realize that they've been tricked and burn with
resentment. Every day of their lives they read the
newspapers and went to the movies. Both fed them on
lynchings, murder, sex crimes, explosions, wrecks, love
nests, fires, miracles, revolutions, war. This daily diet
made sophisticates of them. The sun is a joke. Oranges
can't titillate their jaded palates. Nothing can ever be
violent enough to make taut their slack minds and
bodies. They have been cheated and betrayed. They
have slaved and saved for nothing."

Nathanael West, *The Day of the Locust*[2]

Writers have the worst luck in Hollywood. They eke out a
meager living compared to their much better compensated
brethren in the directors' and actors' guilds. They share the
ignominy of having their work sent to re-write, butchered
by directors and actors and, worst of all, studio executives.
Their words are put through the particular inquisitorial
filter known to the film industry as focus groups that take a
Torquemada-like glee in their power over the narrative output
of the culture industry. All in all, the writer's lot is a tough

one. No cinematic image from the pantheon of Hollywood masterworks describes the plight of the writer better than the opening scenes of Billy Wilder's *Sunset Boulevard* (1950). After panning the camera back across the asphalt of Sunset Boulevard during the credit sequence Wilder cuts to a parade of police cars headed towards a palatial estate. A medium shot then sets the scene in the back of the house where police officers look for evidence and Weegee-like newspapermen photograph a man floating head down in a swimming pool. We then see Wilder's directorial genius firmly on display.

As the protagonist's omniscient and disembodied voice speaks directly to the audience the director completely flips the shot and give us a frontal view of our paradoxically dead narrator from the bottom of the pool looking up through twelve feet of water. In one of the most daring sequences of the post-war Hollywood cinema, Wilder shows us William Holden's floating, well-appointed corpse framed by cops and paparazzi alike. It is as if Holden's character, the unemployed screenwriter Joe Gillis, has been sacrificed for the sins of Hollywood and indeed the shot depicts Holden in a cruci-fied otherworldly manner.

Joe Gillis didn't meet his demise at the hands of Hollywood studio executives. He was gunned down in the film's climactic scene by Norma Desmond, a washed up silent movie diva who did not successfully make the transition to the sound era. Desmond was played by the legendary actress Gloria Swanson who was also a silent era Hollywood film diva who had a modest career in the sound era with the exception of *Sunset Boulevard* for which she was nominated for an Oscar. (Ironically, *Sunset Boulevard* won the Academy Award for best screenplay in 1950). Hollywood of course does not simply chew up its writers. It has an even more devastating track record when it comes to leading actresses.

Swanson's Norma Desmond is simply the most dramatically self-reflexive example of this cannibalistic tendency.

Looking up from the bottom of the pool, floating helplessly and lifelessly in the cold embrace of the Hollywood machine, we are confronted with a contemporary art world that itself has become fascinated with the life cycle and thanatological impulses of the star system. One thinks of the character Tod Hackett, the protagonist of Nathanael West's novel *Day of the Locust* (1939) who aspires to be a great painter and artist but who works in Hollywood as a costume designer and background painter. Recruited to the Los Angeles dream factory after graduating from Yale University, Hackett cavorts with an array of Hollywood extras, aspiring starlets, and various tawdry hangers-on while contemplating the completion of an epic apocalyptic painting entitled *The Burning of Los Angeles*. West's Los Angeles is one where boredom becomes entwined with failed dreams, peopled by a tribe of jaded aspirants to whom "the sun is a joke and oranges can't titillate their palates." His Hollywood is where dreams go to die and where daily doses of car crashes, revolutions, murders, scandals, sex crimes and other sundry extreme events no longer shock one's nervous system but become part of a banal parade of non-events too numerous to recount and therefore drained of their urgency.

Perhaps foreshadowing the great dystopian genre of the Hollywood disaster film, Hackett wants to paint a canvas depicting that land in flames, razed by a cleansing fire that every few years tears through the canyons of Malibu and the Hollywood hills.

This great novel of Hollywood angst is but the first entry into a now long legacy of contemporary art's infatuation with the glamour as well as the seedy faded glory of various Hollywood players. Andy Warhol, Richard Prince,

Cindy Sherman, and now Francesco Vezzoli are all part of this legacy each in their own way.

The unavoidable truth that one can glean from this insatiable interest expressed by contemporary art in the aura of Hollywood is that stardom and disaster are two sides of the same coin. This is a tenet that one can trace back to Greek mythology or the tragedies of Sophocles. Hubris, fame, disgrace, and comeuppance. They are all part and parcel of the same very flawed and very human drive. We as a species are fascinated by it. One forgets that Andy Warhol's iconic images of Marilyn and Liz were painted at the same time as his Death and Disaster series that were populated with gruesome media images of car crashes and electric chairs. Marilyn had already tragically fallen to a drug overdose while Liz had famously taken seriously ill during the filming of *Cleopatra*. These starlets were each in their own way forces of nature but they were also the cultural equivalent of car crashes. We couldn't look away. The extremity of the lives of these actresses was often matched by the surprisingly over-the-top melodramas that were produced by the Hollywood studios in the post war years.

A case in point is John M. Stahl's tragic romance *Leave Her to Heaven* (1945), in which a stunningly beautiful twenty-five year old Gene Tierney plays Ellen Berent, a pathologically possessive socialite who is hell-bent not to let anything or anyone get between herself and her newly minted novelist-husband Richard Harland played by a restrained Cornel Wilde. Not quite a film noir but disturbing nonetheless, *Leave Her to Heaven* is an extreme study in aberrant psychology as Ellen's overly obsessive relationship with her recently deceased father is projected onto the figure of Wilde's oblivious and love-smitten writer. A death brought on by Ellen's

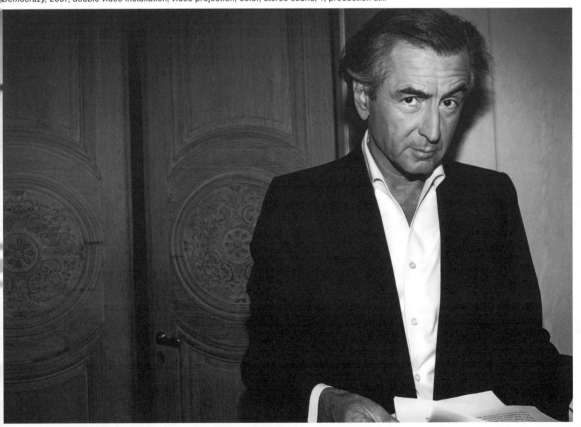

Democrazy, 2007, double video installation, video projection, color, stereo sound, 1; production still

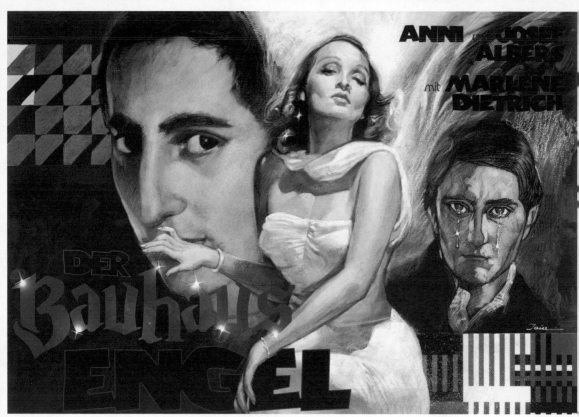

Der Bauhaus Engel – Anni vs. Marlene (The Prequel), 2006, poster, digital print on glossy paper, variable dimensions

premeditated and conscious negligence, a self-induced abortion, and a suicide cum murder forms the deviant backbone of this at first seemingly innocent love story. When Ellen becomes infuriatingly jealous of Richard's disabled younger brother Danny she coaxes the boy into trying to increase his endurance by swimming across the lake that forms the idyllic backdrop for Richard's remote vacation cottage. Donning a pair of fabulous sunglasses, wearing an elegant robe, and with her hair and make up done to perfection, Ellen rows a small boat behind the physically challenged boy who can only swim with his arms. As Danny begins to tire, Ellen coldly encourages him to keep trying. As Danny struggles Ellen responds calmly with a flat and menacingly affectless voice saying "Take it easy. You don't want to give up when you've come so far." Danny haltingly forges on across the lake declaiming, "The water's colder than I thought. I ate too much lunch. I've got a stomach ache." And then his body slowly slides below the dark water popping up just briefly to shout out "Help me!" before disappearing again for the last time. The disturbing genius of this scene is the silent pause that Tierney's character takes before jumping in after the boy (a "heroic" act only brought on by the approach on the shore line of her whistling husband). The duration of the pause between Danny's final submergence and Ellen's faux rescue attempt is excruciatingly long in film time. The camera lingers on her emotionless face for one beat too many before both Ellen and then Richard jump in the water to attempt to rescue the now drowned boy.

This scene from *Leave to Her Heaven* is only matched in its perversity by Ellen's later self-inflicted fall down a flight of stairs which purposefully induces a spontaneous miscarriage of her unborn child who's love she is unwilling to share with that of her husband. Later in the film, unable

to bear the thought that Richard might be in love with her adopted younger sister Ruth, Ellen takes her own life while carefully implicating Ruth in her own murder. If she can't have Richard then neither will her sister. The lessons of Sophocles were certainly learned well by the denizens of the golden era of Hollywood. Jealously, pride, unbridled ambition, intense emotional turmoil, psychopathologies... they are all the foundation of Hollywood melodramas which when examined closely are far more extreme than one could possibly imagine. In many of these cases (but not all) it is the actresses who carry the burden of Hollywood's need for combustible emotional catharsis.

Another interesting case study in the diva-driven canon of Hollywood melodrama can be found in Douglas Sirk's hyper-saturated melodrama *Written on the Wind* (1956). Here I mean saturated in both its visual and emotional senses. Starring a somewhat stoic if impossibly handsome Rock Hudson alongside a restrained Lauren Bacall, this film tells the story of a rich yet completely maladjusted Texas oil family and their more adjusted and sober surrogate relatives played by Hudson and Bacall. Based on the 1945 novel of the same name by Robert Wilder, *Written on the Wind* was a thinly veiled recounting of a real life scandal involving the Broadway singer Libby Holman and her husband, tobacco heir Zachary Smith Reynolds, in which Holman was indicted for murdering her husband before his family had the charges dropped to avoid a public scandal. In Sirk's version, alcoholism, greed, impotence, nymphomania, Oedipal conflicts, and patriarchal failures all come together to create a tragic morass of human vulnerability and neurosis.

German Filmmaker Rainer Werner Fassbinder, himself a master of melodrama and a huge fan of the films of Douglas Sirk, suggested when discussing *Written on the Wind* that

"insanity represents a form of hope in Douglas Sirk's work."[3] This can clearly be seen in the twisted emotional dance between the film's main characters, the rich and spoiled siblings Kyle and Marylee Hadley played by Robert Stack and Dorothy Malone respectively, and Kyle's childhood best friend and the unrequited object of Marylee's affection Mitch Wayne played by Rock Hudson. The interloper into this odd familial scenario is the executive assistant Lucy Moore played by Lauren Bacall who ends up choosing Kyle over Mitch at the beginning of the film. As you can imagine, in a film by Douglas Sirk this turns out to have been a poor choice. The siblings Kyle and Marylee each have their own demons brought on by a domineering and patriarchal father. When the notoriously underachieving Kyle fears that he is impotent and unable to father a child with Lucy, he returns to his old alcoholic ways falling into a downward spiral of self-loathing and paranoia. Marylee on the other hand, continually frustrated by her inability to seduce Mitch who she has loved since her youth, turns into a nymphomaniac who will fuck anything that comes her way especially if her victim bears any resemblance to her precious Mitch.

Mitch loves Lucy but can't have her because his best friend (who he has taken care of his entire life) is married to her. Marylee loves Mitch but can't have him because he thinks of her as a sister, wants to avoid an incest-like relationship, and is quietly in love with Lucy. Kyle, who may or may not love Lucy, does love Mitch like a brother, but is so completely dominated by his father that his apparent failure to even be able to father a child drives him to insanity. Everything comes to a head when Lucy does indeed get pregnant with Kyle's child but Marylee makes an insinuation about Mitch's possible role in the pregnancy that sends Kyle into a drunken rage. Are you still with me? I hope so. One

always needs an emotional flow chart for Sirk's films in order to map out the vectors of relationships as they evolve and inevitably explode across the screen. The denouement of this tragedy involves a scene in which a defeated, self-loathing and alcohol-sodden Kyle confronts the good surrogate son Mitch with a gun while Marylee looks on. Mitch tries to convince Kyle that he is not the father of his now miscarried child. As Mitch and Kyle talk, Marylee lunges for the gun that goes off after a brief struggle leaving Kyle dead. Wow.

For our purposes though, the most important scene in the entire film comes before this final unraveling when Marylee is brought home against her own will by the police after she is caught in a hotel tryst with a lowly gasoline station attendant. Sent to her room, Marylee plays loud jazz music and dances with a framed photograph of Mitch in a state of wild and wantonly rebellious abandon. Sirk floods this scene with his characteristic hyper-saturated colors moving from a white virginal light to a lascivious palate composed of reds and shadows. In this scene Marylee is dressed in a hypersexual, diaphanous, red see-through dressing gown. As the music's tempo picks up and builds to a crescendo, Marylee's father slowly climbs the grand staircase on his way to confronting her about her prurient activities. As the music reaches its climax, Marylee's body flails on a fainting couch as her father collapses from a heart attack and tumbles down the stairs. So much for the pater familias. As Fassbinder suggests when speaking of Dorothy Malone's depiction of Marylee, "Dorothy does something evil–she makes her brother suspicious of Lauren and Rock. Yet even so, I love her as I've seldom loved a person in a movie. As a viewer I'm with Douglas Sirk on the trail of human despair. In *Written on the Wind*

everything good and "normal" and "beautiful" is always very disgusting, and everything evil, weak and confused makes you feel sympathy. Even for those who manipulate the good people."[4]

It isn't Rock Hudson's Mitch or Lauren Bacall's Lucy that carries the weight of the underlying narrative in this film. That burden belongs to Kyle and Marylee. Both are character studies of broken individuals in extremis (not insignificantly, Dorothy Malone won the Academy Award for Best Actress in a Supporting Role for her work in this film). Fassbinder is right though. This is film about the bad and ugly people. We don't care about Hudson and Bacall even as we feel intensely for the tragically flawed siblings of the oil tycoon. In the end, as Mitch and Lucy drive off into the sunset, Marylee takes on the mantle of the family as she suggestive fondles a model of an oil derrick while sitting at her father's desk. In speaking about the work of Douglas Sirk, Fassbinder goes on to state that "Human beings can't be alone, but they can't be together either."[5] This is the paradoxical dialectic of the human condition as told through the lens of Sirk's melodramas.

If Dorothy Malone stole the film in *Written on the Wind* as an extreme, rebellious female figure what do we make of Elizabeth Taylor some ten years later in John Houston's scandalous 1967 release *Reflections in a Golden Eye*? Based on the 1941 novel of the same name by Carson McCullers, Houston's film tells the story of two military couples living a country club-like existence on a military base somewhere in post-war America. Marlon Brando plays Major Wendell Penderton, a clearly psychologically distressed individual who is haunted by his barely repressed homosexual urges. His wife Leonora, played by Elizabeth Taylor, is a lustful and domineering woman who in response to Wendell's complete

lack of sexual interest in her is having a torrid affair with her husband's best friend and superior officer Lieutenant Colonel Morris Langdon played by Brian Keith. The fourth member of this bridge club is Landon's wife Alison played by Julie Harris. Suffering from psychological trauma in the wake of the death of a newly born child, Alison is under careful watch by all as she had previously tried to cut off her nipples with gardening shears. Taylor taunts Brando at every turn and flaunts her sexuality as a kind of cudgel at one point defiantly slipping out of all of her clothes in front of Brando as she walked up the stairs to her bedroom. Meanwhile Brando has an unrequited sexual fixation on a young soldier under his command who takes care of the horses on the military base. Brando whips Taylor's horse in frustration, Taylor whips Brando in the face repeatedly at a cocktail party in retaliation, the private steals into Taylor's room at night in order to fetishistically stroke her lingerie while she sleeps, and eventually, driven mad by all of this, Alison is institutionalized and then dies of a heart attack. It's all too much when Brando bursts in on the soldier at the foot of Taylor's bed and shoots him dead out of jealously, self-loathing, and frustration. One wonders how this film ever bombed at the box office! On top of this extreme and perverse melodrama that somehow unbelievably made it by the censors, Houston shot the entire film with a golden filter giving the entire proceedings a heightened intensity and a dreamlike sensibility. It's interesting to compare these two contrasting female characters, one a less than sympathetic petulant and self-obsessed child and the other a thoughtful and cultured institutionalized hysteric. Both are extreme in their own right and are equally consumed in the end by the stultifying and conservative social milieu that they each find themselves in.

A perhaps more sympathetic and stronger female figure can be found in Elizabeth Taylor's starring role opposite her then-husband Richard Burton in Vincente Minelli's 1965 film *The Sandpiper* (1965) in which she plays Laura Reynolds, a free-spirited and unrepentantly bohemian unwed mother living on the Big Sur coast in central California. Laura brings to mind the character of Antigone in the tragedy of the same name by Sophocles. The daughter of the unknowingly incestuous union between the cursed Oedipus and his own mother Jocasta, Antigone rebels against the Theban authorities by giving her brother the proper burial denied to him as punishment for his rebellion. It all ends badly for everyone as Antigone is captured and then kills herself in despair. However, the figure of Antigone as a strong rebellious female agent lives on. Elizabeth Taylor's character Laura was an Antigone-like presence in *The Sandpiper* but more importantly the scandal-plagued life that the actress lived off camera is perhaps even more telling for this discussion. Raised under the scrutiny of the Hollywood press machine as a child actress she careened from one passionate relationship to another with only the most notorious being with Richard Burton. She went through eight marriages and several life threatening illnesses. She was a force of nature and yet a complete creation for the camera and unlike her cohort Marilyn Monroe she was able to survive the all-consuming jaws of the paparazzi Moloch. She was a rebel and a survivor.

Why spend so much time investigating the hyper-melodramatic female figures that populate the first decades of post-War Hollywood cinema? Looking more carefully at these strange cinematic moments helps us reflect on the work of Francesco Vezzoli who has spent his career working with just such survivors enlisting the talents of figures

as wide ranging as Courtney Love, Lauren Bacall, Sharon Stone, and Karen Black. Some are thought of as legends, while others have been called B-actresses, fallen stars, or much worse. Many of these actresses have passed through the fires of scandal, bad reviews, and a multitude of hyper-melodramatic film scenarios. Perhaps this is why he has been so obsessed with these figures. In Gloria Swanson, Gene Tierney, Dorothy Malone, Elizabeth Taylor, and even Antigone, we see the precursors to Vezzoli's contemporary pantheon of tragic melodramatic women. In his *Trailer for a Remake of Gore Vidal's Caligula* (2005), for example, we witness a veritable casting call of what Fassbinder calls "Sirkian hope," in other words insanity. Although only lasting a few minutes, this steroidal exercise in dramatic excess takes the most extreme moment in the history of the Roman empire and populates it with the likes of A-listers, B-listers and forgotten heroines alike such as Helen Mirren, Karen Black, Courtney Love, Michelle Phillips, and Milla Jovovich. As with his casting of Sharon Stone as an aspiring American politician in his election-themed film *Democrazy* (2007), Vezzoli always puts a mirror in front of our media-driven culture making us recognize the figures that he casts and bask in their celebrity, while at the same time inserting them into a feedback loop that cycles around and around until the Hollywood image machine is run into the ground. Whether it's the extreme Hollywood hyperbole of his version of Caligula or the baffling interchangeability of his all too generic and completely vacuous political candidates in *Democrazy*, it's quite a different strategy than that suggested by Tod Hackett in *The Day of the Locust* who dreamt of Los Angeles burning to the ground. In Ovid's retelling of the story of Echo and Narcissus an oracle suggests to Narcissus's mother that if he will simply fail to recognize himself he

will have a long life under the sun. This act of humility in refusing to look at ourselves is a nice thought but is not exactly how we are programmed. We can't simply look away from the car crash. We look at ourselves in the mirror and are fascinated by what we see. How else can we truly know who we are as a culture? One result of this is the profusion of reality television. Another can be found in the amazing cinematic lessons on the human condition brought to us by Douglas Sirk and his ilk. It is these Sirkian lessons that have been fully processed by Francesco Vezzoli who embraces the tragedy of Echo and Narcissus not as a warning but rather as a call to arms.

1 Ovid, *Metamorphoses*, III, 346–348.
2 N. West, *The Day of the Locust* (New York: Random House, 1939).
3 R.W. Fassbinder, *The Anarchy of the Imagination: Interviews, Essays, and Notes,* ed. M. Töteberg and L. Lensing (Baltimore: The Johns Hopkins University Press, 1992), 82.
4 Fassbinder, *The Anarchy* cit. 83.
5 Fassbinder, *The Anarchy* cit. 79.

FROM BRESCIA TO HOLLYWOOD AND BACK. CONVERSATION WITH THE ARTIST

Cristiana Perrella

CP

The MAXXI exhibition introduces the project entitled *The Trinity*, which also involves the MoMA PS1 and the MOCA, for a great three-part retrospective which examines the main aspects of your work. It's an important moment of reflection and also, in terms of the complexity of the project and its sheer size, rather unusual for an artist your age. How did you come up with the idea for this project?

FV

By trying to dribble boredom, predictability, or the pompousness of the concept of the retrospective, and therefore by turning an exhibition in which 95% of the works showcased already exist into something more subversive and multi-territorial, something poised between Cher's farewell tour and a piece by Gordon Matta Clark. What's important is not just that my work is being shown for the first time from its many angles, but that the way in which it is being done is in itself a new statement, not a point of arrival but a chance to raise the stakes. Hence, an exhibition that's actually an anti-retrospective, an anti-museum, an exhibition that functions like the launch of the film, like a global media event. There's a world premiere, the MAXXI exhibition, then there's the moment when, just like a movie, *The Trinity* is on all the screens at the same time, in Rome, in New York, in Los Angeles. For me, simultaneousness is the most important element in this project, without wanting to diminish the

importance of the task I carry out in each of the museums. Obviously, what we're doing at the MAXXI is massive if compared with what's happening at the MoMA or the MOCA...

CP

How did you organize it?

FV

It includes every single aspect of my work, the embroidery, the tapestries, the premieres performances, the photographs, the videos... But what's most important is the intervention in space which the project must measure up to, a huge space, with a very strong character, which I am tempted to call "futurist," transformed into a sort of nineteenth-century gallery, toying with the decorations with ferns, kentias, red damasks, stuccoes...

CP

Your work on the space itself, your longing to not be subjected to it but to choose or create it, to reshape it, is a crucial element in the way you deal with the project for an exhibition; this was also true for your very earliest experiences, such as the *Degree Show* at the Central Saint Martins where your works hung in the bathrooms. You then began to connote the environment with velvet curtains and decorative elements, until you created or used true and proper architectures, often in sharp contrast with the nature of the display space. One aspect of your life which has become increasingly important, but which has rarely been interpreted by the critics.

FV

Unquestionably my intervention in the exhibition space is essential to the other two *The Trinity* shows as well: in New York we bought a nineteenth-century deconsecrated church that we will reconstruct right in the courtyard of the MoMA PS1. In Los Angeles, we will appropriate or recreate a cinema completely in 1920s style. In these three

exhibitions the intervention in space is brought to an almost delirious apotheosis, whose risk I am well aware of. But even if we weren't able to achieve perfection, for me, the success is already there. All my projects are experimental, they are the trial of an idea. To my mind, an experiment works if, whenever I tell someone about it, I can see the reaction on their face. What's important to me is ambition, the ambition that comes with buying a church and reconstructing it inside a museum, of trying to get one of the oldest movie houses in the history of Hollywood, of having the hybris to turn Zaha Hadid's architecture into a nineteenth-century ambient. Like all my other projects, even Pirandello's performance at the Guggenheim or Polanski's advert, the idea is upstream, not downstream. Paradoxically, its realization is less important to me.

CP

Your intervention in space is an ephemeral element, which, however elaborate and monumental it may be, is lost when the show ends and the works are sent back to the various collections. You have never wanted to consider the pieces and the space as a single work, in spite of the fact that their relationship is the fruit of a very specific ideational process, whose conceptual intentions go beyond those of the individual pieces.

FV

No, in fact, I'm not interested, as art history is entirely a decontextualization. In the 1930s exhibitions were organized with fabrics on the walls or music in the galleries, now we see the same works sacralized on white walls, with no baseboard because it would interfere with the gaze. The Parthenon was colored, and now the iconography of Classicism is white… art history is one big mistake, I believe in the *hic et nunc*. I'm trying to make it so that the people who come to see my

Vaghe Stelle dell'Orsa, 1999, laser print on canvas with metallic embroidery, 3 elements, 40 × 29 cm ea.

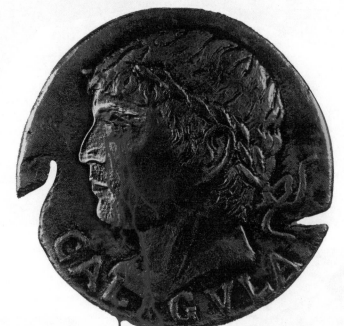

FROM THE CREATOR OF "COMIZI DI NON AMORE"
THE REIMAGINING OF A MOVIE THAT SCANDALIZED THE WORLD

FRANCESCO VEZZOLI
IN
GORE VIDAL'S

CALIGULA

STARRING

ADRIANA ASTI KAREN BLACK BARBARA BOUCHET
GERARD BUTLER BENICIO DEL TORO MILLA JOVOVICH
HELEN MIRREN MICHELLE PHILLIPS GLENN SHADIX
TASHA TILBERG SPECIAL APPEARANCE BY GORE VIDAL

SPECIAL GUEST STAR
COURTNEY LOVE

COMING SOON TO A THEATRE NEAR YOU

Poster for a Remake of Gore Vidal's Caligula, 2005, silkscreen on paper, variable dimensions

shows experience specific feelings owing to the way I put them together. What's left afterward are findings that gradually become more and more like…findings. It is impossible to reconstruct the spaces of the past: an object, a memento, must have the strength to survive even in the wrong context.

CP

How do you explain this allergy to the white cube?

FV

It's not an allergy. I like white museum space very much. I'm allergic to artificiality, I think that the purity of the museum clashes with the impurity of the world, or with the impurity of the shapes in which the pieces are placed later. An Yves Klein work will survive anyway, but if you think of the context it came from and where it hangs today these are two completely different aesthetic, spatial and emotional moments.

CP

The MAXXI project essentially consists of a critical reflection on the institutionalization of your work and, in a broader sense, on the museum's function, calling into question elements such as the exhibition space and the reception on the viewer's part, but, above all, its role in conserving, historicizing, suggesting a critical reading and making emerge and strengthen the value of the works, even from a material viewpoint. Even the title of the exhibition, *Galleria Vezzoli*, seems to allude to the relationship with the market…

FV

No doubt it is a play on words and concepts: you have a great opportunity, in the most important museum in the country, designed by an international star-architect, and you call the exhibition *Galleria Vezzoli*, that is, you toy with the transformation of this space into a gallery, with the commercial side of art.

CP

At the Gagosian in New York, for the *Sacrilegio* exhibition, you turned the gallery into a church instead.

FV

If we want to delve more deeply we might say that all these projects are really a sort of denial of the role of the museum, even if it's not an aggressive denial. I was taught to think of the museum as a sacred place while today we are at a time in history when at the center of the art system is the market. Moreover, museums, except for some rare cases, have lost their archival and protective capacity in regard to the artist, and have instead developed functions linked to communication and entertainment. The role of the person who works there is gradually less that of studying an artist's oeuvre, of contextualizing it and making it understood.

CP

The theme of the museum also leads to the need to correlate past and present, to the reflection on the role of history in the heart of contemporary culture. The museum is the place where you can recognize constants, legacies, the conceptual lines that in a country's art, for example, are passed down… Your work has always entertained a dialogue with the past, with art history, which has recently become tighter and has found an emblematic formal and conceptual expression in the works that you began to realize in 2010, placing your marble self-portraits before academic, Neoclassical sculptures, copies from Antiquity, but also authentic Roman heads, for an asymmetric, dynamic and ironic relationship. One of these works, *Self-Portrait as Hemperor Hadrian Loving Antinous* (2012) was exhibited at the Antiquarium of Villa Adriana in Tivoli for the *Antinoo. Il Fascino della bellezza* show alongside some of the masterpieces of ancient sculpture. How was this work on the Classical born?

FV

It was born as usual as a sort of small revenge, but one with a smile, in respect to an art system that at times seems to be excited about nothing. I found it amusing – and still do – to create artworks that play on an overturning of aesthetic values but financial ones as well. Today you can buy heads from the 1st century AD for much less than a drawing from the 1960s, a drawing that wasn't even made by one of the great masters, and I have always enjoyed, in my videos and in all the rest, drawing attention to these contradictions of contemporary society, reflecting on the factors that determine the creation of value.

CP

For years you worked on fame, you studied the media- and communication-related phenomena that determine it. You thought about how, through them, desire is aroused and appreciation is achieved, and you have cleverly manipulated the codes in videos and performances in which you involved international stars by producing a pilot for a TV show inspired by Pasolini (*Comizi di non amore,* 2004), staging an American presidential campaign with Bernard-Henri Lévy and Sharon Stone as candidates (*Democrazy,* 2007), putting together the Bolshoi and Lady Gaga (*Ballets Russes Italian Style (The Shortest Musical You Will Never See Again,* 2009), having Roman Polanski direct a commercial for a nonexistent perfume with Michelle Williams and Natalie Portman (*Greed,* 2009). Now that your attention has shifted "from Hollywood to the Louvre," as you yourself mentioned in an interview, is it safe to say that you have abandoned stardom to instead liaise with a form of fame, perhaps a less glamorous one, but one that is longer-lasting, that is, the kind of fame that comes with belonging to art history?

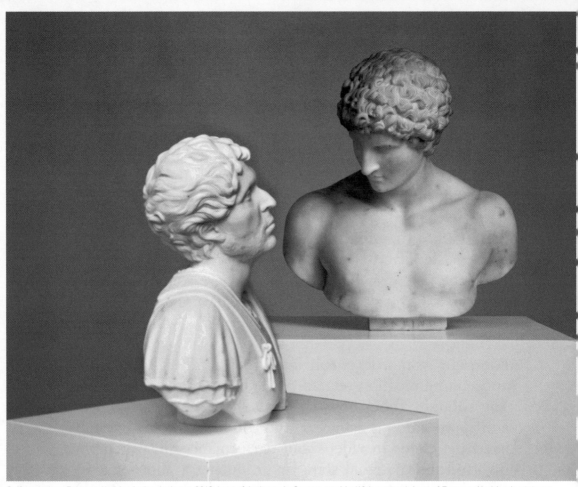

Self-portrait as Emperor Hadrian loving Antinous, 2012, bust of Antinous in Carrara marble (19th century), bust of Emperor Hadrian in statuary marble, 2 elements bust of Antinous 46 × 39 × 20 cm; bust of Emperor Hadrian 45 × 45 × 19 cm

FV

I have shifted my attention because I failed, and I want this to be known. I failed because I involved some very famous figures in my work, but the Roman Polanski video with Natalie Portman and Michelle has 150,000 hits on the Internet, while the real advert for Dior perfume has 1,500,000. So these works did not become a part of the collective imaginary, I don't know whether it's because of a mistake I made, or because they weren't presented the right way. I think having made some very strong gestures, even courageous and complex ones. Of having arrived where many directors never have, that is, questioning the system, arguing with the system, anticipating it (like in the case of Natalie Portman who at first refused to do advertising, but after being in *Greed* did the Dior commercial). In any case my work is part of a niche imaginary: all those who read *Artforum*, *Vogue* and *W Magazine* are familiar with it, but it has not pervaded the global imaginary.

CP

And why do you think that is?

FV

I am convinced that it's not because the work is weak, but because it's complex. I used absolute symbols, like the celebrities, but so submerged in references and cross-references that their power of seduction was as if paralyzed. At the same time, the presence of those stars in the work was so strong that they destabilized it, shouted it down. It's so hard to get these people to work with you, the fact of having managed to involve them in my projects comes before any other quality of the work. And in this sense it is as if I had won my bet, but a bet with myself and, paradoxically, not with art. This is sort of the same thing that happened with my existence, I have had some remarkable encounters, a whole series of experiences,

which then flowed into my work and made my art possible, but which was also viewed, precisely because of its exceptional nature, with a hint of suspicion, as an excess to be taken for granted. A stupendous life, Herbert Muschamp took me to see Ricky Martin, at the height of his popularity, together with Donald Trump, when he was running for president. After the concert we went backstage to his dressing room—we were the only ones allowed to enter—while Barbara Walters and Liz Smith, the two gossip queens of U.S. journalism, had to stay outside—and we found Ricky Martin alone with his father...and outside people throwing bills at Donald Trump because he was one of the candidates. After something like that what else can you create but *Democrazy*, don't you think? But all this, if you tell people about it makes them nervous. If you think that I made *Democrazy* with Bernard-Henri Lévy and Sharon Stone, and with John McCain's spin doctor who teaches at Harvard and who even left McCain as soon as Obama entered the race. Plus with Clinton's electoral consultants...you tell me who manages to put stuff like this together. But *Vogue* liked it and *Corriere della Sera* liked it because I was Italian and it was like Raffaella Carra's show coming to New York, but this never really made a dent, it has always been seen as a heap of privileges or unexplainable luck, so that at a certain point I got tired of doing it because I got sick of hearing people ask me how I did it, a question that, at a certain point, was almost insulting.

CP

So you decided to abandon your work with celebrities and try new paths. I think the turning point was *La Nuova Dolce Vita* (2009), which you presented first in Paris, at the Jeu de Paume, then at Ca' Corner in Venice, where you put Eva Mendes in the clothing of female icons linked to Rome, from Anita Ekberg to Paolina Borghese by Canova, from Bernini's

Ecstasy of Saint Theresa, to the goddess emerging from the water of the *Ludovisi Throne*, introducing for the first time the theme of Antiquity and the language of sculpture. How would you describe this change?

FV

I see the work of post-celebrities as being very introverted, as being closed in on itself, focusing on reflecting on exclusively artistic themes to which the world of collecting and criticism reacts in a more relaxed way, because, yes, they are works that undermine a value system, the system of art's prices, but they are not distant, unleashed, like the ones where I put together a whole army of power that makes you feel overwhelmed.

CP

But dialoguing with the masterpieces of ancient art, appropriating them and using them as material for your works, this seems to be an even greater ambition.

FV

Of course it's an even greater ambition. I want to buy sculptures that cost 200,000 dollars and paint them with watercolors. Obviously, I haven't lowered my ambitions, but have raised them. I said to myself: "fine, I unnerved everyone by measuring up to Lady Gaga and Natalie Portman, what more can I do? Phidias!" The basic mechanism is still the same one, but it is not read the same way. Also at the origin of these new works is the need to face values and emotions that are absolute, universal. My gaze toward the past is essentially aimed at proving that the world never changes, a thought that has been obsessing me since I was a student at a classical lyceum. As Gore Vidal says at the start of *Caligula*—the sentence is a key to a reading of the whole project: "Every moment in history is dark." In every moment there has been abuse of power by means of money, sex,

wars. Nothing changes. This is why I insist on remembering that the Parthenon was colored, that antique sculpture was colored, because this helps you to understand how there was already a playful, carnal side to the way art was experienced in those days, and this shows some constants that I think are important.

CP

Italian identity is a very strong element in your work, which at the same time reveals a great knowledge and understanding of global phenomena, a capacity to dialogue with the international art system. Might we describe your position as being suspended between provincialism and cosmopolitanism?

FV

Yes, I'd say that that's a very appropriate description. When I was nineteen I spent three months in London and two weeks in Brescia. I followed the Pet Shop Boys or John Maybury in the clubs and then I'd I rush back to eat the breaded cutlets made by my beloved grandmother. Now I spend a month in Milan, three days in New York and three in Los Angeles. Let's say I respect the English-speaking world's intellectual supremacy, but that's not a reason for me to forgo the melancholy languor of my roots. And I think this is a key to interpreting the most schizophrenic aspects of my work.

CP

You went to London to study art at Saint Martin's College. FV: I went to London, rather than to be an artist, to flee from Brescia, to follow my legends at the time, Derek Jarman, Leigh Bowery, Boy George... The awareness of wanting to be an artist came much, much later.

CP

What was the impact with the London art scene?

FV

It was the impact with an evolved, media-related, aggressive art system that had nothing to do with the world of Arte Povera or with artists like Alighiero Boetti through which I would have trained. One of my first important encounters was with Lorcan O'Neill, who was working with Anthony d'Offay at the time. I understood what a great art gallery was, the completely different way of conceiving work than in Italy. Then the Young British Artists exploded and watching these artists who so strongly claimed their class identity I wondered what mine was. I had to answer lower-to-middle-class, which in itself wasn't very sexy, but it was the truth. This was the stimulus that led to the birth of *An Embroidered Trilogy*, which for me was a sort of summary of bourgeois identity, antiques more than modern objects. Obviously, it also meant pointing your finger at some of the stigmas of Italian thinking: looking to the past, the inability to turn to the various modernities coming from other places, from various creative disciplines.

CP

Did you feel this Italian identity strongly when you were in England? Did its characteristics become clearer to you?

FV

I resented it somehow, and still do, but I have always thought that it was also necessary to claim it. In globalized society, you cannot be separated from your identity, you have to resist the temptation of homogenization.

CP

And how did they take this initial awareness of your Italian identity in London?

FV

It caused a great deal of friction, the way I think it still does. Proof of this was an exhibition like *Sacrilegio* in New York,

where I introduced some *topoi* from Italian culture—gold leaf, the Madonna, the church…

CP

…Mom…

FV

…Mom, yes, and all this triggered the rejection. It's something that, especially in the United States, they realize they can't discuss, for one reason or another. A system of signs that they can't read, also because it doesn't come in a single message, it's hard to interpret.

CP

And when you got back to Italy, did this type of need and attitude find any travel companions?

FV

Not travel companions, let's say my stubbornness helped me to find allies and supporters.

CP

A reflection on Italian identity belongs to the work of many of our artists…

FV

No doubt, and they are "spurious" artists, in the sense that they have also toyed with the idea of the corruption of their own aesthetic-creative identity, with the idea of mixing. As I was saying before at the bottom there's a political problem, in the sense that the Italian and European art system is a less ideological system than the American one. A book was recently published by Gaea Pallavicini in which she talks about a documentary that, before Neorealism, Roberto Rossellini had made for Galeazzo Ciano with two lobsters having sex. I find it wonderful and it helps us to understand what the heart of the matter is: we come from a political tradition that isn't linear like the American tradition, they have never had a dictatorship. With a dictatorship

the artist must survive. If we take the greatest cornerstones of our literature, it's always Pirandello asking for a Fascist membership, D'Annunzio needless to say, Rossellini made the video for Galeazzo Ciano, De Sica acted in "white phone" movies for a decade so that he could save enough money to make *Bicycle Thieves*...We're not accustomed to the figure of the artist of the utmost integrity, it's not embedded in our DNA because the poor artist wants to survive; historically, European countries have undergone too many political upheavals for the artist to emerge unharmed, tracing his black mark, like a Japanese artist on a white canvas, saying "this is my idea, I have been working on this mark for eighty years and I'm a great artist."

CP

We have Fontana...

FV

Yes, indeed the proof that the most Minimalist of all our artists is someone who first made ceramic Baroque sculptures. The Italian way is impure. It's a complexity, even an ambivalence, which is often misinterpreted, misunderstood.

CP

Since you first started, have things changed from this standpoint?

FV

For some, yes, for others, no. There are still some who believe in an academic system, a radical one with separate sections, while I believe that the real future will take us toward a confused, pluralistic world, in which the Italian way will be given more room.

CP

But can an artist today be of world relevance and fame? Is there still the chance of being a Warhol or a Dalì, considering the multiplicity of cultures, markets, at play?

FV

To my mind, yes, you have to do hard work on yourself, or else play an unquestionable role from a political point of view, like Ai Weiwei. But it is possible. You have to have a deep knowledge of the media, the critical debates, and understand what the absolutes are, clearly filtered through your own sensitivity. This is a great challenge for art, but I think it's true for everyone, poets, writers, filmmakers... even the cinema is having a hard time understanding what the universal themes are today.

CP

What do you think the universal theme of your works is?

FV

The tears, the pain are universal, and this is the theme at the root of everything I do. When the memory of the figures that appear in my works has vanished, when they will have become an apparently nostalgic concentration of incomprehensible information, the only thing that will be legible, especially from the early works, is the pain, the desperation they express. The fact that they are linked to an analysis of a divided identity, between public and private, fits in very well with the deep changes that have recently been induced by the use of social networks, which have altered the threshold that separates the spheres. Today everyone wants to have a public image and this way they feed their private selves to others.

CP

In your work you bring yourself, your image into play totally... There's a strong autobiographical element, linked to your path, your obsessions, your personal history...

FV

Yes, from Brescia to Hollywood and back...

CP

There are elements of self-mythology, self-celebration, which remind me of one of your fellow citizens, Guglielmo Achille Cavellini.

FV

Cavellini's influence does exist, I spend my whole childhood with red-white-and-green stickers announcing the centennial of his birth, 1914–2014. But let's say that my approach is more Dannunzian, decadent. I don't fear failure, I'm not interested in whether or not my acts of megalomania succeed perfectly. The spring-board is my being provincial, and at this time in history more than ever, my belonging to a provincial country. If I had been born in Rome at the time of the *Dolce Vita* I wouldn't have made the art I have. I was motivated by my country's loss of relevance, by the loss of creative, economic focus. This decline obsesses me, just as I am obsessed by Italian art when it clashes with the international system. It's a country that doesn't count, this is the height of my desperation. While doing my work I have felt that if I had had stronger and more powerful systems behind me I could have seen my dreams come true more easily, but they would have been less valuable. If there had been just one producer working with Natalie Portman in Italy, it would have been easy for me to ask my gallerists to call that producer so that I could contact her. But this wasn't the case. This explains why I am so happily bound to fashion, because I find that it is the only Italian industry that at this moment is unquestionably a world leader. The only one that has a constant, credible dialogue with the global media. My interest in fashion and glamour does not stem from my personal inclination, but from a conscious choice, because I believe that objectively, in the historical period we are

living in, they are our country's only legible references at a global level.

CP

And you don't think art is?

FV

Maurizio Cattelan's art yes, not the other kind of art, unfortunately.

The works exhibited on the occasion of the "Galleria Vezzoli" show at the MAXXI are listed in chronological order. Ownership is only indicated if a museum, public institution or foundation is concerned.

Homage to Josef Albers' "Homage to the Square" (Fade to Grey), 1995, cotton embroidery on canvas, 30 × 24 cm (framed)

Homage to Josef Albers' "Homage to the Square" (Green), 1995, cotton embroidery on canvas, 32 × 26 cm (framed)

Mark Rothko in Conversation Piece, 1995, cotton embroidery on canvas, 26 × 32 cm (framed)

Oooh! I'd Love Some Hanky Spanky, 1995, cotton embroidery on canvas, 20 × 38.5 cm (framed)

OK – The Praz is Right!, 1997, video projection, DVD, color, stereo sound, 5', edition of 6 and 2 artist's proofs, Castello di Rivoli, Museo d'Arte Contemporanea Collection Rivoli (Turin), donation by the Regione Piemonte
Directed by: John Maybury; starring: Iva Zanicchi, Francesco Vezzoli; produced by: Chiara Bersi Serlini; artistic director: Luca Corbetta; filmed in Rome at the Mario Praz museum in September 1997

Ricamo Praz, 1997, cotton embroidery on canvas, 29.7 × 28.2 cm (framed)

Gloria!, 1998, laser print on canvas with metallic embroidery, Ø 24 cm, 33 × 43.5 cm (framed)

Il sogno di Venere, 1998, video projection, DVD, color, stereo sound, 4', edition of 6 and 2 artist's proofs, Castello di Rivoli, Museo d'Arte Contemporanea Collection, Rivoli (Turin), donation by the Regione Piemonte
Directed by: Lina Wertmüller; starring: Franca Valeri, Francesco Vezzoli; produced by: Chiara Bersi Serlini; artistic director: Luca Corbetta; photography: Blasco Giurato; makeup and hairstyling: Gilberto Provenghi; executive production: Intel Film, Rome; filmed in Rome inside the home of Suso Cecchi D'Amico and in a nightclub in Rome in June 1998.

A Love Trilogy – Self-Portrait with Marisa Berenson as Édith Piaf, 1999, video projection, DVD, color, stereo sound, 5'10", edition of 6 and 1 artist's proof, The Museum of Contemporary Art Collection, Los Angeles
Directed by: Francesco Vezzoli; starring: Marisa Berenson, Francesco Vezzoli; produced by: Chiara Bersi Serlini; artistic director: Luca Corbetta; photography: Federico Salsano; makeup

and hairstyling: Gilberto Provenghi; costumes: Archivio Valentino Couture, Rome; executive production: FilmMaster Art, Milan; filmed inside Cerveteri Castle in September 1999

Douglas Sirk, 1999, cotton embroidery on canvas, 32 × 31 cm (framed)

Édith Piaf, 1999, cotton embroidery on canvas, 28 × 20 cm (framed)

Les Parapluies de Cherbourg, 1999, cotton embroidery on canvas, 15.5 × 15.5 cm

The End (teleteatro), 1999, video projection, DVD, color, stereo sound, 4', edition of 6 and 2 artist's proofs Castello di Rivoli, Museo d'Arte Contemporanea Collection, Rivoli (Turin), donation by the Regione Piemonte
Directed by and photography: Carlo di Palma; starring: Valentina Cortese, Francesco Vezzoli; produced by: Chiara Bersi Serlini; artistic director: Luca Corbetta; photography: Carlo Di Palma; makeup and hairstyling: Gilberto Provenghi; filmed inside the home of Valentina Cortese in January 1999

The Life of Silvana Mangano, 1999, laser print on canvas with metallic embroidery, 36 elements, 33 × 43.5 cm ea. (framed)

Vaghe stelle dell'Orsa, 1999, laser print on canvas with metallic embroidery, 3 elements, 47 × 35 cm (framed)

Silvana Mangano as Mary Magdalene, 1999 – 2009, print on canvases and metallic needles, 59 × 49 cm (framed)

Édith Piaf as Marisa Berenson, Marisa Berenson as Édith Piaf, 2000, laser print on canvas with metallic embroidery, 2 elements Ø 24 cm ea., 33 × 43.5 cm (framed)

Édith Piaf in La voix humaine, 2000, laser print on canvas with metallic embroidery, 33 × 43,5 cm (framed)

En Homage à Édith Piaf, 2000, wool embroidery on canvas, 61.5 × 81.5 cm

La caduta degli dei – Embroidering the Tombs of the Artists (André Gide), 2000, laser print on canvas with metallic embroidery, Ø 24 cm, 33 × 43.5 cm (framed)

La caduta degli dei – Embroidering the Tombs of the Artists (Marcel Proust), 2000, laser print on canvas with metallic embroidery, Ø 24 cm, 33 × 43.5 cm (framed)

La caduta degli dei – Embroidering the Tombs of the Artists (Valslav Nijinsky), 2000, laser print on canvas with metallic embroidery, Ø 24 cm, 33 × 43,5 cm (framed)

La caduta degli dei – Embroidering the Tombs of the Artists (Wassily Kandinsky), 2000, laser print on canvas with metallic embroidery, 3 elements, Ø 24 cm, 33 × 43.5 cm (framed)

The Kiss (Let's Play Dynasty!), 2000, video projection, DVD, color, stereo sound, 6', edition of 6 and 1 artist's proof, MAXXI – National Museum of XXI Century Arts Collection, Rome
Directed by: Francesco Vezzoli; starring: Helmut Berger, Francesco Vezzoli; produced by: Chiara Bersi Serlini; artistic director: Luca Corbetta; costumes: Fendi Alta Moda, Rome; executive production: FilmMaster Art, Milan; filmed in Milan in June 2000 inside an apartment with furnishings that belonged to Ludwig II of Bavaria

Il ragazzo che ha freddo (Helmut Berger & Luchino Visconti), 2000 – 2001, laser print on canvas with metallic embroidery, 15 elements, Ø 24 cm 33 × 45.5 cm ea. (framed)

The End of "The Human Voice", 2001, double video projection, DVD, b/w and color, stereo sound, 15', edition of 6 and 2 artist's proofs, Castello di Rivoli, Museo d'Arte Contemporanea Collection, Rivoli (Turin), acquired thanks to the contribution of the Compagnia di San Paolo
Directed by: Francesco Vezzoli; starring: Bianca Jagger, Francesco Vezzoli; produced by: Chiara Bersi Serlini; artistic director: Luca Corbetta; photography: Darius Khondji; executive production: FilmMaster Art, Milan; filmed in London in December 2001 in the royal suite of Hotel Claridge

Gloria Swanson Embroidered Her Own Autograph, 2001, laser print on canvas with metallic embroidery, 62.5 × 50.5 cm

Joan Crawford Embroidered Her Own Tears, 2001, laser print on canvas with metallic embroidery, 9 elements, 35 × 35 cm ea.

Self-Portrait with Vera Lehndorff as Veruschka, 2001, digital print on aluminum, 120 × 125 cm, edition of 6 and 3 artist's proofs

Sunset Boulevard, 2001, cotton embroidery on canvas, 2 elements, 61 × 63 cm ea. (framed)

Embroidering Orpheus: Jean Cocteau through the Eyes of Francesco Vezzoli, 2002, laser print on canvas with metallic embroidery, 2 elements, 61 × 83 cm (framed)

Enamorada, 2002, laser print on canvas with metallic embroidery, 60 × 49 cm (framed)

Framed! (Jean Cocteau Embroidered Tears on the Mask of the Muse), 2002, laser print on canvas with metallic embroidery, 60 × 50 cm (framed)

Francesco by Francesco: Before & After, 2002, gelatin silver print, 2 elements, 61 × 83 cm (framed), edition of 6 and 2 artist's proofs, Acacia Collection

Francesco by Francesco: Before & Ever After, 2002, gelatin silver print, 2 elements, 77 × 59 cm ea. (framed), edition of 6 and 1 artist's proof, Acacia Collection

Francesco by Francesco: Happily More than Ever, 2002, laser print on canvas with metallic embroidery, 2 elements, 64 × 52 cm ea. (framed), Acacia Collection

Francesco by Francesco: Self-Portrait as Halston, 2002, laser print on canvas with metallic embroidery, 2 elements, 61 × 83 cm (framed)

Francesco Vezzoli as Jean Cocteau, 2002, laser print on canvas with metallic embroidery e collage, 51.5 × 44 cm (framed)

Homage à Jean Cocteau: Raymond Radiguet et le poète, 2002, drawing on canvas with metallic embroidery, 2 elements, 64 × 52 cm ea. (framed)

Homage to Francesco Scavullo: Sophia Loren, 2002, laser print on canvas with metallic embroidery, 64 × 52 cm (framed)

Smoking Diva (Mildred Pierce), 2002, cotton embroidery on canvas, 64 × 52 cm (framed)

The Human Voice: Thank You For Calling Me Back, 2002, laser print on canvas with metallic embroidery, 47 × 57 cm (framed)

The Eyes of Queen Cristina, 2002, laser print and watercolor on canvas, embroidered collage and metallic thread, 62 × 51 cm

Francesco by Francesco: Self-Portrait as the Kessler Twins, 2003, laser print on canvas with metallic embroidery, 2 elements, 62 × 83 cm (framed)

After Richard Prince, 2004, laser print with metallic embroidery, 47.6 × 36.2 cm (framed)

Amália Traïda, 2004, video projection, DVD, b/w and color, stereo sound, 10', edition of 2 and 2 artist's proofs, MAXXI – National Museum of XXI Century Arts Collection, Rome
Directed by: Francesco Vezzoli; starring: Sonia Braga with a special appearance by Lauren Bacall; artistic director: Matthias Vriens; artistic producer: Luca Corbetta

Comizi di non amore, 2004, film, DVD, color, stereo sound, 63' 50'', edition of 1 and 1 artist's proof, Fondazione Prada Collection, Milan
Directed by: Stefano Mignucci; starring: Catherine Deneuve, Marianne Faithfull, Antonella Lualdi, Jeanne Moreau and Ela Weber; coordination and artistic supervision: Luca Corbetta; costumes: Luca Sabatelli; produced by: Fondazione Prada; executive production: Einstein Multimedia; filmed in Rome in February 2004 in the Roma Studios of Dinocittà

Fine, 2004, laser print on canvas with metallic embroidery, 45 × 49.5 × 3.5 cm (framed)

La fine di Edipo Re, 2004, silkscreen on canvas with cotton embroidery, 430 × 780 cm, Fondazione Prada Collection, Milan

La regina di Rio (Dancin' Days vs. Amália Traïda), 2004, laser print on canvas with metallic embroidery, 73 × 62 × 5 cm

Le 120 sedute di Sodoma, 2004, laser print on canvas with metallic embroidery, Argyle chairs in wood, 120 elements, 136 × 47 × 48 cm ea., Fondazione Prada Collection, Milan

Caligula Killed Tiberius (Peter O'Toole), 2005, oil on canvas with metallic embroidery, 40 × 29 cm

Flower Arrangement – Homage to Bruce Nauman, 2005, roses, wicker basket, wooden base, b/w prints on aluminum, variable dimensions, edition of 3 and 1 artist's proof, Van Haerents Art Collection, Brussels

Greatest Hits – Milva Canta Bruce Nauman: "Vattene dalla mia mente! Vattene da questa stanza!", 2005, neon sign, sound, laser print on canvas with metallic embroidery, variable dimensions, edition of 3 and 2 artist's proofs

Poster for a remake of Gore Vidal's Caligula, 2005, silkscreen on paper, variable dimensions, edition of 6 and 2 artist's proofs, Castello di Rivoli, Museo d'Arte Contemporanea Collection, Rivoli (Turin)

Trailer for a Remake of Gore Vidal's Caligula, 2005, video projection, DVD, color, stereo sound, variable dimensions, 5' edition of 3 and 2 artist's proofs, Castello di Rivoli, Museo d'Arte Contemporanea Collection, Rivoli (Turin)
Directed by: Francesco Vezzoli; starring: Adriana Asti, Karen Black, Barbara Bouchet, Gerard Butler, Bencio del Toro, Milla Jovovich, Helen Mirren, Glenn Shadix, Tasha Tilberg, special guest stars Gore Vidal and Courtney Love; artistic director: Matthias Vriens; artistic producer: Luca Corbetta; executive production: Joseph Uliano for Crossroads

Films, Inc., Los Angeles; produced by: Keeley Gould; photography: Paul Laufer; costumes: main cast Donatella Versace, costumes by Leesa Evans, costume consultant for main cast Joe McKenna; editing: Greg Harrison; hairstyling: Eva Duarte, Yiotis Panayiotou; makeup: Hebba Thorisdottir, Lisa Storey, Siu ming Carson

All About Anni – Anni vs. Marlene (The Saga Begins), 2006, poster, digital print on glossy paper, variable dimensions

Anni & Marlene in Hollywood – Coming Soon, 2006, poster, digital print on glossy paper, variable dimensions

Anni vs. Marlene (Double Feature), 2006, poster, digital print on glossy paper, 2 elements, variable dimensions

Der Bauhaus Engel – Anni vs. Marlene (The Prequel), 2006, poster, digital print on glossy paper, variable dimensions

Marlene Redux: A True Hollywood Story!, 2006, video projection, DVD, color, stereo sound, 15', variable dimensions, edition of 1 and 1 artist's proof, François Pinault Foundation Collection
Directed by: Francesco Vezzoli; artistic director: Matthias Vriens; artistic producer: Luca Corbetta; editing: Greg Harrison

Self-Portrait as a Movie Poster, 2006, poster, digital print on glossy paper, 3 elements, variable dimensions

Suddenly Last Summer II – The Return Of Sebastian, 2006, poster, variable dimensions

The Return of Bruce Nauman's "Bouncing Balls, 2006, video, color, stereo sound, 8', edition of 3 and 2 artist's proofs
Directed by: Francesco Vezzoli; starring: Brad Rock; in collaboration with Matthias Vriens

Untitled (Marlene Redux: A True Hollywood Story! Part two), 2006 – 2007, Gobelin tapestry, cotton embroidery on wool canvas, metal needle, 300 × 300 cm, François Pinault Foundation Collection

Untitled (Marlene Redux: A True Hollywood Story! Part three), 2006 – 2007, Gobelin tapestry, cotton embroidery on wool canvas, metal needle, 300 × 300 cm, François Pinault Foundation Collection

Untitled (Marlene Redux: A True Hollywood Story! Part four), 2006 – 2007, Gobelin tapestry, cotton embroidery on wool canvas, metal needle, 300 × 300 cm, François Pinault Foundation Collection

Blonde Bauhaus, 2007, poster, digital print on glossy paper, variable dimensions

Emmanuelle, 2007, poster, digital print on glossy paper, variable dimensions

Gigolo, 2007, poster, digital print on glossy paper, variable dimensions

Querelle, 2007, poster, digital print on glossy paper, variable dimensions

Surrealist Portrait of Mae West Crying her Own Autograph (with Anita Ekberg's Eye), 2007, laser print on canvas with metallic embroidery, 54 × 43.5 cm (framed)

The Premiere of a Play That Will Never Run, 2007, poster, inkjet print on glossy paper, variable dimensions

Whatever happened to Baby Francesco, 2007, laserprint on canvas with metallic embroidery, 16 × 12 cm

Surrealiz (Lucio Fontana as Marco Antonio), 2008, inkjet print on canvas with metallic embroidery, paper, 152 × 113 cm

Untitled (La Dolce Vita Featuring René Magritte), 2008, laser print on canvas with metallic embroidery, paper, 160 × 190 cm (framed)

A Place in the Sun, 2009, wool embroidery on canvas, 52 × 72 cm (framed)

Greed, The Perfume That Doesn't Exist, 2009, crystal, paper, ribbon, 40 × 27 × 13 cm, edition of 1 and 2 artist's proofs

Jeu de Paume, Je t'aime! (Advertisement for an Exhibition That Will Never Open), 2009, video, HD, color, stereo sound, 20", edition of 3 and 1 artist proof Directed by: Francesco Vezzoli; starring: Eva Mendes; photography: Pasquale Abbattista; artistic producer: Luca Corbetta; executive production: Max Brun (Hi!Production); original costume from "La Dolce Vita" by Federico Fellini (Consultant: Flora Brancatella)

Poker Face (Self-Portrait with Mother Gaga – after de Chirico) , 2009, inkjet print on canvas, metallic and cotton embroidery, costume jewelry, 82 × 71.5 cm, The Ella Fontanals-Cisneros Collection, Miami

Propa-Ga-Ganda (After Rodchenko), 2009, silkscreen on paper, 2 elements, variable dimensions, edition of 3 and 1 artist's proof

You Don't Have to Watch Dynasty to Have an Attitude (after Gustav Klimt), 2009, cotton embroidery on canvas, metallic embroidery, 39 × 63 cm (framed)

Le gant d'amour (after de Chirico & Jean Genet), 2010, inkjet print on canvas, metallic embroidery, costume jewelry, makeup, paper, 74.5 × 61.5 × 2.5 cm (framed)

Bleeding Portrait of Jean Cocteau as Saint Maurelio (after Cosme' Tura), 2011, print on canvas, metallic embroidery and costume jewelry, 108 × 28 × 5 cm, artist's frame

Bleeding Portrait of Jean Marais as Saint Francesco (after Cosme' Tura), 2011, print on canvas, metallic embroidery and costume jewelry, 105 × 28 × 5 cm artist's frame

Just a Gigolo, 2011, poster, digital print on glossy paper, variable dimensions, edition of 3 and 1 artist's proof

Portrait of the Artist's Mother (after Pinturicchio), 2011, HD Video, 2' 20" ea., edition of 3 and 1 artist's proof Directed by: Francesco Vezzoli; starring: Rosa Maria Guizzi Vezzoli; photography: Pasquale Abbattista; artistic producer: Luca Corbetta; executive production: Max Brun (Hi!Production); costumes: Flora Brancatella; makeup: Stefano Anselmo

Satire of a Satyr, 2011, 19th-c. head in red porphyry, marble plinth, self-portrait in white marble, red quartz plinth, 2 elements, porphyry head and plinth: 46 × 24 × 22 cm, white marble self-portrait and plinth: 44 × 25 × 23 cm, overall dimensions: 46 × 60 × 23 cm, Rennie Collection, Vancouver

Self-Portrait as Apollo del Belvedere's Lover, 2011, marble bust, self-portrait in marble (19th c.), 2 elements 76 × 51 × 50 cm and 85 × 52 × 50 cm

Self-Portrait as Helios vs. Selene by Jean-Léon Gérôme, 2011, marble bust, self-portrait in marble (19th c.), 145 × 145 × 210 cm

Antique not Antique: Self-Portrait as a Crying Roman Togatus, 2012, self-portrait in white marble, marble torso of a togatus, 100 × 45 × 40 cm

Madonna of the Bauhaus, 2012, wooden sculpture (19th c.), wool embroidery on canvas and embroidery loom, 76 × 50 × 36 cm

Self-Portrait as Antinous Loving Emperor Hadrian, 2012, head of Emperor Hadrian in marble, self-portrait as Antinous in Carrara marble, 2 elements, head of Hadrian 40 × 19 × 20 cm, self-portrait 42 × 24 × 21 cm

Self-Portrait as Emperor Hadrian Loving Antinous, 2012, bust of Antinous in Carrara marble (19th c.), self-portrait as Emperor Hadrian in statuary marble, 2 elements, bust of Antinous 46 × 39 × 20 cm; self-portrait as Emperor Hadrian 45 × 45 × 19 cm

Unique forms of continuity in high heels (after Umberto Boccioni), 2012, bronze sculpture, 122 × 90 × 50 cm, edition of 3 and 1 artist's proof

The biography records the artist's exhibitions and prizes from 1997 to 2012. The list of exhibitions is organized in chronological order, including the solo shows (underlined) and group shows, accompanied by indications relating to the catalogue and reviews published on the occasion of each of the events.

Exhibitions

1997

"Fatto in Italia", Geneva, Centre d'Art Contemporain, 24 May – 5 October, exhibition and catalogue curated by P. Colombo, Electa, Milan; traveling to London, The Institute of Contemporary Art, 22 October – 22 December.

1998

"Fast Forward: New Italian Film Makers and Video Artists", Providence, Brown University, 10 – 12 April.

"La coscienza luccicante", Rome, Palazzo delle Esposizioni, 16 September – 30 October, exhibition and catalogue curated by P. Sega Serra Zanetti and M. G. Tolomeo, Gangemi, Rome.

1999

"An Embroidered Trilogy: Francesco Vezzoli", Milan, Galleria Giò Marconi, 19 May – 16 July.

Reviews
P. F. Carvel, *Divine & Divani*, "L'Uomo Vogue", Milan, no. 303 September 1999, p. 59.
D. Curti, *Contraddizioni in bianco e nero*, "viviMilano", suppl. "Corriere della Sera", Milan, 20 November 2002, p. 52.
I. Chapman, *Fontana, Bock e Vezzoli*, "Arte", Milan, no. 311, July 1999, p. 152.
G. Marogna, *Ritratto di fine secolo*, "Elle", Milan, September 1999.
G. Politi, *Gea's Corner*, "Flash Art", Milan, 32, no. 216, June – July 1999, p. 79.
Scatti d'autore in mostra alla galleria Marconi, "vivereMilano", suppl. "La Stampa", Milan, 22 November 2002.
E. Vergani, *E l'artista ricama seduto tra le dive*, "Corriere della Sera", Milan, 30 May 1999, p. 53.
A. Vettese, *In Galleria*, "Il Sole 24 Ore", Milan, no. 139, 23 May 1999, p. 34.

"An Embroidered Trilogy", Rome, The British School at Rome, 25 May – 12 June, exhibition curated by C. Perrella.

Reviews
F. Giuliani, *Un superkolossal in dieci minuti*, "La Repubblica", Rome, 25 May 1999, p. 10.

I ricami ironici di Francesco Vezzoli, "Flash Art", Milan, 32, no. 216, June – July 1999, p. 61.
M. Valì, *Il Praz è giusto. Tra Zanicchi e Valeri gli scherzi di Vezzoli*, "La Stampa", Turin, 7 June 1999, p. 21.

"An Embroidered Trilogy", Bologna, GAM, Galleria d'Arte Moderna, 29 May.

Reviews
B. Torresin, *Tra I fan di Clemente spunta la Zanicchi*, "La Repubblica", Rome, 29 May 1999.

"The passion and the wave. 6th International Istanbul Biennial", Istanbul, Istanbul Biennial, 17 September – 30 October, exhibition and catalogue curated by P. Colombo, Istanbul.

Reviews
C. Perrella, *Video-ossessioni accanto al Bazaar*, "Alias", suppl. "il manifesto", Rome, 2, no. 37, 18 September 1999, p. 6.
L. Vergine, *Biennale di Istanbul. Passioni d'Arte sul Bosforo*, "il manifesto", Rome, 20 October 1999, p. 22.
G. Williams, *6th International Istanbul Biennial*, "Art Monthly", London, no. 232, December 1999 – January 2000, pp. 26 – 27.

"Francesco Vezzoli", London, Anthony d'Offay Gallery, 22 September – 21 October.

Reviews
Francesco Vezzoli: An Embroidered Trilogy – Exhibition, "Entertainment News", London, 20 September 2000.
Francesco Vezzoli: Needlepoint and Video Trilogy, "The Evening Standard", London, 21 September 1999.
Last Chance – Art – Francesco Vezzoli, "The Evening Standard", London, 19 October 1999.

"Omaggi e oltraggi", 1 October – 13 November, Milan, Claudia Gian Ferrari Arte Contemporanea.

"Videodrome", New York, New Museum of Contemporary Art, 22 October – 11 November, exhibition curated by D. Cameron.

"An Embroidered Trilogy", Geneva, Centre d'Art Contemporain, 4 – 21 November, exhibition curated by P. Colombo.

"Exit: International Film & Video", London, Chisenhale Gallery, 4 December – 30 January 2000.

2000

"Art and Facts", Turin, Galleria Franco Noero, 29 February – 29 March, exhibition curated by M. Casadio.

Reviews
G. Curto, *Art and Facts. Franco Noero, Turin*, "Flash Art", Milan, 33, no. 221, April – May 2000, p. 120.

"Francesco Vezzoli. A Love Trilogy – Self-Portrait with Marisa Berenson as Edith Piaf", Bologna, GAM, Galleria d'Arte Moderna, 7 – 30 April, exhibition curated by D. Eccher.

Reviews
G. Bartorelli, *Francesco Vezzoli. Spazio Aperto, GAM*, "Flash Art", Milan, 33, no. 222, June – July 2000, pp. 117 – 118.
P. Naldi, *La Berenson come la Piaf: lo Star System di Vezzoli*, "La Repubblica", Milan, 7 April 2000.

"Group show", London, Anthony d'Offay, 5 May – 3 June.

"Generator", Trevi, Flash Art Museum 21 October – 1 December; traveling to Bologna, Galleria Loretta Cristofori, 27 January – 3 March 2001, exhibition and catalogue curated by G. Politi, Giancarlo Politi Editore, Milan.

"Migrazioni e multiculturalità. Il premio per la giovane arte italiana del Centro nazionale per le Arti Contemporanee 2000", Rome, Centro nazionale per le arti contemporanee, 15 December 2000 – 18 March 2001 exhibition curated by P. Colombo, catalogue curated by A. Mattirolo and S. Pinto, Allemandi, Turin 2001.

Reviews
F. Castelli Gattinara, *Mille metri per l'arte italiana del XXI secolo*, "Vernissage", suppl. "Il Giornale dell'Arte", Turin, 2, no. 12, January, 2001, pp. 14 – 15.
C. Colasanti, *Migrazioni e acquisizioni*, "Flash Art", Milan, 34, no. 226, February – March 2001, p. 74.
C. Corbetta, *Events: Centro di Arte Contemporanea a Roma*, "Vogue Italia", Milan, no. 604, December 2000, p. 36.
C. Piccoli, *Ragazzi da museo*, "D la Repubblica delle Donne" suppl. "La Repubblica", Milan, no. 229, 5 December 2000.
L. Pratesi, *Artisti pionieri del contemporaneo*, "Musica!" suppl. "La Repubblica", Rome, 11 January 2001, pp. 40 – 41.
A. Vettese, *Belle opere in cerca di un curatore*, "Il Sole 24 Ore", Milan, no. 338, 17 December 2000, p. 38.

2001

"Bra mot melankol / Remedy for melancholy", Sollentuna, Edsvik konst och kultur, 3 February – 1 April, exhibition curated by A. Kreuger e E. Stankevicius, catalogue curated by A. Kreuger; traveling to Visby, Baltic Art Center, 7 – 29 April.

Reviews
M. Allerholm, *Art for the heavy-hearted,* "Dagens Nyheter", Stockholm, 10 February 2001.
M. Allerholm, *If the show is to be seen as a cure for something, then it is for the stereotyped notion of the artist as melancholic,* "NU: The Nordic Art Review", Stockholm, vol. 3, no. 2, February 2001.
A. Brodow, *Art that doesn't want to look like art,* "Svenska Dagbladet", Stockholm, 17 February 2001.
J. P. Nilsson, *Som i en skrattspegel (Like in a funny mirror)* "Aftonbladet", Stockholm, 27 February 2001.

"Magic and Loss – Contemporary Italian Video", London, Pandemonium: The London Festival of Moving Images, 2 March – 8 April, exhibition and catalogue curated by R. Davis; traveling to Vilnius, Contemporary Art Centre, 30 March – 15 April.

Reviews
K. Stanciene, *Vaistai nuo liudesio,* "7 meno dienos", Vilnius, 27 July 2001, p. 7.

"SurFace", Lund, Lunds Konsthall, 1 June – 24 August, exhibition and catalogue curated by P. Kyander, Lunds Konsthall – Aura, Lund.

Reviews
L. Kirsebom, *Konsthallen samlar varlden pa ytan,* "Sydsvenskan", Stockholm, 2 June 2001.
S. Olofson, *Upp till ytan i konsthallen,* "Skanska Dagbladet", Stockholm, 2 June 2001.

"Boom! Espresso. Arte oggi in Italia", Florence, Manifattura Tabacchi, 10 June – 20 July, exhibition curated by S. Risaliti.

"Platea dell'Umanità, 49° Esposizione Internazionale d'Arte", Venice, la Biennale di Venezia, 10 June – 4 November, exhibition curated by H. Szeemann, C. Liveriero Lavelli, Electa, Milan.

Reviews
N. Aspesi, *Arte Video e performance, a Venezia trionfa l'eccesso,* "La Repubblica", Rome, 7 June 2001, p. 46.
D. Auregli, *Giovani artisti dai luoghi del dolore,* "il manifesto", Rome, 10 June 2001, p. 12.
R. Ballarin, *La Top Model Veruschka mescola passato e presente,* "Il Gazzettino", Venice, 7 June 2001.
R. Barilli, *Ma Boetti e Rotella avrebbero meritato di più,* "Il Corriere della Sera", Milan, 8 June 2001, p. 37.
D. Birnbaum, *Groans of Venice: More is less,* "Artforum", New York, vol. 40, no. 1, September 2001, pp. 154 – 157.
A. Cenci, *Biennale 2001, la platea è globale,* "il manifesto", Rome, 30 March 2001, p. 13.

F. Fanelli, *Mamma Biennale, morbida e onnivora,* "Vernissage", suppl. "Il Giornale dell'Arte", Turin, 2, no. 18, July – August 2001, pp. 4 – 5.
A. Freyberg, *Arty Party People,* "The Evening Standard", London, 8 June 2001.
L. Goldstein, *Venice: The Fashion of Art,* "Time", New York, vol. 157, no. 24, 18 June 2001.
H. N. Jocks, *Alles, was zum Menschsein gehort,* "Kunstforum International", Cologne, no. 156, August – October 2001, pp. 47 – 73.
F. Minervino, *La Biennale e le tartarughe,* "La Stampa", Turin, 6 June 2001, p. 27.
MG. Minetti, *Cartoline della Biennale,* "Specchio", suppl. "La Stampa", no. 280, Turin, 23 June 2001, pp. 74 – 87.
F. Poli, *La geografia artistica di Harald Szeemann,* "il manifesto", Rome, 10 June 2001, p. 12.
P. Pollo, *Veruschka 30 anni dopo: stesso abito, stessa foto,* "Corriere della Sera", Milan, 4 June 2001, p. 21.
M. Pratesi, *KRAK! Riflessioni in margine alle 49° Biennale veneziana ed oltre,* "Erba d'Arno", Fucecchio – Florence, nos. 84 – 85, September 2001.
G. Scardi, *Ma lieve riemerge il Classico,* "Il Sole 24 Ore", Milan, 10 June 2001, p. XII.
W. Trager, *Biennale Venedig – Plateau der Menschheit,* "Kunstforum International", no. 156, Cologne, August – October 2001, pp. 74 – 173.
M. Vallora, *L'arte è una tela di Penelope,* "La Stampa", Turin, 10 June 2001, p. 23.
M. Vallora, *L'uomo in mostra,* "Specchio", suppl. "La Stampa", Turin, no. 277, 2 June 2001, pp. 100 – 104.
S. Vendrame, *A bridge towards the future,* "Tema Celeste", Milan, no. 86, Summer 2001, pp. 44 – 49.
A. Vettese, *La mensola della globalità,* "Il Sole 24 Ore", Milan, 10 June 2001, p. XII.
A. Vettese, *I giovani artisti italiani alla 49° Biennale di Venezia,* "Vernissage", suppl. "Il Giornale dell'Arte", 2, no. 17, Turin, June 2001, n. pag.
A. Vettese, *Venezia: Platea dell'Umanità,* "Abitare", Milan, no. 409, September 2001, pp. 171 – 178.
C. Vogel, *The Art World Returns to Venice, Dipping en Masse Into Nostalgia,* "The New York Times", New York, 14 June 2001, p. E1.
A. Zordan, *Sopravvivere alla Biennale,* "Marie Claire", Milan, no. 8, August 2001.

"Squatters", Porto, Fundação Serralves, 23 June – 16 September, exhibition curated by various authors, catalogue, Porto; traveling to Rotterdam, Witte de With, Center for Contemporary Art, 15 July – December.

Reviews
M. Beccaria, *Fragmentos de um discurso amoroso,* "Glamour. Arte e Seduzida e Sedutora", Museu de Arte Contemporânea de Serralves – Jornal Pùblico, Porto, no. 3.
P. Emerenciano, *A cidade,* "Pùblico", Lisbon, 14 July 2001.

L. Marinho, *A arte està na rua,* "Comércio do Porto", Porto, 23 June 2001.
Ocupacoes nas ruas do Porto, "Blitz", Lisbon, 21 August 2001.
B. Ulmer, *Substância màgica,* "Glamour. Arte e Seduzida e Sedutora", Museu de Arte. Contemporânea de Serralves – Jornal Pùblico, Porto, no. 3.

"Haraldur Jònsson, Annika Strom, Francesco Vezzoli", Vilnius, Contemporary Art Centre, Vilnius, 5 July – 19 August, exhibition curated by A. Kreuger and E. Stankevicius.

"Generator 3", Lucca, Baluardo di San Regolo, Giardino Botanico, 7 – 29 July.

"The 1st Tirana Biennial. Escape", Tirana, National Gallery and Chinese Pavillion, 15 September – 15 October, exhibition curated by H. Kontova, catalogue, Giancarlo Politi Editore, Milan.

Reviews
M. Casadio, *Elsewhere. La Biennale di Tirana Sett. 01,* "Vogue Italia", Milan, no. 615, November 2001.

"A Sense of Wellbeing. Loss, History and Desires", Karlovy Vary, Bagni reali, 22 October – 18 November, exhibition curated by M. Scotini.

"East Wing Collection n. 5", London, Courtauld Institute of art, 9 November 2001 – 9 September 2002, exhibition curated by C. Chaffee.

2002

"Francesco Vezzoli", Rivoli, Castello di Rivoli, Museo d'arte contemporanea, 30 January – 5 May, exhibition and catalogue curated by M. Beccaria, Castello di Rivoli, Rivoli.

Reviews
G. S. Brizio, *Vezzoli a Rivoli,* "Arte e Critica", Rome, no. 29, January – March 2002, p. 47.
L. Buck, *Turds for the Turner,* "The Art Newspaper", London, no. 121, January 2002.
M. V. Capitanucci, *Contemporanea per tre,* "Costruire", Milan, no. 226, March 2002.
S. Casciani, *Review Arte o vita? Shirin Neshat, Francesco Vezzoli,* "Domus", Milan, no. 847, April 2002, pp. 20 – 23.
G. Celant, *Bellezze a ricamo,* "L'Espresso", Rome, a. XLVIII, no. 12, 21 March 2002, p. 127.
C. Corbetta, *A Rivoli con Vezzoli e Neshat,* "Grazia", Milan, no. 9, 5 March 2002, p. 130.
C. Corbetta, *Mostre. Il reale quotidiano,* "Vogue Italia", Milan, no. 619, March 2002, p. 54.
G. Curto, *Shirin & Francesco. Rivoli: l'iraniana Neshat con l'italiano Vezzoli,* "TorinoSette", suppl. "La Stampa", Turin, no. 672, 25 January 2002.
Castello di Rivoli update, "Tema Celeste", Milan, January – February 2002, no. 89, p. 119.
Da Arianna a Penelope. A lezione di

tessitura, "Mood. Lo spirito delle cose",
Milan, no. 30, 20 March 2002.
A. Detheridge, *Autentiche ambiguità,*
"Il Sole 24 Ore", Milan, no. 32, 3 February
2002, p. 40.
*...e la video-arte "ricamata" di Francesco
Vezzoli",* "Stile arte", Brescia, no. 55,
February 2002, p. 36.
F. Fanelli, *Dora Maar piange al telefono,*
"Vernissage" (cover), suppl. "Il Giornale
dell'Arte", Turin, 3, no. 25, March 2002,
pp. 4 – 5.
Francesco Vezzoli, "Flash Art
International", Milan, vol. 34, no. 223,
March – April 2002, p. 43.
Francesco Vezzoli, "InformaGiovani",
Turin, no. 1, January – February 2002.
*I cast della Neshat, i set di Tillmans, il jet-
set di Vezzoli,* "Il Giornale dell'Arte", Turin,
18, no. 206, January 2002, p. 20.
In tre a Rivoli, "L'Arca", Milan, no. 168,
March 2002, p. 101.
C. Leoni, *Shirin Neshat, Wolfgang Tillmans,
Francesco Vezzoli,* "Flash Art", Milan, 35,
no. 233, April – May 2002, pp. 106 – 107.
P. Levi, *Arte al Castello. Due sguardi
giovani protagonisti al Rivoli,*
"La Repubblica", Turin, 30 January 2002, p. 8.
A. Mi., *L'artista iraniana e la condizione
della donna,* "La Stampa", Turin, no. 25,
27 January 2002, p. 44.
R. Moliterni, *Vezzoli, una lacrima sul video,*
"La Stampa", Turin, no. 25, 27 January
2002, p. 23.
*Nuove mostre a Rivoli: Neshat +
Vezzoli,* "Città informa", Turin, 3, no. 3,
January – February 2002.
A. Oberti, *Video-installazioni tra realtà e
immaginario,* "Corriere dell'Arte", Turin,
9 February 2002.
F. Pasini, *Francesco Vezzoli, Castello di
Rivoli,* "Artforum", New York, vol. 40, no. 8,
April 2002, p. 143.
C. Perrella, *Dive e Icone ricamate in
videoclip,* "il manifesto", Rome, 1 February
2002, p. 15.
Rivoli, "Segno", Pescara, no. 182,
January – February 2002, p. 9.
M. Rossi, *Dettagli di mondo,* "Gulliver",
Milan, no. 2, February 2002.
M. Salvati, *Il linguaggio multimediale,*
"Il Corriere di Turin", Turin, 21, no. 2,
February 2002.
Shirin Neshat e Francesco Vezzoli,
"TorinoSette", suppl. "La Stampa", Turin,
no. 673, 1 February 2002, p. 55.
L. Vergine, *Come essere divertenti e
strazianti,* "Corriere delle Sera", Milan,
28 January 2002, p. 23.
G. Verzotti, *Francesco Vezzoli,* "Tema
Celeste", Milan, no. 90, March – April 2002,
pp. 44 – 47.
P. Ziegler, *Vive le Star. Glamour heute,*
"Frame. The State of the Art", Vienna,
no. 10, January – March 2002.

"The Films of Francesco Vezzoli",
New York, New Museum of
Contemporary Art, 12 February –
21 April, exhibition curated by
D. Cameron.

Reviews
N. Cobolli Gigli, *Giovani Italiani all'estero.
E l'ora del Made in Italy,* "Arte", Milan,
no. 345, May 2002, pp. 72 – 79.
M. Dailey, *Preview. U. S. Shorts,* "Artforum",
New York, vol. 40, no. 5, January 2002, p. 50.
M. Gioni, *New York Cut Up,* "Flash Art
International", Milan, vol. 34, no. 224,
May – June 2002, pp. 77 – 80.
M. Gioni, *New York Cut Up,* "Flash Art",
Milan, vol. 35, no. 233, May – June 2002,
pp. 100 – 104.
D. Rimanelli, *Francesco Vezzoli, New
Museum of Contemporary Art. New York,*
"Artforum", New York, vol. 40, no. 9,
May 2002, p. 176.
E. Schambelan, *Review of exhibitions:
Francesco Vezzoli at the New Museum,*
"Art in America", New York, no. 9,
September 2002, pp. 135 – 136.
R. Smith, *Art in Review; The films
of Francesco Vezzoli,* "The New York
Times", New York, 12 April 2002, p. E36.

"De Gustibus. Collezione privata
italiana", Siena, Palazzo delle Papesse,
Centro per l'arte contemporanea,
2 March – 12 May, exhibition and
catalogue curated by A. Bonito Oliva
and S. Risaliti, M & M, Pistoia.

Reviews
M. Chini, *De Gustibus,* "Flash Art", Milan,
35, no. 233, April – May 2002, p. 119.

"Camp Vampy Tacky", Rennes,
La Criée Centre d'Art Contemporain,
21 March – 27 April, exhibition curated
by A. Buffard and L. Frogier.

Reviews
Confusions subversives, "Mouvement",
Paris, no. 16, April – June 2002.
J. Lavrador, *Camping Creatures,*
"Les Inrockuptibles", Paris, no. 334,
17 – 23 April 2002, p. 87.
J. Philippe, *Campy Vampy Tacky,*
"Bug-Rennet", Rennes, 21 March 2002.

"Primavera Forward", New York,
Chanel, 12 – 25 April.

"Melodrama", Vitoria – Gasteiz,
Artium, Centro – Museo Vasco de
Arte Contemporaneo, 26 April –
22 September, exhibition curated
by M. Mascher and D. LeVitte Harten,
catalogue, Artium, Vitoria Gasteiz;
traveling to Granada, Centro José
Guerrero, Diputacion de Granada,
18 October 2002 – 19 January
2003, Vigo, MARCO, Museo
de Arte Contemporanea de Vigo,
22 March – 22 June 2003.

"Penetration", New York, Friedrich
Petzel and Marianne Boesky Gallery,
6 June – 15 August, exhibition curated
by M. Fletcher.

"Ouverture... arte dall'Italia",
Monfalcone, Galleria Comunale d'Arte

Contemporanea, 15 June – 28 July,
exhibition and catalogue curated by
A. Bruciati, Galleria Comunale d'Arte
Contemporanea, Monfalcone.

"Opening Show", Rome, Galleria
Roma Roma Roma, 20 June – 3 August,
exhibition curated by G. Brown,
F. Noero and T. Webster.

"The Needleworks of Francesco
Vezzoli. Blinky Palermo award of
the East German Savings Bank
Foundation for the Free State of
Saxony", Leipzig, Galerie fur
Zeitgenössische Kunst, 23 June –
22 September, exhibition and
catalogue curated by J. Winkelmann,
Hatje Cantz Publishers, Leipzig.

Reviews
S. von Altmann, *Gott, wie glamourös,*
"Kreuzer das leipziger Stadtmagazin",
no. 7, July 2002.
Beeindruckende videoinstallation,
"Victor's Das Magazin", no. 4, Winter
2001 – 2002.
G. Boriani, *Andy Warhol e Francesco
Vezzoli,* "Tema Celeste", Milan, no. 92,
July – August 2002, p. 119.
D. Eichler, *Francesco Vezzoli. Galerie für
Zeitgenössische Kunst, Leipzig,* "Frieze",
London, no. 71, November – December
2002, pp. 98 – 99.
P. Guth, *Prophetische Kommentare
zum aktuellen Kultur-Klima,* "Leipziger
Volkszeitung", 24 June 2002.
P. Guth, *Meister der salonfähigen
Oberfläche,* "Leipziger Volkszeitung",
29 June 2002.

"Verso il Futuro. Identità nell'arte
italiana 1990 – 2002", Rome, Museo
del Corso, 26 June – 25 August,
exhibition curated by C. D'Orazio
and L. Pratesi, Charta, Milan.

Reviews
E. Sassi, *Il futuro in un decennio,* "Corriere
della Sera", Rome, 2 July 2002, p. 53.
M. R. Sossai, *Verso il Futuro.* "Flash Art",
Milan, 35, no. 236, October – November
2002, p. 118.

"Disturb", Idra, 1st Public School of
Hydra, 7 July 2002 – 15 January 2003,
exhibition and catalogue curated
by D. Antonitsis, Idra.

"Second Liverpool Biennial of
Contemporary Art", Liverpool,
14 September – 24 November,
exhibition curated by C. Grunenberg,
catalogue curated by various authors,
Liverpool Biennial of Contemporary
Art, Liverpool.

Reviews
P. Bonaventura, *Visual Arts: A tricky
jigsaw that forms a bigger picture,*
"The Financial Times", London,
13 September 2002.

T. Godfrey, *Liverpool Biennial,*
"The Burlington Magazine", London,
vol. 144, no. 1196, November 2002,
pp. 701–703.
R. Haynes, *What a show!,* "The Big Issue",
London, September 2002.
News & Around: Biennale di Liverpool,
"Tema Celeste", Milan, no. 93, September
2002, pp. 117–118.
A. Paudice, *Events: Prove di dialogo tra
artisti e città, La Biennale di Liverpool,*
"Vogue Italia", Milan, no. 625, Milan,
September 2002.
A. Searle, *Spin City: Terrorism,
celebrity culture, the legacy of empire.
The Liverpool Biennial takes on all
the big issues,* "The Guardian", London,
19 September 2002.

"Premio del Golfo. Biennale Europea
Arti Visive 2002", La Spezia, Palazzo
dello Sport, 21 September–
20 October, exhibition and catalogue
curated by B. Corà, Maschietto
& Musolino, Montecatini Terme

"Ipotesi di Collezione", Rome,
MACRO–Museo d'Arte
Contemporanea, 11 October–
11 January 2003, exhibition curated
by D. Eccher.

Reviews
M. Codognato, *Ipotesi di grandezza per
un neo-museo,* "Il Sole 24 Ore", Milan,
no. 328, 1 December 2002, p. 40.
F. Giuliani, *La casa dell'arte
contemporanea,* "La Repubblica", Rome,
11 October 2002, p. 9.

"East Wing Collection No. 5", London,
Courtauld Institute of Art Gallery,
Somerset House, Strand, 9 November
2002–9 September 2003, exhibition
and catalogue curated by C. Chaffee,
Courtauld Institute of Art, Somerset
House, Strand, London.

Reviews
A. Searle, *I'll get my jacket,* "The Guardian",
London, 18 November 2003, p. 10.

"VideoZone. The 1st International
Video-Art Biennial in Israel,"Tel Aviv,
Center for Contemporary Art,
20–26 November, catalogue curated
by S. Edelsztein and Tal Yahas,
Center for Contemporary Art, Tel Aviv.

"Francesco by Francesco:
A collaboration with Francesco
Scavullo", Milan, Galleria Giò Marconi,
21 November 2002–31 January 2003.

Reviews
L. Beatrice, *Robert Mapplethorpe,
Helmut Newton, Francesco Vezzoli,* "Flash
Art", Milan, 36, no. 238, February–March
2003, pp. 140–141.
F. Bonazzi, *Events: Milano in
tasca,* "Vogue Italia", Milan, no. 630,
February 2003, p. 80.

P. Manazza, *Le donne e i paesaggi
del maestro Newton,* "Corriere Economia",
suppl. "Corriere della Sera", Milan,
25 November 2002.
A. Masoero, *Vernissage: Mapplethorpe,
Newton, Vezzoli,* "Panorama", Rome, XL,
no. 48, 28 November 2002, p. 260.
A. d. Masoero, *Le tre grazie della
fotografia,* "Vernissage", suppl.
"Il Giornale dell'Arte", Turin, 3, no. 33,
December 2002, p. 21.
R. Mutti, *Mapplethorpe, Newton e
Vezzoli: i "big" da Marconi,* "TuttoMilano",
suppl. "La Repubblica", Milan, no. 310,
21 November 2002.
P. Nicolin, *Le donne di Newton,*
"La Repubblica", Milan, 21 November
2002, p. 16.
C. Piccoli, *Sinfonia in nudo,*
"D la Repubblica delle Donne", suppl.
"La Repubblica", Milan, no. 327,
23 November 2002.
G. Salvaggiulo, *Donne nude, paesaggi
e make up. Tre fotografi, tre idee
di bellezza,* "vivereMilano", suppl.
"La Stampa", Milan, 23 November 2002.
C. Vanzetto, *Tre obiettivi sul
corpo,* "Corriere della Sera", Milan,
21 November 2002.
L. Vergine, *Il fascino del feticcio sta
proprio nel ricamo,* "Corriere della Sera",
Milan, 25 November 2002, p. 25.

2003

"Il racconto del filo. Ricamo e cucito
nell'arte contemporanea", Rovereto,
MART, – Museo di Arte Moderna
e Contemporanea di Trento
e Rovereto, 30 May–7 September,
exhibition and catalogue curated by
F. Pasini and G. Verzotti, Skira, Milan.

Reviews
S. Brunetti, *Francesco Vezzoli,* "Juliet", Milan,
no. 114, October–November 2003, p. 50.
L. Cherubini, *Ago e filo per la trama della
vita,* "Il Giornale", Milan, 2 June 2003, p. 24.
*Il racconto del filo: ricamo e cucito
nell'arte contemporanea,* "DIECIeLode",
September 2003, pp. 62–63.
A. Masoero, *Vernissage: Il racconto
del filo e Melotti,* "Panorama", Rome,
XLI, no. 23, 5 June 2003, p. 192.
F. Pasini, *Il racconto del filo,* "Linus",
June 2003, p. 76.
L. Pratesi, *E Vezzoli fece il punto
su Depero,* "il Venerdì", suppl.
"La Repubblica", Rome, 30 May 2003.
L. Vergine, *Smarginate d'artista,* "Alias",
suppl. "il manifesto", Rome, 6, no. 25,
21 June 2003, p. 22.
A. Vettese, *Dare agli artisti del filo da
torcere,* "Il Sole 24 Ore", Milan, no. 142,
25 May 2003, p. 36.
C. Visconti, *Per filo e per segno,*
"Il Giornale dell'Arte", Turin, 20, no. 221,
May 2003, p. 24.
G. Zoppello, *Uno chalet con cupola,*
"l'Adige", Trento, 22 May 2003.
B. Zorzi, *Casetta di Heidi? Macché,*

è un'opera d'arte, "l'Adige", Trento,
23 May 2003.

"Carte blanche à Philippe Terrie-
Hermann", Paris, La fémis, école
nationale supérieure des métiers de
l'image et du son, Centre national des
arts plastiques, 25 June, exhibition
curated by P. Terrier-Herman.

"Black Box", Edinburgh, International
Film Festival, 1 August–7 September,
exhibition curated by S. Danielsen
and S. Dunn.

"New Space! Group Show!,
Turin, Galleria Franco Noero,
18 September–18 October.

"Fantastic Prophecy", Utrecht,
BAK, basis voor actuele kunst;
Academiegalerie, 1 November–
14 December, exhibition curated
by A. Fletcher and L. Psibilskis.

"Progetto video", Bari, Sala Murat,
4 November–14 December, exhibition
curated by M. R. Sossai.

2004

"L'arte in testa. Storia di
un'ossessione da Picasso oltre
il duemila", Isernia, MACI–Museo
di Arte Contemporanea, 12 March–
6 June, exhibition and catalogue
curated by L. Beatrice, MACI, Isernia.

"Francesco Vezzoli", Milan,
Fondazione Prada, 25 March–
16 May, catalogue curated by
G. Celant, Fondazione Prada, Milan.

Reviews
R. Allegretti, *Francesco Vezzoli,*
"Espoarte", May–June 2004, pp. 40–41.
G. Amadasi, *L'arte è un reality
show,* "Grazia", Milan, 13 April 2004,
pp. 109–112.
G. Amadasi, *Francesco Vezzoli,* "Marie
Claire", Milan, May 2004.
L. Beatrice, *Francesco Vezzoli,* "Flash
Art", Milan, 37, no. 246, June–July 2004,
p. 126.
D. Bellini, *Vezzoli sceglie di chiudere la
trilogia della morte di Pasolini con 120
sedie Mackintosh,* "Il Riformista", Rome,
30 April 2004.
M. Belpoliti, *Mie divine al tombolo,* "Alias",
suppl. "il manifesto", Rome, 7, no. 21,
22 May 2004, p. 20.
F. Bonazzoli, *Quattro divine per un'opera-
show,* "Corriere della Sera", Milan,
26 March 2004, p. 54.
P. Calcagno, *Gioco delle coppie tra le
attrici, è il reality show di Prada,* "Il Tempo",
Rome, LXI, no. 86, 27 March 2004, p. 19.
G. Celant, *Francesco Vezzoli,* "Interview",
May 2004, pp. 62–64.
S. Conti, *Reality Bites,* "W Magazine",
New York, May 2004.

C. Corbetta, *Le regole del gioco*, "Domus", Milan, no. 869, April 2004, pp. 68–71.
C. Corbetta, *Francesco Vezzoli*, "Boiler Magazine", Milan, no. 5, 2005, special issue "Viva Italia!", pp. 22–33.
M. Corgnati, *Un reality show con la Deneuve. Ecco l'ultima sorpresa di Prada*, "La Repubblica", Milan, 26 March 2004, p. 9.
E. del Drago, *Francesco Vezzoli picture show*, "Luna", April 2004.
N. Dolfo, *Donne e ricami in un reality show*, "Brescia Oggi", Brescia, 25 March 2004.
A. Filippi, *I "Comizi" secondo Vezzoli*, "Giornale di Sicilia", 27 March 2004, p. 41.
Fondazione Prada, "Vogue Hellas", Greece, March 2004, pp. 3–4.
Francesco Vezzoli da Prada, "Interni", April 2004.
S. Francia, *Mecenatismo moderno*, "Fashion", 30 April 2004, pp. 52–54.
A. Frish, *Francesco Vezzoli Pasolini Reloaded*, "Style & The Family Tunes", 1 April, pp. 120–121.
A. Frisch, *Francesco Vezzoli*, "Flash Art", Milan, no. 236, May–June 2004 pp. 102–104.
A. Frisch, *Francesco Vezzoli*, "Flash Art International", Milan, May–June 2004, pp. 95–99.
R. Ghezzi, *I ricami del cinema*, "ViviMilano", Milan, 24 March 2004.
F. Giuliani, *Un Bresciano a Milano con tutte le lacrime del mondo*, "Dipende–Giornale del Garda" May 2004.
F. Lor., *Reality show d'artista tra dive e lacrime all'uncinetto*, "Giornale di Brescia", 27 March 2004.
A. Mammì, *Pasolini reality show*, "L'Espresso", Rome, L, no. 10, 11 March 2004, pp. 123–125.
G. Maraniello, *Francesco Vezzoli. Fondation Prada*, "Artpress", Paris, no. 300, April 2004, pp. 72–73.
H. Marsala, *Francesco Vezzoli*, "Exibart. On paper", Florence, May 2004, p. 37.
J. J. Martin, *Miuccia: Reality TV's Latest Fan*, "Fashion Week Daily", 30 March 2004.
S. Menegoi, *Vezzoli, dai salotti a Salò*, "Il Giornale dell'Arte", Turin, XX, no. 230, March 2004, p. 23.
Milan: Prada Foundation, "Contemporary", no. 61, 2004, p. 62.
F. Molinari, *A Milano*, "La ceramica moderna & antica", April–May 2004.
F. Montoneri, *La realtà è un reality show*, "Panorama", Rome, XLII, no. 18, 29 April 2004, p. 217.
R. Moratto, *Ispirato a Pier Paolo Pasolini*, "Arte e Critica", Rome, no. 38, April–June 2004, p. 52.
H. Muschamp, *Planet Prada*, "New York Times Magazine", New York, 11 April 2004, pp. 45–51.
Needlework, "V Magazine", New York, Spring 2004.
F. Pasini, *Vezzoli, ora i Comizi sono "di non amore"*, "L'Unità", Rome, 18 April 2004, p. 25.
F. Pasini, *Far girare il pensiero*, "Linus", May 2004, pp. 100–104.
F. Pasini, *Francesco Vezzoli. Fondazione*

Prada, Milan/Milano, "Tema Celeste", Milan, no. 104, July–August 2004, p. 87.
F. Poletti, *Fondazione Prada: ricami ad arte di Francesco Vezzoli*, "Glasses and fashion" May 2004.
M. Ravasio, *Voto e magari ti sposo. Ma solo in diretta tv*, "Gulliver" May 2004.
E. Renard, *Pasolini contre Berlusconi*, "Mixte", Paris, April 2004.
M. Sciaccaluga, *Francesco Vezzoli: Così è (se vi pare)*, "Arte", May 2004, pp. 92–100.
S. Sherwin, *Stangers When We Meet*, "I-D The Drama Queen Issue", May 2004 pp. 126–131.
L. Sotis, *Deneuve, La Bella del reality show*, "Corriere della Sera", Milan, 25 March 2004, p. 7.
A. Subotnick, *Sew Business*, "Art Review", New York, LIV, April 2004, pp. 78–83.
Top five di Francesco Vezzoli, " Carnet Arte", June–July 2004.
A. Trabucco, *Francesco Vezzoli*, "Segno", Pescara, 29, no. 196, May–June 2004, pp. 44–45.
E. Troncy, *TV Art Show*, "Numéro", no. 52, 1 April 2004, p. 30; 44–51.
P. Vagheggi, *Quei ricami ispirati a Pasolini*, "La Repubblica", Rome, 22 March 2004, p. 32.
M. Vallora, *Jeanne Moreau e la Deneuve per il reality show pasoliniano*, "La Stampa", Turin, 26 March 2004, p. 25.
G. Verzotti, *Francesco Vezzoli. Fondazione Prada*, "Artforum", New York, vol. XLIII, no. 1, September 2004, pp. 279–280.
A. Vettese, *Piangere per troppa fama*, "Il Sole 24 Ore", Milan, no. 107, 18 April 2004, p. 44.
Vezzoli sfida la trash tv, "Carnet Arte", April–May 2004.
Vezzoli, "Monopol", April–May 2004.

"Lucio Fontana", Burgdorf, Museum Franz Gertsch, 8 April–27 June.

"Angelo Filomeno, Simon Periton, Philip Taaffe, Francesco Vezzoli", New York, Gorney Bravin + Lee, 25 June–30 July.

"Untitled (As Yet), The Yugoslav Biennial of Young Artists", Belgrade; Vrac, Konkordija Cultural Centre, 9 July–5 August, exhibition curated by S. Mitrovic, A. Nikitovic and J. Vesic, catalogue curated by J. Vesic, Belgrado.

"58th Edinburgh International Film Festival", Edinburgh, 13–24 August.

"The Future Has a Silver Lining. Genealogies of Glamour", Zurich, Migros Museum für Gegenwartskunst, 28 August–31 October, exhibition and catalogue curated by T. Holert and H. Munder, JRP|Ringier, Zurich.

Reviews
T. Zolghadr, *The Future Has a Silver*

Lining. Migros Museum, Zurich, Switzerland, "Frieze", London, no. 87, November–December 2004, p. 108.

"Nachtelijke uitspattingen / Nocturnal Emission", Groningen, Groninger Museum, 25 September– 21 November.

"26a Bienal Internacional de São Paulo", San Paolo, Parque do Ibirapuera, 26 September– 19 December, catalogue, San Paolo.

"Nuit Blanche", Paris, Hôpital Cochin–Port Royal Chapter House, 2 October, exhibition curated by G. Maraniello.

"Fantastic Prophecy", Utrecht, BAK, basic voor actuele kunst, Academiegalerie, 1 November– 14 December.

"Experiments with Truth", Philadelphia, FWM, The Fabric Workshop and Museum, 4 December–12 March 2005, exhibition and catalogue curated by M. Nash, Philadelphia.

2005

"Francesco Vezzoli", Porto, Museu de Arte Contemporânea de Serralves, 22 January–10 April, exhibition curated by J. Fernandes.

Reviews
Amália traída de F. Vezzoli, "JN–Edição Norte", 25 January 2005, p. 44.
Amália traída, "Vogue Portugal", 1 March 2005, p. 73.
J. Brandão, *O papel das "divas" na sociedade*, "Primeiro de Janeiro", Rio de Janero, 24 January 2005, p. 15.
M. Cruz, *Do vídeodramatismo de Vezzoli ao "olho-tela" de Raoul de Keyser*, "DN–Edição Norte", Lisbon, 22 January 2005, p. 40.
O. Fabia, *Lágrimas glamorosas*, "Público", 22 January 2005, p. 18 .
Francesco Vezzoli, "Guia do Lazer", Lisbon, 20 January 2005, pp. 6–7.
J. M. Gaspar, *"Foi muito fácil chorar Amália,* " JN–Edição Centro", 22 January 2005, pp. 46–48.
L. Marinho, *"O trabalho do artista deve ser sempre revolucionário"*, "Cómercio do Porto", Lisbon, 22 January 2005, pp. 43–44.
H. Osório, *Vidas para além da vida*, "Visão", 20 January 2005, p. 20.
Sonia Braga encarnará a Amalia Rodrigues en un vídeo biográfico, "El Dia de Toledo", Toledo, 23 January 2005, p. 106.
Sonia Braga interpretará a Amalia Rodrigues en un vídeo biográfico, "El Diario Mobtanés", 24 January 2005, p. 54.

"Lo sguardo italiano. Fotografie
italiane di moda dal 1951 ad oggi",
Milano, Rotonda di via Besana,
25 January – 20 March, exhibition and
catalogue curated by M. L. Frisa with
F. Bonami and A. Mattirolo, Charta, Milan.

"African Queen", New York,
The Studio Museum in Harlem,
26 January – 27 March, exhibition
curated by various authors.

"Fuori tema. Italian Feeling".
XIV Quadriennale di Roma, Rome,
GNAM – Galleria Nazionale d'Arte
Moderna, 9 March – 31 May,
exhibition curated by L. M. Barbero
with M. Tonelli, catalogue, Electa, Milan.

"Contrabandistas de Imagénes:
Selecciòn de la 26° Bienal
de São Paulo", Santiago del Cile,
Espacio Quinta Normal, MAC –
Museo de Arte Contemporáneo,
31 March – 29 May, exhibition curated
by A. Hug, catalogue, Museo de Arte
Contemporáneo, Santiago del Cile.

"Expanded Painting. Prague
biennale 2", Prague, 26 May –
15 September, exhibition curated by
H. Kontova and G. Politi, catalogue,
Giancarlo Politi Editore, Milan.

"Chronos. Il tempo nell'arte dall'epoca
barocca all'età contemporanea",
Caraglio – Cuneo, CeSAC – Centro
sperimentale per le arti
contemporanee, 28 May – 9 October,
exhibition curated by A. Busto,
A. Cottino, F. Poli, catalogue curated
by A. Busto, Marcovaldo, Caraglio.

"Francesco Vezzoli – Trilogia della
Morte", Venice, Fondazione Giorgio
Cini, 9 June – 8 September, exhibition
curated by G. Celant.

Reviews
F. Bonazzoli, E alla Biennale di Venezia
porta Francesco Vezzoli, "Corriere della
Sera", Milan, 10 June 2005, p. 57.
E. Brocardo, Caligola A volte ritorna,
"Vanity Fair", 23 June 2005, pp. 108 – 110.
M. C., Protegidos por la moda, "Vogue
España", November 2005.
R. Conti, Francesco Vezzoli, "Pelle no
Leather", June 2005 , pp. 38 – 39.
C. Corbetta, Il Caligola di Vezzoli,
"Domus", Milan, no. 882, June 2005,
pp. 38 – 39.
Trilogia della Morte Francesco Vezzoli alla
Fondazione Cini, "Venice Foundation",
June 2005, pp. 8 – 9.
Vezzoli rilegge Pasolini nella trilogia,
"La Prealpina", 22 May 2005.
C. Walden, Venice Spy, "The Daily
Telegraph", 14 June 2005.

"L'esperienza dell'arte", LI Esposizione
Internazionale d'Arte, Venice,
La Biennale di Venezia, 12 June –
6 November, exhibition curated by M. De
Corral, catalogue, Marsilio, Venice.

Reviews
L. Barber, Anyone for Venice?,
"The Observer", London, 19 June 2005.
S. Bucci, La Biennale femminista riscopre
Caligola,"Corriere della Sera", Milan,
25 May 2005, p. 35.
S. Bucci, Venezia, alla Biennale l'arte
è anche politica, "Corriere della Sera",
Milan, 9 June 2005, p. 37.
P. Chessa, Biennale. E sulla laguna l'arte
si fece piccola, "Panorama", Rome, XLIII,
no. 25, 23 June 2005.
M. Cicogna, Come è allegra Venezia,
"Vanity Fair", Milan, no. 25, 30 June 2005.
R. Dorment, The Star Pavilions, "The Daily
Telegraph", London, 15 June 2005.
F. Fanelli, L'esperienza dell'arte nel
Padiglione Italia, "Vernissage", suppl.
"Il Giornale dell'Arte", Turin, 6, no. 62,
July – August 2005, pp. 10 – 13.
A. M. Gingeras, Stealing the Show,
"Artforum", New York, vol. 44, no. 1,
September 2005, pp. 265 – 268.
C. Higgins, Venice Diary, "The Guardian",
London, 11 June 2005.
C. Iles, Venice Bienniale 2005, "Frieze",
London, no. 93, September 2005,
pp. 98 – 101.
S. Kent, Up the Arsenale, "Time Out",
London, no. 1821, 13 – 20 July.
R. Leydier, 51 Biennale d'art
contemporain, "ArtPress", Paris, no. 315,
September 2005, pp. 73 – 75.
A. Mammi, Nostra Signora Biennale,
"L'Espresso", Rome, LI, no. 24,
23 June 2005.
S. Pirovano, Esperienza dell'arte,
sempre un po' più lontano, due mostre
a confronto, "Around Photography",
Bologna, 2, no. 6, July – September 2005.
R. Rugoff, Venice Top Ten (In No
Particular Order), "Frieze", London,
no. 93, September 2005, pp. 102 – 103.
M. Sciaccaluga, Biennale di Venezia.
Italiani, chi sale chi scende, "Arte", Milan,
no. 382, June 2005, pp. 82 – 88.
A. Searle, The best of the Biennale,
"The Guardian", London, 14 June 2005.
M. Spiegler, Effetto Biennale, "Venissage",
suppl. "Il Giornale dell'Arte", Turin,
6, no. 62, July – August 2005, p. 22.
G. Vidal, Caligola sul Sunset Strip,
"Rolling Stone Magazine Italia", Milan,
no. 20, June 2005.
C. Vogel, Subdued Biennale Forgoes
Shock Factor, "The New York Times",
New York, 13 June 2005, p. E1.
T. Zolghadr, Venice Biennale 2005,
"Frieze"no. 93, London, September 2005,
pp. 98 – 101.

"Girls on film", New York, Zwirner
& Wirth, 7 July – 2 September,
exhibition curated by K. Bell.

"Dall'occhio elettronico. La collezione
video del Castello di Rivoli
Museo d'Arte Contemporanea",
Rivoli, Castello di Rivoli,
21September – 16 October.

"BYO. Bring Your Own", Nuoro,
MAN – Museo d'Arte della Provincia
di Nuoro, 23 September 2005 –
8 January 2006, exhibition curated
by S. Cincinelli, A. Mugnaini,
catalogue, MAN, Nuoro.

"Omaggio al quadrato", Turin,
Galleria Franco Noero,
13 October – 5 November.

"KunstFilmBiennale", Cologne,
Kölnischer Kunstverein,
19 – 24 October.

"Superstars: Von Warhol bis
Madonna", Vienna, Kunsthalle,
4 November 2005 – 22 February
2006, exhibition curated by G. Matt,
catalogue curated by S. Mittersteiner,
T. Mießgang, Hatje Cantz Verlag,
Osfildern.

2006

"Hollywood Boulevard", São
Paulo, Galeria Fortes Vilaça,
19 January – 11 March, exhibition
curated by A. Melo.

Reviews
A. G. Filha, Arte em busca do glamour
perdido, "O Estado de São Paulo",
Caderno 2 – 16 January 2006.

"Satellite of Love", Rotterdam, Witte
de With, Center for Contemporary Art,
26 January – 26 March.

"The Bruce Nauman Trilogy", Berlin,
Galerie Neu, 15 February – 31 March.

"Day for Night. Whitney Biennial",
New York, Whitney Museum of
American Art, 2 March – 28 May,
exhibition and catalogue curated
by C. Iles and P. Vergne, Whitney
Museum of American Art, New York.

Reviews
D. Carrier, Whitney Biennial,
"The Burlington Magazine", London,
May 2006, pp. 367 – 368.
A. Danto, I'll be your mirror, "The Nation",
vol. 282, no. 17, May 2006, pp. 39 – 41.
P. Eeley, 2006 Whitney Biennial, "Frieze",
London, no. 100, June – August 2006,
pp. 256 – 257.
M. Kimmelman, Biennial 2006:
Short on Pretty, Long on Collaboration,
"The New York Times", New York,
3 March 2006, pp. 29 – 37.

"Video Venice: Highlights from
the 2005 Venice Biennial", Adelaide,
The Adelaide Festival of Arts,
3 – 19 March.

"40 Years", Paris, Yvon Lambert,
18 March – 22 April.

"Ecce Homo, 33 + 1 artisti
contemporanei da collezioni private",
Milan, Spazio Oberdan, 23 March –
21 May exhibition and catalogue
curated by G. De Angelis Testa and
S. Risaliti, Electa, Milan.

"A Short History of Performance – Part
IV", London, Whitechapel Art Gallery,
1 – 14 April.

"Francesco Vezzoli: the Gore Vidal
Trilogy", 15 April – 20 May, Beverly
Hills, Gagosian Gallery, foldout,
Beverly Hills.

Reviews
J. Zellen, *Francesco Vezzoli. Gagosian
Gallery, Beverly Hills*, "ArtPress", Paris,
no. 325, July – August 2006, pp. 78 – 79.

"La force de l'art", Paris, Galeries
Nationales du Grand Palais,
10 – 25 May, exhibition curated by
various authors, catalogue curated
by F. Bousteau, Beaux Arts magazine
(Numero hors-série), Beaux Arts
SAS, Paris.

"Francesco Vezzoli", Dijon,
Le Consortium, 23 May – 12 August,
exhibition curated by E. Troncy.

"Francesco Vezzoli's Marlene Redux:
A True Hollywood Story! (Part One)",
London, Tate Modern, 2 June.

Reviews
C. Corbetta, *London. Francesco Vezzoli
Marlene Redux A True Hollywood Story*,
"Domus", Milan, no. 895, September
2006, p. 8.

"Review: vidéos et films Collection
Pierre Huber", Grenoble,
Magasin – Centre National d'art
Contemporain, 4 June – 3 September,
exhibition and catalogue curated
by Y. Aupetitallot, JRP|Ringier, Zurich.

"People. Volti, corpi e segni
contemporanei nella collezione di
Ernesto Esposito", Napoli, MADRE
Museo d'Arte Contemporanea
Donnaregina, 29 June – 28 August,
exhibition and catalogue curated
by E. Cicelyn and M. Codognato,
Electa, Milan.

Reviews
C. Corbetta, *People on Show*,
"L'Uomo Vogue", Milan, pp. 130 – 133.
P. Esposito, *"People", i segni del*

contemporaneo, "Il Mattino", Naples,
27 June 2006, pp. 46 – 47.
F. Matitti, *Quanta gente al "Madre"!,*
"L'Unità", Rome, 13 August 2006, p. 22.
A. Pepe, *Madre "remixed" by Ernesto Esposito,*
"L'Evento", Rome, 30 June 2006, p. 9.
*Volti, corpi e segni contemporanei
dalla collezione Ernesto Esposito,*
"La Repubblica", Rome, 3 July 2006, p. 39.

"Yes Bruce Nauman",
New York, Zwirner and Wirth,
7 July – 9 September.

Reviews
D. Cohen, *A Chorus of "Yes" in Homage to
the King of "No, No, No"*, "The New York
Sun", New York, 24 August 2006, p. 15.
M. Schwendener, *Yes Bruce Nauman,*
"Time Out", New York, no. 147,
7 – 13 September 2006.
R. Smith, *The Body, Electric: Text and,
Yes, Videotape,* "The New York Times",
New York, 4 August 2006, p. E25.

"Figures de l'acteur. Le Paradoxe
du comédien", Avignon, Collection
Lambert, 8 July – 15 October,
exhibition and catalogue curated
by E. Mézil, catalogue, editions
Gallimard, Paris.

"A la recherche d'une beauté
disparue: omaggio a Luchino
Visconti", Monfalcone, GC. AC
Galleria Comunale d'Arte
Contemporanea, 24 – 30 July,
exhibition curated by A. Bruciati.

"HyperDesigno. 6th Shanghai Biennal",
Shanghai, 5 September – 5 November,
exhibition and catalogue curated
by various authors, Shanghai Art
Publishers, Shanghai.

"Neo-con. Contemporary Returns
to Conceptual Art, "New York,
Apexart, 6 September – 14 October;
traveling to Rome, The British School
at Rome, 10 October – 10 November,
exhibition curated by C. Perrella.

Reviews
C. Perrella, *Neocon,* "Flash Art", Milan,
XL, no. 263, April – May 2007, pp. 112 – 114.
A. Polveroni, *Nel Club degli eccentrici,*
"D – la repubblica delle donne", suppl.
"La Repubblica", Rome, no. 524,
11 November 2006, pp. 292 – 293.
E. Sassi, *Vezzoli & the Balls: recita un
pornostar,* "Corriere della sera", Rome,
17 October 2006, p. 6.

"Highlights from the
KunstFilmBiennale Köln in Berlin",
Berlin, KW Institute for Contemporary
Art, 24 September – 4 October,
exhibition curated by B. Engelbach.

"Dirty Yoga. 5th Taipei Biennial",
Taipei, Taipei Fine Arts Museum,
4 November 2006 – 25 February 2007,

exhibition curated by D. Cameron
e J. - Jieh Wang, catalogue curated
by various authors, Taipei Fine Arts
Museum Taipei.

Reviews
S. Kendzulak, *2006 Taipei Biennial,* "Flash
Art International", Milan, vol. 40, no. 252,
January – February 2007, p. 114.

"Francesco Vezzoli's Caligula",
Belgrado, Museum of Contemporary
Art, 17 November – 18 December,
exhibition and foldout curated
by M. Martic, Belgrade.

2007

"Trailer for a Remake of Gore Vidal's
Caligula", Cologne, Kino im Museum
Ludwig, from 18 January.

Reviews
Brass e Vezzoli, duello alla Biennale,
"Bresciaoggi", Brescia, 16 June 2005.
E. Broccaro, *Caligola: A volte ritorna,*
"Vanity Fair", Milan, 23 June 2005,
pp. 108 – 110.

"Apocalittici e integrati. Utopia
nell'arte italiana di oggi", Rome,
MAXXI, National Museum of XXI
Century Arts, 30 March – 1 July,
exhibition curated by P. Colombo,
catalogue curated by A. Mattirolo,
Electa, Milan.

Reviews
C. A. Bucci, *L'arte dell'utopia è qui al
MAXXI in mostra 24 giovani italiani,*
"La Repubblica", Rome, 29 March 2007, p. 16.

"Vertigo: il secolo di arte off-media dal
Futurismo al web", Bologna, MAMbo,
Museo d'Arte Moderna di Bologna,
6 May – 4 November, exhibition and
catalogue curated by G. Celant with
G. Maraniello, Skira, Milan.

"Francesco Vezzoli. Democrazy",
Venice, La Biennale di Venezia,
52 Esposizione Internazionale d'Arte,
10 June – 21 November, exhibition
and catalogue curated by I. Gianelli,
Electa, Milan.

Reviews
M. Casadio, *Ida Gianelli. Padiglione
Italia Francesco Vezzoli,* "L'Uomo
Vogue", Milan, no. 381, May – June 2007,
pp. 168 – 171; 345.
M. Champenois, *Stars, politique et
vidéo,* "Le Monde2", Paris, 2 June 2007,
pp. 48 – 51.
J. M. Colard, C. Moulène, *Les visages de
l'Art,* "les Inrockuptibles", Paris, no. 603,
19 June 2007, p. 42.
P. Conti, *La Biennale e l'arte al tempo
della guerra,* "Corriere della Sera" Milan,
7 March 2007, p. 49.

P. Coppola, *La Stone stile Hillary in un video sfida virtuale per la Casa Bianca*, "La Repubblica", Rome, 30 May 2007, p. 22.
È un'opera di Francesco Vezzoli sulla manipolazione, "Corriere della Sera", Milan, 31 May 2007, p. 45.
S. Grosso, *Biennale. Una Venezia in affitto*, "Corriere della Sera", Milan, 6 June 2007, p. 39.
Le elezioni presidenziali alla Biennale di Venezia, "Flash Art", Milan, XL, no. 264, June – July 2007, p. 51.
F. G. Lorrain, *Sharon Stone et BHL présidents à Venise*, "Le Point" 7 June 2007, no. 1812, p. 152.
S. Montefiori, *B. H. Levy, Io e Sharon Stone candidati presidenti: ma in America la politica non è fiction*, "Corriere della Sera", Milan, 31 May 2007, p. 45.
L. Pratesi, *Le pale d'altare diventano multimediali*, "La Repubblica", Rome, 25 June 2007, p. 23.
Se la democrazia è uno spot con Sharon Stone e il filosofo Lévy, "La Repubblica", Venice, 4 June 2007, p. 36.
P. Vagheggi, *Tutti i colori dell'arte al presente*, "La Repubblica", Rome, 14 February 2007, p. 54.

"Looking up", Braga, Mário Sequeira Gallery, June – September.

"Francesco Vezzoli: A true Hollywood Story!", Toronto, The Power Plant, 8 September – 4 November, exhibition curated by G. Burke, catalogue, The Power Plant, Toronto.

Reviews
Al Power Plant la vera Hollywood di Vezzoli, "Flash Art", Milan, XL, no. 266, October – November 2007, p. 75.
D. Rimanelli, *Francesco Vezzoli at Power Plant*, "Artforum", New York, September 2007, p. 181.

"Passage du Temps. Collection Francois Pinault", Lille, Tri Postal, 16 October – 1 January 2008, exhibition and catalogue curated by C. Bourgeois, Skira, Milan.

Reviews
B. Géniès, *Souriez ! c'est de la vidéo*, "Nouvel Observateur", Paris, 15 December 2007.
G. Lefort, *Beau "Temps" sur lille*, "Libération", Paris, 30 October 2007, p. 27.
J. M. Wynants, *L'éternelle quête de la lumière* "Le Soir", Brussels, 28 November 2007, p. 33.
"Senso Unico: A Show of Eight Contemporary Italian Artists", New York, P.S.1 Contemporary Art Center, 21 October 2007 – 14 January 2008.

Reviews
I. Costa, *Un bilancio a "Senso Unico"*, "Oggi", Milan, 6 January 2008, p. 7.

"Performa 2007", New York, Solomon, R. Guggenheim Museum, 27 October – 20 November, exhibition and catalogue curated by R. Goldberg, JRP | Ringier, Zurich.

Reviews
E. C. Baker, *Francesco's Vezzoli's Right You Are (If You Think You Are), by Luigi Pirandello at the Guggenheim Museum*, "Art in America", New York, no. 3, March 2008, pp. 52 – 53.
F. Bonami, *Performa 07 NY*, "Domus", Milan, January 2008, pp. 120 – 121.
T. Coburn, *Alright on the night*, "Artreview", London, December 2007, p. 28.
A. La Rocca, *The Italian Rapscallion*, "New York Magazine", New York, 24 October 2007, p. 1.
K. Sonnenborn, *Performa 07*, "Frieze", London, no. 113, March 2008, pp. 45 – 46.

"Le fleur du mal", Benevento, Arcos – Museo d'Arte Contemporanea del Sannio, 6 November 2007 – 31 January 2008, exhibition and catalogue curated by D. Eccher, Electa, Milan.

Reviews
M. Fuani, *I fiori del male*, "Flash Art", Milan, XLI, no. 268, February – March 2008, p. 150.

"Francesco Vezzoli. Primadonnas", München, Pinakothek der Moderne, 15 November 2007 – 17 February 2008, exhibition curated by B. Schwenk.

Reviews
T. Ackermann, *Wenn Prominente weinen*, "Welt am Sonntag", 18 November 2007.
C. Mayer, *Softporno im Medienzirkus*, "Süddeutsche Zeitung", 17 – 18 November 2007.
J. Neustadt, *Hillarys Tränen glitzern in München*, " Die Welt", 7 January 2007.
B. Reiter, *Macht medialer Mythen*, "Augsburger Allgemeine", 19 November 2007.
M. Scherf, *Sein und Schein*, "SZ Extra ", 15 November 2007.
B. Sonna, *Krokodilstränen für die Diva*, "Art", 7 November 2007.
H. Thomsen, *Die Show der Show*, "Die Tageszeitung", 22 January 2008.
H. Willembrock, *Macht und Erotik*, "Südkurier", 5 December 2007.

"Martian Museum of Terrestrial Art – Mission: to Interpret and Understand Contemporary Art", London, Barbican Centre, 6 March – 18 May, exhibition curated by L. Lee and F. Manacorda, Lars Müller, catalogue, Barbican Centre, London.

"The Dawn of Tomorrow Contemporary Art in Italy from Italian Collections", Istanbul, Project 4L, 26 March – 26 April.

"Una stanza tutta per sé", Rivoli, Castello di Rivoli, 2 April 2008 – 18 January 2009, exhibition curated by M. Beccaria.

Reviews
M. Paglieri, *Quando la solitudine diventa arte*, "La Repubblica", Rome, 2 April 2008, p. 12.
Una stanza tutta per sé. Castello di Rivoli, "ESPOARTE. Contemporary Art Magazine", IX, no. 55, October – November 2008, p. 130.

"Gli Artisti della Collezione ACACIA", Milan, Palazzo Nicolosio Lomellino di Strada Nuova, 8 May – 15 June, exhibition curated by G. De Angelis Testa and A. Daneri

"The Cinema Effect: Illusion, Reality, and the Moving Image. Part II: Realisms", Washington, Hirshhorn Museum and Sculpture Garden, 19 June – 7 September, exhibition and catalogue curated by di K. Brougher, Hirshhorn Museum, Washington; Giles, London.

"I Want a Little Sugar in My Bowl", New York, Asia Song Society, 9 – 24 August.

"Democrazy, An installation by Francesco Vezzoli", Miami, The Wolfsonian FIU, 24 October – 7 December.

"Head to Head: Political Portraits", Zurich, Museum Fur Gestaltung, 31 October 2008 – 22 February 2009, catalogue curated by C. Brändle, Lars Müller Publishers.

Reviews
S. Menegoi, *Democrazy / On Otto*, "Spike Magazine", Summer 2007.
S. Rothkopf, *Francesco Vezzoli talks about Democrazy, 2007, 1000 words*, "Artforum", New York, September 2007, pp. 449 – 450.
C. Swanson, *Sharon Stone Republican Hillary*, "New York", 11 June 2007.

2008

"Focus on Contemporary Italian Art", Bologna, MAMbo, Museo d'Arte Moderna, from 6 December, exhibition and brochure curated by G. Maraniello, Bologna.

Reviews
P. Naldi, *Nel teatro della collezione storica entrano venticinque nuove opere* "La Repubblica", Bologna, 15 March 2008, p. 16.

2009

<u>"Greed. A Fragrance by Francesco Vezzoli"</u>, Rome, Gagosian Gallery, 6 February – 21 March.

Reviews
C. Bollen, *Roman Polanski by Francesco Vezzoli*, "Interview", New York, February 2009, pp. 101 – 104.
D. Brinn, *What does Greed smell like?*, "The Jerusalem Post", Jerusalem, 5 February 2009, p. 24.
J. Collard, *The moment The Anti-consumer ad*, "The Time Magazine", New York, 31 January 2009.
L. Colonnelli, *Profumo di Vezzoli*, "Corriere della Sera", Milan, 7 February 2009.
P. Conti, *Lo spot del profumo che non c'è: Vezzoli mette in mostra la pubblicità*, " Corriere della Sera", Milan, 31 January 2009, p. 41.
L. De Sanctis, *Il profumo di Vezzoli, inganno che seduce,* "La Repubblica", Rome, 12 February 2009, p. 18.
M. di Forti, *Vezzoli Il profumo dei media*, "Il Messaggero", Rome, 6 February 2009, p. 23.
E. del Drago, *Francesco Vezzoli, eau de femme célèbre*, "il manifesto", Rome, 24 February 2009, p. 14.
A. Gazzera, *Profumo di bluff*, "Vanity Fair", Milan, 11 February 2009.
R. Lattuada, *Le lacrime di Duchamp*, "Il Mattino", Rome, 13 February 2009, p. 23.
A. Mammi, *Kolossal effimero*, "L'Espresso", Rome, 22 January 2009, pp. 100 – 101.
F. Matitti, *Qui il profumo non c'è però si può "vedere"…*, "L'Unità", Rome, 7 February 2009, p. 58.
L. Pratesi, *E, dopo la finta campagna elettorale, faccio un profumo (che sento solo io)*, "Il Venerdì", suppl. "La Repubblica", Rome, 6 February 2009, pp. 82 – 83.
L. Pratesi, *Francesco Vezzoli*, "Flash Art", Milan, XLII, no. 276, April – May 2009, p. 96.
G. Simongini, *Il marketing che odora d'illusione*, "Il Tempo", Rome, 7 February 2009, p. 29.
C. Soffici, *Vezzoli, la star che forse non fa arte. Ma è il migliore a farla…*, "Il Giornale", Rome, 7 February 2009, p. 28.
P. Ugolini, *Francesco Vezzoli da Gagosian a Roma*, "Arte e critica", Rome, May 2009, p. 96.
M. Vallorca, *Vezzoli e Polanski l'essenza che non c'è*, "La Stampa", Turin, 9 February 2009, p. 32.
G. Verzotti, *Francesco Vezzoli at Gagosian Rome*, "Artforum", New York, April 2009, Vol. XLVII, no. 8, p. 205.

"Un Certain Etat du Monde? A Certain State of the World?", Moscow, Garage, Centre for Contemporary Culture, 19 March – 14 June.

"The art of fashion", Rotterdam, Museum Boijmans van Beuningen, 19 September 2009 – 10 January 2010, exhibition and catalogue curated by J. Teunissen, J. Clark, Museum Boijmans Van Beuningen, Rotterdam; traveling to Wolfsburg, Wolfsburg Museum, from 5 March 2011.

Reviews
I. Repiso, *Los raros se juntan*, "Publico", Madrid, 20 September 2009, p. 59.

<u>"Dalí Dalí featuring Francesco Vezzoli"</u>, Stockholm, Moderna Museet, 19 September – 17 January 2010, exhibition curated by J. Peter Nilsson, catalogue, Moderna Museet and Steidl Verlag, Gottingen.

Reviews
S. Rothkopf, *Dalí Dalí Featuring Francesco Vezzoli*, "Art forum", New York, no. 3, September 2009, p. 152.

"Something About Mary", New York, The Arnold & Marie Schwartz Gallery Met, 22 September – 31 January.

Reviews
T. Loos, *Acts of Faith*, "Vogue", London, October 2009, p. 198.

"Italics. Arte italiana fra tradizione e rivoluzione, 1968 – 2008", Venice, Palazzo Grassi, 27 September – 22 March, exhibition and catalogue curated by F. Bonami, Electa, Milan; traveling to Chicago, Museum of Contemporary Art, 14 November 2009 – 14 February 2010.

Reviews
L. Cherubini, *Italics. La mostra della discordia? È da vedere,* "Il Giornale", Milan, 3 October 2008, p. 34.
Italics, tra revisionismo, assenze e contestazioni "La Repubblica", Rome, 29 September 2008, p. 34.
V. Trione, *"Italics". La scommessa di Palazzo Grassi*, "Corriere della Sera", Milan, 24 October 2008, p. 55.
P. Vagheggi, *Italics. La rivolta degli artisti "una selezione sbagliata",* "La Repubblica", Rome, 15 September 2008, pp. 34 – 35.

"Civica 1989 – 2009: celebration, institution, critique", Trento, Fondazione Galleria Civica – Centro di ricerca sulla contemporaneità, 10 October 2009 – 31 January 2010.

"Francesco Vezzoli : À chacun sa vérité", Paris, Jeu de Paume, 20 October 2009 – 17 January 2010.

Reviews
J. Benhamou-Huet, *Vezzoli, Lady Gaga et le Bolchoï,* "Vogue Paris", November 2009.
V. B., *Chacun son point de croix,* "Têtu", Paris, January 2010.

V. Duponchelle, *Francesco Vezzoli*, "Figaro Scope", Paris, 4 November 2009, p. 43.
J. Restorff, *Suche nach dem einzigen Bild*, "Kunstzeitung", Berlin, 1 October 2009.
G. Rossi Barilli, *Star in cerca di autore*, "Flair", Milan, November 2009.

<u>"Francesco Vezzoli. Marlene Redux: A True Hollywood Story"</u>, Vienna, Kunsthalle Wien, 7 November – 6 December, catalogue curated by G. Matt, S. Genzmer, Verlag für moderne Kunst, Nuremberg.

Reviews
F. Krenstetter, *Draußen Phantastereien drinnen Fragwürdiges,*"Observer", Vienna, 13 November 2009, p. 45.

<u>"Francesco Vezzoli – Ballets Russes Italian Style (The Shortest Musical You Will Never See Again)"</u>, Los Angeles, The Museum of Contemporary Art, 14 November, catalogue curated by V. Castellani, Shapco Printing, Minneapolis.

Reviews
G. Adam, *No holding Back,* "The Financial Times", London, 22 November 2009, p. 15.
M. Boehm, *Francesco Vezzoli presses 'play',* "Los Angeles Times", Los Angeles, 11 November 2009
C. Carrillo de Albornoz, *Revolucion Rusa*, "Vogue España", 1 February 2010.
J. Gelt, *A gala celebration for MOCA,* "Los Angeles Times", Los Angeles, 16 November 2009.
D. Itzkoff, *Lady Gaga Meets the Bolshoi Ballet,* "The New York Times", New York, 29 October 2009.
D. Itzkoff, *The Art World Goes Gaga*, "The New York Times", New York, 23 November 2009.
H. Stolias, *Collection: MOCA's First Thirty Years,* "The Art Newspaper", 11 November 2009.

2010

"Che cosa sono le nuvole? Opere della Collezione Enea Righi", Rovereto, Museion, Museo d'Arte Moderna e Contemporanea di Trento e Rovereto 21 March – 19 September, exhibition and catalogue curated by E. Mezil and L. Ragaglia, Kaleidoscope, Milan.

"Spazio: dalle collezioni d'arte e d'architettura del MAXXI", Rome, MAXXI – National Museum of XXI Century Arts, 30 May 2010 – 23 January 2011, exhibition curated by P. Ciorra, A. D'Onofrio, B. Pietromarchi and G. Scardi, catalogue curated by S. Chiodi and D. Dardi, Electa, Milan.

Reviews
M. Cardillo, *Festa grande per il MAXXI un weekend con l'arte*, "La Repubblica", Rome, 24 May 2010, p. 45.
L. Colonnelli, *MAXXI linee dal futuro*, "Corriere della Sera", Milan, 29 May 2010, p. 58.
F. Giuliani, *MAXXI e MACRO, il grande spettacolo contemporaneo*, "La Repubblica", Rome, 25 May 2010, p. 2.

"Francesco Vezzoli", Moscow, The Garage, Center for Contemporary Art, 19 June – 17 September.

"Forbidden Love: Art in the Wake of Television Camp", Cologne, Kölnischer Kunstverein, 25 September – 27 November.

"SI – Sindrome Italiana, la jeune création artistique italienne", Grenoble, Centre National d'Art Contemporain de Grenoble, 10 October 2010 – 2 January 2011, newspaper published on the occasion of the exhibition, Grenoble.

Reviews
Voyages d'Italie, "L'ARCA International", Milan, no. 97, November – December 2010, p. 121.

"Cosa fa la mia anima mentre sto lavorando? Opere d'arte contemporanea dalla collezione Consolandi", 14 November 2010 – 13 February 2011, exhibition curated by F. Pasini and A. Vettese, catalogue curated by F. Pasini and E. Zanella, Electa, Milan.

Reviews
F. Bonazzoli, *Casa Consolandi rivive a Gallarate*, "Corriere della Sera", Milan, 11 November 2010, p. 17.

"Je crois aux Miracles. 10 ans de la Collection Lambert", Avignon – Collection Lambert, Musée d'Art Contemporain, 12 December 2010 – 8 May 2011.

2011

"L'insoutenable Légèreté de l'être", Paris, Yvon Lambert, 26 January – 3 March.

"Greed, A Fragrance by Francesco Vezzoli", Ceutì, La Conservera, Centro de Arte Contemporaneo, 3 February – 26 June, exhibition and catalogue curated by C. Perrella, La Conservera, Centro de Arte Contemporaneo, Ceutì.

"Francesco Vezzoli. Sacrilegio", New York, Gagosian Gallery, 5 February – 12 March.

Reviews
W. Heinrich, *Poets and Painters" at Tibor de Nagy and Francesco Vezzoli at Gagosian*, "The New York Observer", New York, 15 February 2011.
K. Johnson, *Francesco Vezzoli: Sacrilegio*, "The New York Times", New York, 25 February 2011, C26.
T. Jones – D. M. Davies, *True faith*, "I – D", Milan, no. 311, pp. 229 – 230.
D. Kazanjian, *Mother Love*, "Vogue", New York, January 2011, pp. 122 – 123.
K. Laliberte, *Sacrilegious: Supermodels Get Turned Into Virgin Mary*, "Refinery", Sydney, no. 29, 7 February 2011.
F. Zhong, *When*, "W Magazine", New York, February 2011, p. 93.

"Il confine evanescente", Rome, MAXXI – National Museum of XXI Century Arts, 25 February 2011 – 8 January 2012.

Reviews
E. Sassi, *MAXXI 2011 tra nuova biblioteca, acqua, luci e Transavanguardia* "Corriere della Sera", Milan, 25 February 2011, p. 16.

"Elogio del dubbio", Venice, Punta della Dogana, 10 April 2011 – 31 December 2012, exhibition and catalogue curated by C. Bourgeois, Electa, Milan.

Reviews
A. Bonito Oliva, *Elogio del dubbio*, "La Repubblica", Rome, 23 April 2011, p. 40.
P. Conti, *La sfida di Pinault alla Biennale*, "Corriere della Sera", 9 March 2011, p. 43.

"X. Group Show", Milan, Galleria Giò Marconi, 20 April – 22 July.

Reviews
C. Vanzetto, *Da Fujiwara a Vezzoli, l'eros si fa in 16*, "Corriere della Sera", Milan, 21 April 2011, p. 19.

"Eroi", Turin, GAM, Galleria d'Arte Moderna, 19 May – 9 October, exhibition and catalogue curated by D. Eccher, Allemandi, Turin.

Reviews
L. Mattarella, *Eroi solitari paladini dell'arte contemporanea*, "La Repubblica", Rome, 22 June 2011, p. 60.

"Il mondo vi appartiene – The World Belongs To You", Venice, Palazzo Grassi, François Pinault Foundation, 2 June – 21 February, exhibition and catalogue curated by C. Bourgeois, Electa, Milan.

"Le Surrealisme, c'est moi/ Hommage an Salvador Dalì. Louise Bourgeois, Glenn Brown, Markus Schinwald, Francesco Vezzoli", Vienna, Kunsthalle, 22 June – 23 October, exhibition curated by G. A. Matt, catalogue, Verlag fur Moderne Kunst, Vienna.

"Small Utopia. Ars Multiplicata", Venice, Fondazione Prada, Cà Corner della Regina", 6 July – 25 November, exhibition and catalogue curated by G. Celant, Progetto Prada Arte, Milan.

Reviews
C. Piccoli, *Prada mette in mostra i contemporanei d'Italia*, "La Repubblica", Rome, 4 July 2011, p. 35.

"Prospect 2-0", New Orleans, 22 October 2011 – 29 January 2012, exhibition curated by D. Cameron, catalogue curated by Y. Rouse, New Orleans.

2012

"Francesco Vezzoli. 24 Hours museum", Paris, Palais d'Iena, 24 – 25 January.

Reviews
24 hours museum Vezzoli vs Koolhaas, "Domus", Milan, no. 954, January 2012, pp. 70 – 73.
F. Burrichter, *Play*, "Wired", Milan, January 2012, pp. 33 – 34.
M. Casadio, *Clock On 24h museum*, "Vogue Italia", Milan, January 2012.
C. Corbetta, *Io e la mia signora*, "Rolling Stone", Milan, January 2012, p. 11.
C. Corbetta, *Una notte al 24h Museum*, "Vanity Fair", Milan, 8 February 2012, pp. 110.
N. Cullinan, *Inevitable Osmosis*, "Kaleidoscope", Milan, January 2012, pp. 60 – 69.
B. Galilee, *24 Hour Museum*, "Blueprint", no. 313, April 2012, p. 69.
D. Lattès, *Un thé avec Francesco Vezzoli*, "L' Officiel", Paris, 1 April 2012.
Il Museo a tempo Prada, "Corriere della Sera", Milan, 26 January 2012, p. 33.
C. Mooney, *24 Hour Museum*, "Frieze", London, no. 58, April 2012, pp. 124 – 127.
V. Mouzat, *Miuccia Prada, la fronde mode d'emploi*, "Figaro et vous", Paris, 19 January 2012, p. 27.
Museo da 24 ore effetto Prada, "La Repubblica", Rome, 25 January 2012, p. 50.
V. Trione, *Il museo istantaneo di Vezzoli: la mia arte deve dare i brividi*, "Corriere della Sera", Milan, 23 January 2012, p. 25.

"La Décadence", Paris, Yvon Lambert, 25 January – 25 February.

"Singolarità mobili", Rome, Casa dei Teatri, 1 February – 11 March exhibition and catalogue curated by the Gruntumolani collective group, catalogue, Editoria e spettacolo, Rome.

"Antinoo. Il fascino della bellezza", Tivoli, Villa Adriana, 5 April – 4 November.

Reviews
E. Sa., *Un amore d'Antinoo per Vezzoli imperatore,* "Corriere della Sera", Milan, 6 October 2012, p. 17.

"Gli artisti italiani della collezione ACACIA", Milan, Palazzo Reale, 12 April – 24 June, curated by G. De Angelis Testa and G. Verzotti.

Reviews
C. Campanini, *Prove tecniche di donazione di un museo che non c'è,* "La Repubblica", Milan, 12 April 2012, p. 15.

"Theatre of life", Torun, Centre of Contemporary Art, 18 May – 16 September, exhibition curated by D. Denegri.

"Oltre il muro, Il patrimonio del Museo tra progetti, percorsi speciali e ultime acquisizioni", Turin, Castello di Rivoli, Museo d'arte contemporanea, from 5 June.

"Regarding Warhol, sixty artists fifty years", New York, Metropolitan Museum, 18 September – 31 December, exhibition curated by M. Rosenthal and M. Prather, catalogue, Metropolitan Museum of Art, New York.

Reviews
R. Smith, *The In-Crowd is all here,* "The New York Times", New York, 14 September 2012, p. C23.
R. Storr, *L'eredità del mito Warhol è un percorso a ostacoli,* "Corriere della Sera", Milan, 18 December 2012, pp. 40 – 41.

"For President", Turin, Fondazione Sandretto Re Rebaudengo, 19 September 2012 – 6 January 2013, curated by M. Calabresi and F. Bonami.

Reviews
F. Bonami, *La cultura e il potere. Storie di odio/amore,* La Stampa, Turin, 16 September 2012.
N. Daldanise, *For President. Come la propaganda ha sostituito la politica,* "Arte e Critica", Rome, XIX, October – December 2012, p. 90.
M. Paglieri, *L'arte di farsi eleggere presidente,* "La Repubblica", Turin, 19 September 2012, p. 17.

"Cara domani. Opere dalla collezione Ernesto Esposito", Bologna, Museo d'Arte Moderna di Bologna, 28 September – 2 December, exhibition curated by C. Corbetta, catalogue, Corraini Edizioni, Mantova.

"Homo Faber. Il ritorno del fare nell'arte contemporanea", Milan, Castello Sforzesco, 7 November 2012 – 6 January 2013 exhibition and catalogue curated by M. Di Marzio, Allemandi, Turin.

Reviews
F. Bonazzoli, *Lacrime ricamate sopra il pianoforte,* "Corriere della Sera", Milan, 7 November 2012, p. 21.
Fare conta quanto pensare, "Corriere della Sera", Milan, 7 November 2012, p. 72.

"Francesco Vezzoli, Pablo Bronstein", Turin, Galleria Franco Noero, 10 November 2012 – 15 January 2013.

"Francesco Vezzoli. Olga Forever! The Olga Picasso Family Album", Brussels, Almine Rech Gallery, 28 November 2012 – 2 March 2013.

Reviews
M. DC., *L'homme qui brode,* "L'Echo", 1 December 2012.
C. Laurent, *Hommage à l'Olga de Pablo Picasso,* "La Libre Belgique", 18 January 2013.
S. Steverlynck, *Surviving Picasso,* "Brussel Deze Week", Brussels, 1 February 2013, p. 36.

"Punti di vista. Identità conflitti mutamenti", Cosenza, Galleria Nazionale Palazzo Arnone, 14 December 2012 – 28 February 2013, exhibition and catalogue curated by F. De Chirico and L. Pratesi, Art in progress, Cosenza 2013.

Prizes

2000

Migrazioni. Premio per la Giovane Arte Italiana, Rome, Centro Nazionale per le Arti Contemporanee.

2001

Blinky Palermo Stipendiums 2001 Leipzig, Ostdeutschen Sparkassenstiftung im Freistaat Sachsen.

2002

Premio del Golgo 2002 La Spezia, Biennale Europea delle Arti Visive.

2004

Premio Acacia 2004 Milan, Associazione Acacia.

The bibliography, divided into three sections, includes texts by Vezzoli, interviews and monographic texts on the artist's work. A third section is dedicated to articles of a more general nature.

Books, interviews, writings and projects by Francesco Vezzoli

O Contessina, avrei un desiderio… in *Armando Testa,* exh. cat. (Rivoli, Castello di Rivoli, 21 February – 13 May) Charta, Milan, 2001.

Francesco Vezzoli presents Vera Von Lehndorff in "Veruschka was here", "Flash Art International", Milan, vol. 34, no. 219, July – September 2001, pp. 78 – 83.

Vincente Minnelli: Embroidered Bleeding Tears to Judy Garland, Violette editions, London 2001, 75 signed and numbered editions.

Milano vista da Francesco Vezzoli, "Panorama Milano", Fondazione Nicola Trussardi, Milan, December 2002.

The Icons, "Big Magazine" suppl. "V. I. P. Los Angeles", New York, no. 46, February – March 2003.

Strangers When We Met, interview with Marianne Faithfull, "i-D Magazine", London, no. 243, May 2004

Top Five, "Carnet Arte", Milan, 2, no. 3, June – July 2004.

Madonna. Contro il tempo, "Rolling Stone Magazine", Milan, no. 10, August 2004.

Bad Education, interview with Gore Vidal, "i-D Magazine", London, vols. 2 – 5, no. 255, June 2005.

Caligolhard!, "Vernissage" suppl. "Il Giornale dell'Arte", Turin, 6, no. 63, September 2005, p. 13.

How I convinced Gore Vidal to Be in My Film, "The Art Newspaper", London, no. 161, September 2005.

Caligula and the Politics of Fame, "Flash Art International", Milan, vol. 39, no. 248, May – June 2006, pp. 106 – 109.

Before & After – Francesco by Francesco: Homage to Francesco Scavullo by Francesco Vezzoli, "Quest", special issue "Legend", Berlin, no. 2, 14 September 2006.

Bob Colacello. Caligola e la politica della celebrità, "Flash Art", Milan, XL, no. 264, June – July 2007, pp. 94 – 97.

Just what is it that makes today's home so different, so appealing?, "Domus", Editoriale Domus, Milan, no. 911, February 2008, pp. 142 – 151.

Francesco Vezzoli interviews Tom Burr, "Mousse", Milan, no. 13, March 2008, pp. 32 – 35.

The Post – Publisher, "Kaleidoscope", Milan, no. 1, March – April 2009, p. 67 – 71.

Contro Vezzoli, artist's book produced on the occasion of the exhibition "Civica1989 – 2009" (Trento, Fondazione Galleria Civica, 10 October 2009 – 31 January 2010) Kaleidoscope, Milan 2009.

Questions of style, "Artforum", New York, September 2010, pp. 263 – 264.

Agents Provocateurs Nicki Minaj tranformed by Francesco Vezzoli, "W Magazine", New York, November 2011, cover and pp. 160 – 164.

Interviews, articles and essays about the artist

N. Aspesi, *Vezzoli da Sharon a Milla e Cate. Solo star nelle mie performance,* "La Repubblica", Rome, 21 November 2007, p. 44.

A. Baran, *Francesco Vezzoli Pretty Private Italian Artist Gives Strikingly Honest Interview about Sex,* "Butt Magazine", Amsterdam, no. 19, Spring 2007, pp. 50 – 57.

L. Beatrice, *La magnifica ossesione di Francesco Vezzoli,* "Duel", Milan, no. 85, December 2000 – January 2001.

K. Biesenbach, *Agents Provocateurs Nicki Minaj tranformed by Francesco Vezzoli,* " W Magazine", New York, November 2011, p. 164.

T. Blanks, *Mr Francesco Vezzoli,* "Fantastic man", no. 8 Fall – Winter 2008, cover and pp. 128 – 134.

I. Bonacossa, *Beyond Perversity, Perversity. Beyond Sexuality, Sexuality,* "Label", Turin, no. 18, Summer 2005.

F. Bonazzoli, *Gioielli di pizzo,* "Corriere della Sera", Milan, 26 September 2002.

F. Bonazzoli, *E i ricami di Vezzoli vanno sempre più su,* "Corriere della Sera", Milan, 8 May 2003.

F. Bonazzoli, *Wanted Francesco Vezzoli,* "Urban", Milan, 8, no. 65, January – February 2008, pp. 47 – 49.

S. Bucci, *Il classicismo dei nostri giorni e Sophia Loren diventa una Musa,* "Corriere della Sera", Milan, 25 January 2013, p. 16.

D. Cameron, *Francesco Vezzoli. Lusso, calma e voluttà,* "Flash Art", Milan, 34, no. 229, August – September 2001, pp. 54 – 55.

M. Casadio, *Golden 'N' Sour,* "Vogue Italia", Milan, no. 593, January 2000, pp. 246 – 255.

M. Casadio, *Embroidered,* "Vogue Italia", Milan, no. 594, February 2000, pp. 446 – 453.

S. Castello, E. Muritti, *Francesco Vezzoli: Melodramma vip,* "Elle", Milan, no. 6, June 2003.

G. Celant, *Francesco Vezzoli. Proof that Experimentation Is Alive and Well in Art,* "Interview", New York, May 2004, pp. 62 – 64.

S. Chiodi, *Una sensibile differenza. Conversazioni con artisti italiani di oggi,* Fazi, Rome 2006, pp. 324 – 343.

P. Colombo, *Sul viale del tramonto. L'attività solitaria del ricamo,* "Flash Art", Milan, 34, no. 229, August – September 2001, pp. 60 – 61.

C. Corbetta, *Embroidered divas,* "The Nordic Art Review", vol. II, no. 6, 2000.

C. Corbetta, *Francesco Vezzoli, The awful truth,* "Combo", Milan, 1, no. 0, Summer 2007.

M. Corgnati, *Francesco Vezzoli: Soap Opera d'Arte,* "Carnet Arte", Milan, 2, no. 4, September – October 2004.

A. Dannatt, *It's Not over until Vezzoli Sings,* "The Art Newspaper", London, no. 177, February 2007.

S. Davies, *My Life as a Diva,* "The Daily Telegraph", London, 31 May 2006.

C. D'Orazio, *Francesco Vezzoli,* in *Benvenuti!,* Rome 2000, pp. 34 – 38.

E. D. Drago, *Francesco Vezzoli,* "Klat Magazine", Milan, I, no. 1 Winter 2009 – 2010, pp. 128 – 142.

R. Flood, *Openings: Francesco Vezzoli,* "Artforum", New York, 38, no. 7, March 2000, pp. 120 – 121.

Francesco Vezzoli, "Frieze", London, no. 93, September 2005, p. 152.

A. Frish, *Francesco Vezzoli Pasolini Reloaded,* "Flash Art", Milan, 37, no. 245, April – May 2004, pp. 102 – 105.

M. Gastel, *Vezzi d'arte,* "Donna", Milan, no. 4, April 2003.

J. Hack, *Vezzoli,* "Another Man", London, no. 3, Fall 2005 – Winter 2006, pp. 312 – 313.

O. Koerner Von Gustorf, *Die bitteren Tränen des Francesco V.,* "Welt Am Sonntag", Berlin, no. 24, 11 June 2006.

H. Kontova e M. Gioni, *Francesco Vezzoli. Foto di gruppo con signora,* "Flash Art", Milan, vol. 33, no. 224, October – November 2000, pp. 76 – 79.

H. Kontova, M. Gioni, *Le muse inquietanti. Veruschka e Francesco Vezzoli,* "Flash Art", Milan, 34, no. 229, August – September 2001, pp. 58 – 59.

H. Kontova e M. Gioni, *Francesco Vezzoli. Group Portrait with a Lady,* "Flash Art International", Milan, vol. 34, no. 219, July – September 2001, pp. 74 – 77.

H. Kontova, *Francesco Vezzoli così è (se vi pare),* "Flash Art", Milan, XLI, February – March 2008, no. 268, pp. 70 – 73.

F. Lorenzi, *Lacrime ricamate sul viso dei miti,* "Il Giornale di Brescia", Brescia, 31 January 2002.

A. Mammì, *Dalle stelle alle muse,* "L'Espresso", Rome, 21 December 2011, pp. 119 – 120.

G. Marianello, *Francesco Vezzoli,* "B. T.", Kyoto, vol. 52, no. 788, June 2000.

G. Maraniello, *Mani di fata,* "Flash Art", Milan, 33, no. 224, October – November 2000, p. 80.

G. Matt, *Interviews,* Kunsthalle Wien, Verlag der Buchhandlung Walther König, Cologne 2008.

M. Melotti, *Francesco Vezzoli o della fascinazione,* in "L'età della finzione", Luca Sossella, Rome 2006, pp. 139 – 158.

S. Menegoi, *Democrazy. On Otto. Artists Talk,* "Kunstmagazine", no. 12, Summer 2007, pp. 8 – 16.

D. Morera, *E Veruschka finì a piccolo punto,* "Amica", Milan, no. 5, 30 January 2002.

G. O'Brian, *A Man or God of the Moment: Caligula,* "Another Man", London, no. 2, Spring – Summer 2006

L. O'Neill, *Profil: Francesco Vezzoli,* "Vogue Hommes International", Paris, Fall 2000 – Winter 2001.

L. Piccini, *La banda del pizzo,* "Amica", Milan, no. 14, 3 April 2002.

F. Pini, *Olga, l'altra metà del cielo di Pablo Picasso,* "Sette", suppl. "Corriere della Sera", Milan, 23 November 2012, pp. 78 – 81.

G. Politi, *Dietro le quinte. Chiara Bersi Serlini, editor, muse e producer",* "Flash Art", Milan, 34, no. 229, August – September 2001, pp. 62 – 63.

L. Pratesi, *Torna il Caligola di Brass, ma è fatto ad arte,* "Il Venerdì", suppl. "La Repubblica", Rome, 20 May 2005.

Questionnaire and cover, "Frieze", London, no. 93, September 2005, p. 152.

V. Rocco Orlando, *Francesco Vezzoli,* "Rebel Magazine", Paris, no. 4, Fall 2002 – Winter 2003.

F. Romeo, F. Taroni, *News ricamo: Punto Croce,* "Case da Abitare", Milan, no. 56, April 2002.

B. Rosenweig, *Francesco Vezzoli, Ex-model Veruschka's Needle Point for Beginners,* "Baby Mgzn", Amsterdam, no. 8, Spring 2003.

F. Rovesti, *Quei cammei di Vezzoli,* "Lombardia Oggi", Milan, 14 April 2002.

J. Schmidt, *Needlework,* "V Magazine", New York, no. 27, Spring 2003.

P. Vagheggi, *Contemporanei, Conversazioni d'artista,* Skira, Milan 2006, pp. 253 – 254.

D. Versace, *Scandalo nell'antica Roma,* " MFF Magazine" (interview), Milan, July 2005.

Vezzoli l'eccentrico che piace, "La Repubblica", Rome, 9 July 2007, p. 27.

L. Yablonsky, *Caligula Gives a Toga Party (But No One's really Invited),* "The New York Times", New York, 26 February 2006, pp. 34 – 35; A34.

General bibliography

G. Adam, *I moderni italiani sempre più internazionali,* "Il Giornale dell'Arte", Turin, 19, no. 214, October 2002, pp. 73 – 74.

Anteprima Romena dell'Asta londinese, "Corriere Economia", suppl. "Corriere della Sera", Milan, 26 September 2002.

G. C. Argan, A. Bonito Oliva (edited by), *L'Arte Moderna 1770 – 1970, L'Arte oltre il Duemila,* Sansoni, Milan, 2002, p. 344; p. 353.

A Rose by any Other Name, "Interview", New York, February 2007.

N. Aspesi, *Baguette, arte e moda dentro una sola borsa,* "La Repubblica", Rome, 7 May 2012, p. 44.

P. Bacuzzi, M. E. Le Donne, F. Ponzini, *Arte Contemporanea. I personaggi,* La Biblioteca di Repubblica – L'Espresso, Electa, Rome – Milan 2008, vol. 10, pp. 165 – 166.

L. Baldrighi, *La Fiera d'arte moderna rende omaggio a due grandi lombardi,* "Il Giornale", Milan, 3 May 2002, p. 43.

L. Beatrice, G. Politi (edited by), *Dizionario della Giovane Arte Italiana 1,* Giancarlo Politi Editore, Milan, 2003, p. 22; 309.

L. Beatrice, *Era Fiction,* Fine Arts Unternehmen Books, Zug 2004, pp. 202 – 206.

M. Beccaria, *An Impetuous Force,* "Arco noticias", Madrid, no. 22, October 2001, pp. 72 – 74.

L. Bennetts, *Romen Holiday,* "Vanity Fair", New York, no. 538, June 2005.

M. Bethenod, *Flash Back: Helmut Berger, beauté dangereuse,* "Vogue Paris", no. 829, Paris, August 2002.

F. Bonami, *Arte Contemporanea. Duemila,* La Biblioteca di Repubblica – L'Espresso / Electa, Rome – Milan 2008, vol. 6, pp. 154 – 155.

F. Bonami, *The Good, The Bad and The Ugly,* "Frieze", London, no. 141, September 2011, pp. 29 – 30.

F. Bonazzoli, *Angelo Filomeno, l'artista di Ostuni che dipinge con la macchina da cucire,* "Corriere della Sera", Milan, 21 February 2003, p. 59.

F. Bonazzoli, *Sesso e trasgressione addio. Così l'arte sceglie la castità,* "Corriere della Sera", Milan, 16 July 2008, p. 41.

F. Bonazzoli, *Ma oggi i politici non capiscono che siamo una risorsa,*"Corriere della Sera", Milan, 12 December 2007, p. 49.

A. Bonito Oliva, *Italia 2000. Arte e sistema dell'Arte,* Giampaolo Prearo Editore, Milan 2000, p. 259.

A. Browne, *Talent aiguille / You Give me Diva,* "MIXT(E)", Paris, no. 22, March – April 2003.

D. Brun, *Impara l'arte e mettila in cassaforte,* "Panorama", Rome, 40, no. 44, 30 October 2002, pp. 340 – 341.

J. Burton, *Subject to Revision,* "Artforum", New York, vol. XLIII, no. 2, October 2004, pp. 259 – 262; 305.

G. Carandente, *Ma dove è finito il Pino Pascali?,* "Corriere della Sera", Milan, 21 October 2002, p. 27.

M. Casadio, *The Eye of the Needle,* "V Magazine", New York, no. 16, March – April 2002.

G. Celant, *Eva contro Eva,* "L'Espresso", Rome, 48, no. 44, 31 October 2002, p. 195.

Charley 01, Les Presses du Réel, Dijon, May 2002.

F. Chiara, *Interview. Gore Vidal,* "Vogue Italia", Milan, no. 678, February 2007.

L. Cherubini, *E adesso la Fiera guarda all'America,* "Il Giornale", Milan, 24 June 2002, p. 19.

S. Chiodi, *Innombrables présents,* "Eutropia", Macerata, no. 1, 2001, pp. 89 – 92.

F. Cleto (edited by), *Popcamp,* Marcosymarcos, Milan 2008, pp. 15; 232 – 241.

P. Conti, *Arte contemporanea, l'ira dei musei,* "Corriere della Sera", Milan, 6 December 2008, p. 49.

C. Corbetta, *Pollock, la leggenda. Ecco cosa mi ha insegnato,* "Grazia", Milan, no. 12, 26 March 2002, pp. 118–126.

D. Cunningham, *Evius Project,* "Casa Vogue", Milan, no. 9, October 2001.

G. Curto, *Artissima, il segno dell'autore,* "La Stampa", Turin, 15 November 2001, p. 31.

A. Dannatt, *Pace in Armony,* "Il Giornale dell'Arte", Turin, 19, no. 220, April 2003, pp. 52 – 53.

M. di Capua, *Compra l'arte (italiana) e mettila da parte,* "Panorama", Rome, XL, no. 3, 17 January 2002, pp. 140 – 143.

M. Di Marzio, *Quando l'arte è solo marketing. Tendenze,* "Il Giornale", Milan, 4 May 2002, p. 27.

F. Fanelli, *Artissima: prezzi bassi per volare in alto,* "Il Giornale dell'Arte", Turin, 19, no. 216, December 2002, pp. 55 – 56.

F. Fanelli, *Con l'arte in Testa,* "Vernissage", suppl. "Il Giornale dell'Arte", Turin, 2, no. 13, February 2001, pp. 4 – 7.

A. Fiz, *Gli aggressivi: come investono i raider delle gallerie,* "M", suppl. "Milano Finanza", Milan, no. 1, January 2002.

A. Fiz, *Come nasce una stella: Francesco Vezzoli,* "M", suppl. "Milano Finanza", Milan, no. 6, June 2002.

A. Fiz, *Gli affari da non perdere a Milan,* "Web & Week end", suppl. "Milano Finanza", Milan, 27 April 2007.

A. Fiz, *Investire Arte: è una catena di Sant'Antonio,* "M" suppl. "Milan Finanza", Milan, no. 6, June 2002.

A. Flaccavento, *Star dust memories,* "Dutch", Paris, no. 38, March – April 2002.

Francis Bacon e gli altri Big, "Class Arte", Milan, no. 229, May 2005.

S. Frezzotti, C. Italiano, A. Rorro (edited by), *Galleria Nazionale d'Arte Moderna & MAXXI. Le collezioni 1958 – 2008,* Electa, Milan 2009, pp. 663 – 665.

O. Gambari, *Madonne, fototessere e body art a passeggio nel trionfo dei corpi,* "La Repubblica", Turin, 9 November 2012, p. 2.

J. Gasperina, *I Love Fashion: L' Art contemporain et la mode,* editions Cercle d'Art, Paris, 2006, pp. 36 – 37.

C. Gilman, *Introduction,* "October", New York, no. 124, Spring 2009, pp. 3 – 7.

I. Gianelli, M. Beccaria (edited by), *Castello di Rivoli Museo d'Arte Contemporanea. La residenza sabauda – La collezione,* Umberto Allemandi, Turin, 2003, pp. 366 – 367.

I. Gianelli, M. Beccaria (edited by), *Castello di Rivoli Museo d'Arte Contemporanea 20 anni d'arte contemporanea,* Skira, Milan 2004, pp. 396 – 397; p. 478.

M. Gioni, *Milan,* "Artforum", New York, vol. 45, no. 4, December 2006, pp. 259 – 261.

C. Gleadell, *Auction Houses Aim Too High: Italian Sales,* "Daily Telegraph", London, 28 October 2002.

U. Grosenick (edited by), *Art Now Vol 2,* Taschen, Cologne, 2005, pp. 520 – 523.

G. Guercio, A. Mattirolo (edited by), *Il confine evanescente. Arte italiana 1960 – 2010,* Electa, Milan 2010, pp. 174 – 175; 255 – 257.

I magnifici 100 della critica, "Flash Art", Milan, 36, no. 238, February – March 2003, p. 81.

I magnifici 100. La dittatura del pubblico, "Flash Art", Milan, 36, no. 239, April – May 2003, pp. 88 – 89.

T. Jones (edited by), *Safe+Sound,* i-D Levelprint Ltd., London 2007.

O. Lalanne, *Veruschka, le corps absolu,* "Vogue Paris ", Paris, no. 828, July 2002.

L. Larcan, *La festa dell'arte,* "La Repubblica", Rome, 5 October 2012, p. 19.

C. Leoni, *Giovane Videoarte Italiana,* "Flash Art", Milan, 35, no. 234, June – July 2002, p. 111.

S. Lütticken, *From One Spectacle to Another,* "Grey Room", Cambridge, no. 32, Summer 2008, pp. 62 – 87.

A. Madesani, *Scabrose o ricamate ma sempre immagini,* "La Provincia di Como", Como, 14 January 2003.

P. Manazza, *Un bel quadro si vede dal party,* "Capital", Milan, no. 5, May 2002.

P. Manazza, *La carica degli italiani,* "Corriere Economia", suppl. "Corriere della Sera", Milan, 23 September 2002, p. 15.

R. Mandrini, *Events on show: Ricami d'autore,* "L'Uomo Vogue", Milan, no. 327, January 2002, p. 30.

G. Maraniello (edited by), *Arte in Europa 1900 – 2000,* Skira, Milan, 2002, pp. 113 – 114.

G. Maraniello, *C'est un problème de temps. Notes sur l'art italien d'aujourd'hui,* "Artpress", Paris, no. 279, May 2002.

A. Matarrese, *Invasione artistica,* "L'Espresso", Rome, XLVIII, no. 18, 2 May 2002, pp. 76 – 79.

R. Moliterni, *I cinesi con la testa nell'asfalto,* "La Stampa", Turin, 10 May 2003, p. 25.

B. Musall, *Glamour im Kreuzstich,* "Kultur Spiegel", no. 3, March 2006.

H. Muschyamp, *Euro Pop Hits the Beach: so Hot, so Gritty,* "The New York Times", New York, 29 July 2009, p. 91.

H. Myers, *Biting Satire Is Lost in Beverly Hills,* "Los Angeles Time", Los Angeles, 28 April 2006, p. E. 29.

P. N. *Qualità e giovani, la sfida di Arte fiera,* "La Repubblica", Bologna, 4 January 2013, p. 5.

Omaggio a Boetti e Vezzoli il museo torna alla normalità, "La Repubblica", Rome, 17 October 2012, p. 19.

A. Oneacre, *Portraits of an Artist,* "WWD", New York, 3 October 2002.

A. Oneacre, *Eye: Art of the Party – Face Off,* "W Magazine", New York, vol. 31, no. 12, December 2002.

M. Pa., *Italian Sale, arte a Torino,* "La Repubblica", Turin, 22 September 2011, p. 13.

P. Panza, *Trecento opere: il tesoro del MAXXI,* "Corriere della Sera", Milan, 10 March 2010, p. 37.

F. Poli (edited by), *Arte Contemporanea. Le ricerche internazionali dalla fine degli anni '50 a oggi,* Electa, Milan 2003, p. 319; 345 – 346.

A. Polveroni, *Lo sboom. Il decennio dell'arte pazza tra bolla finanziaria e flop concettuale,* Silvana Editoriale, Cinisello Balsamo 2009, p. 78 – 80; 93.

L. Pratesi, *Addio tele e pennelli meglio la cinepresa,* "La Repubblica", Rome, 27 January 2001, p. 29.

L. Pratesi, *Emergenti, l'arte di investire senza svenarsi*, "Affari & Finanza", suppl. "La Repubblica", Rome, 21, no. 22, 12 June 2006.

L. Pratesi, *New Italian Art. L'arte contemporanea italiana delle ultime generazioni*, Castelvecchi, Rome, 2012, pp. 256 – 259.

M. Pratesi, *Quando gridare "venduto" diventa un complimento*, "Il Venerdì", suppl. "La Repubblica", Rome, no. 722, 18 January 2002.

Radar Arte: Click d'Autore, "Gioia", Milan, nos. 49 – 50, 17 December 2002.

A. Rinaldi, *Arte Fiera, una scommessa italiana,* "Il Corriere della Sera", Milan, 25 January 2013, p. 5.

S. Risaliti (edited by), *Espresso: Arte oggi in Italia*, Electa, Milan 2000, pp. 254 – 261.

Scoop: Behind the scenes, "Vogue Nippon", Tokyo, no. 41, January 2003.

P. B. Sega, M. G. Tolomeo, *Ultime generazioni e new media. L'arte europea alla fine del XX secolo* Clueb, Bologna 2002, pp. 36 – 37; pp. 120 – 121; pp. 158 – 159.

G. Serao, *Nuova generazione l'arte dopo Cattelan,* "La Repubblica", Rome, 19 March 2012, p. 7.

Sex & Landscapes, "Kult", Milan, no. 12, December 2002 – January 2003.

I. Sischy, *Money on the Wall*, "Vanity Fair", New York, December 2006, special issue "The Art Issue".

M. R. Sossai, *Artevideo. Storie e culture del video d'artista in Italia*, Silvana Editoriale, Milan 2002, pp. 80 – 86.

M. R. Sossai, *Declinazione Video. Dall'autobiografia al metalinguismo,* "Flash Art", Milan, 35, no. 234, June – July 2002, pp. 96 – 99.

M. R. Sossai, *Sconfinamenti. L'immagine video e il mondo dell'arte",* "Flash Art", Milan, 34, no. 226, February – March 2001, pp. 108 – 111.

F. Sozzani, L. Stoppini (edited by), *kARTell – 150 items, 150 artworks,* Skira, Milan 2002, p. 231.

N. Spector, *Art and artifice,* "Frieze", London, no. 114, April 2008, p. 23.

R. Stange, *In Media Res,* "Flash Art International", Milan, vol. XLI, no. 262, October 2008, pp. 122 – 125.

M. Stevens, *Radical Meek,* "New York", New York, 27 March 2006.

B. Ulmer, *Magische Substanz,* "Bolero", Zurich, September 2004.

A. Vettese, *A cosa serve l'arte contemporanea. Rammendi e bolle di sapone,* Umberto Allemandi, Turin, 2001, pp. 7 – 9.

L. Vinca-Masini, *L'Arte del Novecento. Dall'Espressionismo al Multimediale,* Giunti, Florence 2003 , vol. 12, p. 837.

E. Williams (edited by), *ZOO 12,* Purple House Limited, London, March, 2002.

L. Yablonsky, *Hollywood's New Wave,* "ARTnews", New York, vol. 105, no. 11, December 2006, pp. 112 – 117.

A. Zorloni, *Structure of the Contemporary Art Market,* "International Journal of Arts Management", Montreal, vol. 8, no. 1, Fall 2005, pp. 61 – 71.

With the support of

MINISTERO
PER I BENI E
LE ATTIVITÀ
CULTURALI

ARCUS

With the contribution of

Camera di Commercio
Roma

Educational
Partner

LOTTO

Institutional XXI

ANCE ASSOCIAZIONE NAZIONALE
COSTRUTTORI EDILI

"InfoCamere"

Technical Sponsor

Gobbetto
Resine Speciali - Milano Italy

Exhibition

Galleria Vezzoli
MAXXI – National Museum
of XXI Century Arts
May 29th – November 24th, 2013

Exhibition curated by
Anna Mattirolo
MAXXI Arte Director

Assistant Curator
Anne Palopoli

General Coordination
Giulia Ferracci

Exhibition Executive Design
Dolores Lettieri

Scenographic project
Susanna Rossi Jost

Office of Conservation and Registrar
Alessandra Barbuto
Simona Brunetti
Roberta Magagnini

Restorers
Fabiana Cangià
Francesca Graziosi

Graphic Design
Sara Annunziata

Exhibition Graphic Production
Coordination
Daniela Pesce

Executive Installation Plan
Media Arte Eventi
Spazio Scenico
Gobbetto
Crimar
Rossetti Group
NA.GEST
A.G. Impianti

Audio video
DeSa Technologies

Lighting Supplies
Erco

Lighting Coordination
Paola Mastracci

Handling
Bastart

Insurance
Willis Italia S.p.A.

Transports
Apice

Assistance to the Public
Civita servizi

We wish to thank the following for lending
the works and the courtesy:

ACACIA Collection
AGI Collection, Verona
Boggio Collection
Castello di Rivoli Museo d'Arte
Contemporanea, Rivoli – Turin
Fondazione Prada, Milan
Shelley Fox Aarons and Philip Aarons
Collection, New York
Gagosian Gallery
Galerie Neu, Berlin
Galerie Yvon Lambert, Paris
Galleria Franco Noero, Turin
Giò Marconi, Milan
Nancy Magoon Collection, Aspen,
Colorado
Martino Collection, Rome
Claudio Morra Collection
Giancarlo and Danna Olgiati Collection,
Lugano
Claudio and Maria Grazia Palmigiano
Collection, Milan
Pinault Foundation
Prada Collection, Milan
Project B Gallery
Rennie Collection, Vancouver
Marc and Livia Straus Family Collection
The Ella Fontanals-Cisneros Collection,
Miami
The Museum of Contemporary Art, Los
Angeles
Edward Tyler Nahem Collection,
New York
Vanhaerents Art Collection, Brussels
Viliani Collection

Private collections of Bassano del
Grappa, London, Montagnola –
Switzerland, Rome, Stockholm, Turin

Thanks to all supporters
who have chosen to remain
anonymous

The curator wishes to thank Francesco
Vezzoli for his great enthusiasm, Luca
Corbetta for his invaluable information as
well as his patient generosity in helping
to develop the "Galleria Vezzoli" project
from start to finish; Flavia De Sanctis
Mangelli for her priceless and expert
professional skills; Carlos Basualdo
for the precious years of synergy and
conversations dedicated to MAXXI's
growth, and Mirella Haggiag for her ever-
passionate support. Thanks also go to
Pepi Marchetti Franchi, Franco Noero,
Pier Paolo Falone, Valentina Castellani
and Giò Marconi for having taken part in
this adventure with true friendship.

Catalogue

General Editor:
Anna Mattirolo

Coordination:
Carolina Italiano

Scientific Research and Editing:
Flavia De Sanctis Mangelli

Collaborator for Bibliographical
Research:
Cloé Perrone
Emanuela Scotto D'Antuono
Carlotta Sylos Calò

Translations:
Sylvia Notini
Richard Sadleir

Creative Direction:
OK-RM and Kaleidoscope

Graphic Design:
OK-RM

© Francesco Vezzoli by SIAE 2013

© 2013 by Ministero per i Beni
e le Attività Culturali
Fondazione MAXXI – Museo nazionale
delle arti del XXI secolo
by Mondadori Electa S.p.A., Milano

www.electaweb.com

Published in 2013 by
Mondadori Electa S.p.A.
at Elcograf S.p.A.
Via Mondadori, 15 – Verona

Photo Credits

Matteo Monti (p.10); Brian Forrest (p.24–
25); Loris Barbano (p.30); GianPaolo
Barbieri (p.35); Annalisa Guidetti and
Giovanni Ricci (p.41); Sebastiano Pellion
(p.43, 114, 146–149, 153, 187–188, 239);
Fabio Mantegna (p.47 – 49); Attilio
Maranzano (p.61 – 63, 154); Matthias
Vriens (p.75, 78–79, 100–101, 221);
Patrizia Tocci (p.99); Jason Schmidt
(p.108 – 109); Ben Duggan (p.121); Matteo
Piazza (p.125, 140, 141); Guy Ferrandis
(p.126, 127, 207); Todd Eberl (p.145);
Adrian Gaut (p.159); Agostino Osio
(p.160, 161, 178); Phillipe D. Photography
(p.165 – 167); Filippo Armellin (p.177);
Beatrice Di Giacomo (p.177); Maurizio
Elia (p.235)

Holders of rights to any unidentified
photographs should contact the
publisher

Photo Courtesy

Gagosian Gallery (p.9, 76, 77, 89, 115,
120, 125, 139 – 141); MAMbo – Museo
d'Arte Moderna di Bologna (p.10):
Galleria Franco Noero, Turin (p.11,
37, 69, 103, 114, 148, 149, 153, 188,
242); Castello di Rivoli Museo d'Arte
Contemporanea, Rivoli (TO); (p.16, 75,
78, 79, 204, 236); the artist (p.15, 17, 23,
29, 36, 42, 50, 51, 90, 91, 107); MOCA
– Museum of Contemporary Art, Los
Angeles (p.24 – 25); MAXXI – National
Museum of XXI Century Arts, Rome (p.31,
70 – 71, 99 – 101, 221); AGI Verona
Collection (p.35); Claudio Palmigiano
(p.41); ACACIA Collection (p.47 – 49);
François Pinault Collection, Paris (p.55
– 57, 92 – 95); Fondazione Prada, Milano
(p.61 – 65); Castello di Rivoli Museo
d'Arte Contemporanea, Rivoli (Turin)/
Museum Ludwig, Cologne/Solomon R.
Guggenheim Museum, New York/Tate
Modern, London (p.75, 78, 79); Galerie
Neu, Berlin (p.83, 222); Galleria Giò
Marconi, Milan (p.84, 177); Prada
Collection, Milan (p.85, 119, 131 – 135,
154);Galerie Yvon Lambert, Paris (pp.102,
155); The Solomon R. Guggenheim
Foundation, New York/Performa07/
Gagosian Gallery (p.108 – 109);
Moderna Museet, Stockholm (p.113);
MOCA – Museum of Contemporary Art,
Los Angeles/Gagosian Gallery/Garage
Center for Contemporary Culture,
Moscow (p.121); MOCA – Museum of
Contemporary Art, Los Angeles/Moderna
Museet, Stockholm/Whitney Museum
of American Art, New York (p.126, 127,
203); Prospect.2/Galleria Franco Noero,
Turin/Rennie Collection, Vancouver
(p.145 – 147); Prada spa (p.159 – 161,
178); Fundación Almine y Bernard
Ruiz – Picasso para el Arte/ Almine Rech
Gallery, Bruxelles (p.165 – 167); Galleria
Franco Noero, Turin/Rennie Collection,
Vancouver (p.187)

The MAXXI would like to thank
all those who wanted to support
this project.

Especially Laudomia Pucci

We wish to thank for their invaluable contribution:
GIORGIO ARMANI
Brioni
Beatrice Bulgari
Cortesi Contemporary
Paolo and Noemia d'Amico
Baronessa Ariane de Rothschild
Sigieri and Carlotta Diaz della Vittoria Pallavicini
eni
Ester Fadlun
FENDI
Ferrovie dello Stato Italiane
Gagosian Gallery
Mirella Petteni Haggiag
JT International Italia S.r.l.
Galerie Yvon Lambert, Paris
Galleria Giò Marconi, Milan
Daniela Memmo
Negri-Clementi Studio Legale Associato
Galleria Franco Noero, Torino
PRADA
Almine Rech Gallery
Sky Italia
Ermanni Tedeschi Gallery, Torino Milano Roma
TOD'S
TRUSSARDI
UniCredit S.p.A
VALENTINO
yoox.com

We also wish to thank:
Alessandra Cerasi Barillari
Paolo Barillari
Mariolina Bassetti
Chiara Bersi Serlini
Elena e Claudio Cerasi
Roberto Ciccutto
Tilde Corsi
Erminia di Biase
Groupama Assicurazioni SpA
Simone Haggiag
JP Morgan International Bank Ltd
Piero Maccarinelli
Renata Novarese
Guendalina Ponti
Rennie Collection, Vancouver
Pilar Crespi Robert
Stephen Robert
Fabio Salini
Luca Scordino
Massimo Sterpi
Soledad Twombly